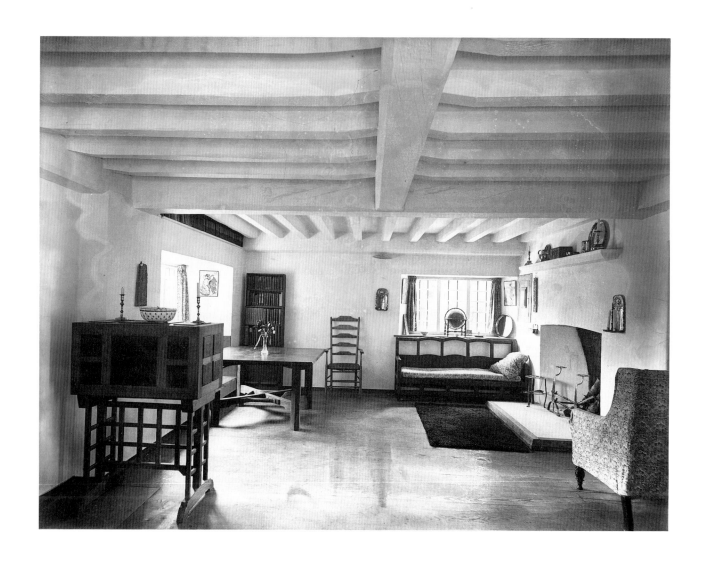

'So I say our furniture should be good citizen's furniture, solid
and well made in workmanship'
William Morris, 'The Lesser Arts of Life', 1882

Annette Carruthers and Mary Greensted

Good Citizen's Furniture

The Arts and Crafts Collections at Cheltenham

Cheltenham Art Gallery and Museums
in association with
Lund Humphries, London

First published in Great Britain in 1994 by
Cheltenham Art Gallery and Museums
Clarence Street, Cheltenham GL50 3JT
in association with
Lund Humphries Publishers Limited
Park House
1 Russell Gardens
London NW11 9NN

British Library Cataloguing-in-Publication Data
A catalogue record for this book is available from
the British Library

ISBN 0 85331 650 3

Designed by Alan Bartram
Made and printed in Great Britain by
BAS Printers Limited
Over Wallop, Hampshire

FRONTISPIECE
The living room of Sidney and Lucy Barnsley's house, Beechanger,
in Sapperton, Gloucestershire, probably in 1904.

Contents

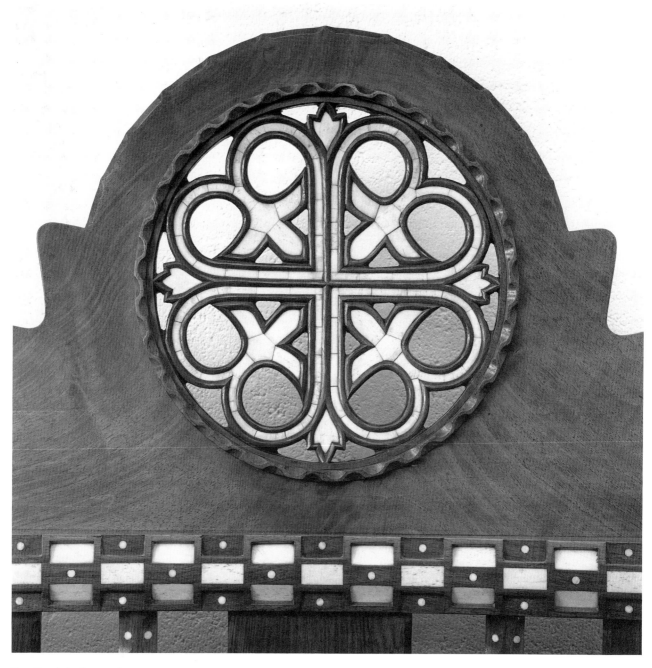

Fig.1 *Detail of a clergy seat by Ernest Gimson, 1915 (see Cat.31). Since 1982 the pattern of the roundel has been used as the logo of Cheltenham Art Gallery and Museums.*

Foreword

In their desire to share with the public the information they accumulate, museums strive to produce catalogues, but often fail for lack of staff resources and funds. In 1987 Cheltenham Art Gallery and Museums published a catalogue of its important collection of Dutch and Flemish painting, centred around the gift of its founder, the third Baron de Ferrieres. This was achieved with external curatorial support and funding and so it is with this catalogue of what must surely be the single most important part of Cheltenham's holdings: its collections related to the English Arts and Crafts Movement.

The catalogue, a major contribution to Arts and Crafts studies with much new material, has been written by Annette Carruthers, who for a time worked on the collection at Cheltenham, and Mary Greensted (née Comino), now back with the Art Gallery after a break of several years. To them we owe a tremendous debt. Since 1989 they have been working with the photographers, Woodley and Quick, whose enthusiasm and dedication have been vital. Particularly grateful thanks are due to the Pilgrim Trust for funding their research. To Lund Humphries we would like to express our appreciation for the keenness with which they wished to share in the dissemination of all this information to a wider public by co-publishing the catalogue.

In the Summer 1989 issue of its *Magazine*, the National Art-Collections Fund described the collection of Arts and Crafts Movement furniture at Cheltenham as being 'probably the best in the world'. What is certain is that nowhere else is the story of the Movement told as well as it is in Cheltenham. Those who buy this catalogue must visit the Art Gallery and Museum as well.

Too many people and institutions have helped in the preparation of this catalogue for me to list them here – their names will be found elsewhere – but to them all, Annette Carruthers, Mary Greensted and I, on behalf of the Art Gallery and Museums Service, express our gratitude, as we do to all those donors, trusts and grant-giving bodies who have enabled us to acquire such a fine collection in the first place.

GEORGE BREEZE
Chief Art Gallery and Museums Officer
Cheltenham Borough Council
October 1993

Acknowledgements

One of the pleasures of working on the Arts and Crafts Movement is that researchers and scholars are so willing to share their information and ideas. We have received much help in producing this catalogue and would like to express our thanks to all who have contributed to it in various ways.

For access to archives and business records, thanks are due to Frank Chambers of Hobbs & Chambers, Philip Dalziel, the staff of the V&A Archive of Art and Design, and especially to Trevor Chinn at Gordon Russell Limited, who has been exceptionally helpful. Roger Beacham, Janet Davies and Neil Sinclair have filled in gaps in the Museum's history. For information on designers, makers and techniques, we thank Ros Allwood, John Beer, John Brandon-Jones, Norman Bucknell, Margot Coatts, Richard Coppin, Peter Cormack, Alan Crawford, Norah Gillow, Cecil Gough, Allan Lupton, Alec McCurdy, Oliver Morel, Alan Morrall, Juliet Kinchin, Kay Rhodes, Barley Roscoe, Godfrey Rubens and Clive Wainwright. Information about and memories of the furniture before it came to the Museum have been provided by Mrs Joan Bottard, General R.C.A. Edge, Mr & Mrs R.H. Heaven, Alison Milton, Lawrence Mitchell, Miss Beatrice Playne, Mrs Hannah Taylor, Douglas and Martin Tubbs, Miss Joyce Winmill, Mr & Mrs M. Worgan and Mrs P.F. Wyber. We also thank Charles Greensted and Alan Saville.

We have enjoyed working with Alan Bartram, Lucy Myers and John Taylor of Lund Humphries.

Most of the new photographs of the collection have been taken by Jamie Woodley and Sarah Quick of Bristol, with some sponsorship in kind from Ilford. Other new photographs are by:
Brian Donnan, Cheltenham Figs 38, 73
Central Photographic Studios, Cheltenham Figs 15, 31, 34, 41, 44, 82, 112, 131
Prudence Cuming, London Fig.55
Impact Photography, Gloucester Fig.154
Michael Jackson, Cheltenham Fig.51
Sotheby's, London Figs 30, 83
Other photographs are from the Museum's Archive collection. We are grateful for permission to print the following:
Abbot Hall Art Gallery, Kendal Fig.160
Felicity Ashbee Fig.80

Mrs Joan Bottard Figs 25, 67, 69
John Brandon-Jones Fig.24
Corinium Museum, Cirencester Figs 190, 194
General R.C.A. Edge Fig.119
Heal & Son, London Fig.125
Oliver Morel Fig.163
Victoria & Albert Museum, London Figs 3, 86, 207
Jane Wilgress Fig. 4
Miss Joyce Winmill Fig.27

Chapter I is by Annette Carruthers, Chapter II by Mary Greensted, and Chapter III is a co-operative account. The catalogue has been compiled largely by Annette Carruthers from information collected over some years in Museum files, and also from new research by George Breeze and the authors.

Notes will be found at the end of each chapter. The following abbreviations have been used in the notes:

AHAG	Abbot Hall Art Gallery, Kendal.
CAGM	Cheltenham Art Gallery and Museums.
EBET	Edward Barnsley Educational Trust, Froxfield, Petersfield, Hampshire.
EBET	Donnellan interview, a transcript in the Barnsley archive of interviews by Philip Donnellan with Ernest Smith, Harry Davoll and others.
GR	Gordon Russell, Broadway, Worcestershire.
GRO	Gloucestershire Record Office, Gloucester.
RCA	Royal College of Art, London.
RIBA	Royal Institute of British Architects, London.
V&A	Victoria and Albert Museum, London.
V&A AAD	V&A Archive of Art and Design, Blythe Road, London.
V&A AAD, A&CES	V&A Archive of the Arts and Crafts Exhibition Society (later the Society of Designer-Craftsmen)
V&A P&D	V&A Prints and Drawings Department.

Any numbers following these abbreviations are the accession numbers of objects.

AC & MG

I 'Good Citizen's Furniture'

'So I say our furniture should be good citizen's furniture, solid and well made in workmanship, and in design should have nothing about it that is not easily defensible, no monstrosities or extravagances, not even of beauty, lest we weary of it ... also I think that, except for very movable things like chairs, it should not be so very light as to be nearly imponderable; it should be made of timber rather than walking-sticks. Moreover, I must needs think of furniture as of two kinds: one part of it being chairs, dining and working tables, and the like, the necessary work-a-day furniture in short, which should be of course both well made and well proportioned, but simple to the last degree; nay, if it were rough I should like it the better ...

But besides this kind of furniture, there is the other kind of what I should call state-furniture, which I think is proper even for a citizen; I mean sideboards, cabinets, and the like, which we have quite as much for beauty's sake as for use; we need not spare ornament on these, but may make them as elegant and elaborate as we can with carving, inlaying, or painting; these are the blossoms of the art of furniture, as picture tapestry is of the art of weaving ...'[1]

When William Morris described his idea of 'good citizen's furniture' in a lecture of 1882, it is significant that his first considerations were that furniture should be well-made and practical in use, and that the pleasure of beautiful objects was secondary; but it is even more telling that he wished to define mundane household goods in such moral terms. In part, this was connected with the developing nineteenth-century view of the home as a spiritual haven from the corruptions of the outside world, but the Bunyanesque overtones of 'good citizen' also derive from the moral concerns of A.W.N.Pugin and John Ruskin, the two major influences on Morris and the Arts and Crafts Movement.

By the beginning of Victoria's reign, changes in British society as a result of the Industrial Revolution had become widespread. The introduction of steam-driven machinery into many crafts and industries led to their increased concentration in areas which were particularly suited to them because of local sources of material or other conditions. New roads and canals, and from the 1830s, railways, eased the movement of people and goods around the country. Many country people moved into the towns and cities, pushed out of farming by new methods of cultivation, which required smaller labour forces, and by the enclosure of common lands. The urban centres expanded rapidly to accommodate them, often in grossly substandard conditions.

The introduction of cost-efficient techniques such as the division of labour to suit machine-production, was not applicable everywhere. In trades such as cabinet-making,

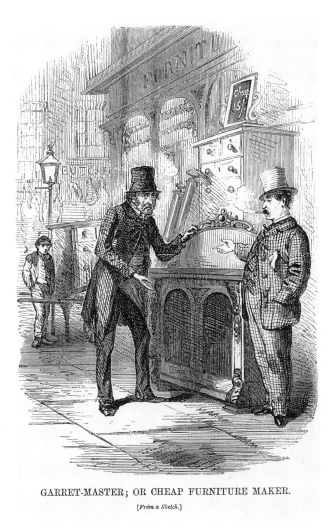

GARRET-MASTER; OR CHEAP FURNITURE MAKER.

[*From a Sketch.*]

Fig.2 *A poor furniture maker tries to sell his work to a retailer. From 'London Labour and the London Poor', by Henry Mayhew, 1861-2.*

however, where machine use was less developed than in, for instance, the ceramics and textiles industries, the workings of competition in a crowded market produced similar results. Although high-class cabinet-makers and some small-town firms retained traditional practices in their workshops, at the lower end of the trade large numbers of people laboured at repetitive jobs for long hours and low pay. They could take little pride in work which was often made to sell as cheaply as possible to the increasing number of middle-class consumers. Henry Mayhew's *London Labour and the London Poor*, published in 1861-2, gives a vivid picture of the situation in the metropolis (Fig.2).[2] In the country, local makers of simple everyday things could often no longer compete in price with work made in the towns.

New work practices evolved to suit the few machines and

tools available and to ensure rapid construction of goods at low prices, inevitably affecting the nature of the finished product. In addition, new machines for processing timber, for sawing logs and for producing thin veneers meant that materials could be bought in ready-prepared. Veneering became a process which could be done cheaply, whereas it was labour-intensive and expensive when the timber had to be cut by hand, and makers could now rapidly produce the kind of perfectly smooth finish which formerly had required great skill and much time. The use of thin veneers to disguise a poor-quality carcase wood in the mid nineteenth century became a symbol of the sham, used by Wilkie Collins and Charles Dickens in their novels as indicators of suspect characters. Mr Sherwin in *Basil* and the Veneerings in *Our Mutual Friend* are also criticised by their creators for an overwhelming love of the 'brand new'.[3]

Many who were involved in manufacturing became concerned about the standard of design in British goods. On purely commercial grounds, it was important to have the right kind of work to compete with products from abroad. Early attempts to improve design by, for instance, Josiah Wedgwood in the eighteenth century, involved promoting new methods of production and bringing in artists to provide designs. The romantic concept of the artist as a separate, unworldly and inspired figure, divorced from the mundane reality of the everyday, had become prevalent in the eighteenth century and was used by Wedgwood to add cachet to his goods. Wedgwood vases from the 1770s were often decorated with classical reliefs designed by sculptors such as John Flaxman and John Bacon.

This policy of harnessing the talents of artists to improve industrial production was continued by the Wedgwood firm and in the 1840s was followed by Henry Cole's pseudonymous business, Felix Summerly's Art Manufactures, for which Richard Redgrave, John Bell and Daniel Maclise made designs. Their products were often interesting and attractive, and in Cole's case the insistence on decorative motifs suited to the function of particular pieces is relevant to the later development of the Arts and Crafts Movement; but the use of artists as freelance designers did nothing to solve the problems of British industry, the lack of visual education among workers and management, and the often appalling conditions of work in the factories.

These problems began to be aired in the writings of William Blake, Charlotte Brontë, Thomas Carlyle and Charles Dickens, and received much attention in the 1830s and 1840s when factory inspectors and parliamentary commissions reported on the conditions of female and child labourers in factories, mines and the countryside.

In 1836, A. W. N. Pugin, an extraordinary designer and architect who crammed a highly productive career into his short life, published in *Contrasts* his ideas on how society was going wrong, and made a connection between the products of a nation and its spiritual life. Pugin's beliefs were shaped by his love of Gothic art and architecture and his devotion to Catholicism, and he looked to the medieval period for a model of a society with better values. In *Contrasts* he compared his beloved Gothic architecture with the debased classicism of the nineteenth century, and in one of the most telling illustrations, showed a medieval almshouse with a Victorian poor house, one a haven for dignified old people, the other a place of punishment for the deprived, who are destined to suffer the ultimate indignity of dissection after death. Thus he connected art and life, and saw architecture as the expression of community life. He also defined a set of principles for the creation of architecture as a living practical system rather than an applied style.

To Pugin's vision of a more spiritual society John Ruskin added an analysis of why in his view contemporary work was so poor. It was not simply a lack of Christian values, but resulted from the changes in status of the artist and the concomitant alteration in the role of the artisan. Ruskin believed that the art of the Middle Ages was more beautiful than that of the nineteenth century because all involved in its production had some freedom of expression in their work, and their enjoyment of their labour had visible results. He criticised the accepted social divide between intellectual and practical workers and suggested that the architect should be fully conversant with all the skills and materials of the trade.

William Morris eagerly took up all these ideas, which appealed to his strong sense of social justice, and he formulated a powerful message about the importance in life of both art and work.

For Morris, art was the focal point. As a boy at school he had discovered architecture and archaeology, and at university in Oxford he gave up his plans for a career in the Church and instead dedicated his life to Art, in company with his friend, Edward Burne-Jones. He tried for a while to become a painter with Dante Gabriel Rossetti; and moving in Pre-Raphaelite circles, he became thoroughly immersed in the idea that art and morality in society are entwined.

As a wealthy man, Morris was in a position to do something about his ideas, and after some years spent experimenting with different types of work, he established with friends the firm of Morris, Marshall, Faulkner & Company. Begun in 1861, this was consciously intended to bring art into the manufacture of household goods, and its first

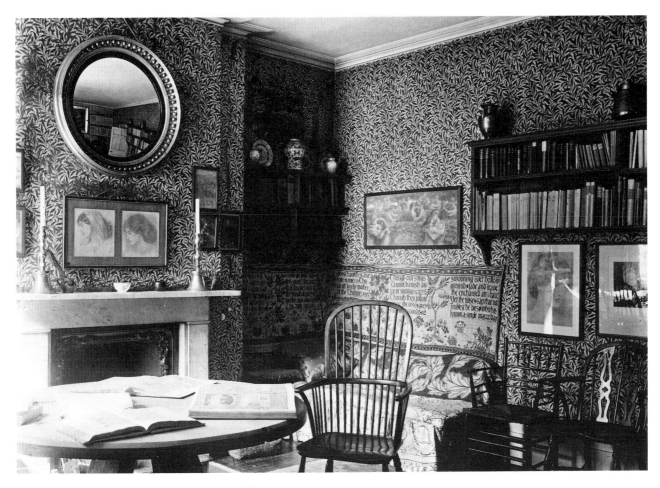

Fig.3 *Interior at 8 Hammersmith Terrace, London, 1923, the home of May Morris. Wallpaper and furnishings by Morris & Company and table by Morris himself (see Cat.1).*

circular counted among its offerings mural decoration, carving, stained glass, metalwork and jewellery, furniture, embroidery and stamped leather. The partners, who included Burne-Jones, Rossetti, Philip Webb and Ford Madox Brown, produced designs which were made by professional makers, so the position was not entirely different from that of established firms, except for their emphasis that as a group they would be able to give artistic supervision lacking from similar companies. Their guiding principle was that art should come first and the public be persuaded to buy what the artists produced, rather than the usual commercial approach of trying to supply a demand.

In the beginning, the firm's main success was its stained glass. From 1864, Morris designed wallpaper patterns, though these did not gain popularity until some years later, and he was particularly interested in the techniques of textile production. He taught himself embroidery stitches and in

the mid 1870s was often to be found covered in indigo from the dye-vats. His dedicated practical approach is captured vividly in a small drawing by Burne-Jones of 'Morris lecturing on Weaving', in which all the audience sees of the lecturer is his back as he bends over the loom. The fact that Morris, a wealthy middle-class man with a rising reputation as a poet, was prepared to work with his hands in this way, was very important as an example to those who followed.

Morris, Marshall, Faulkner & Company also provided a model for later groups to copy, although the co-operative nature of the original organisation proved uneconomic as Morris and Webb were left to do most of the work. From 1875 the firm was renamed Morris & Company. It remained in business until the Second World War, providing individual items of wallpaper, fabrics, furniture, metalwork, glass, ceramics and so on, and also an interior design service for the whole house. From 1877 it had premises in Oxford

Street, where customers could make their choice and young designers could go to look at the latest work. In order to survive so long, compromises had to be made, and many of the later pieces of furniture and other goods were more elaborate and costly than Morris would have liked, prompting his famous outburst in 1876 against 'ministering to the swinish luxuries of the rich'.[4]

This conflict of interests, between wanting to create beautiful things and believing that more people should have the possibility of enjoying art in everyday life, caused Morris to become active in politics, and his speeches and political writings were the third major way in which he influenced his contemporaries and a younger generation. In his own firm, Morris was able to put into practice methods of working that gave his employees a pride in their skills, but he was conscious of the miserable lives of many workers and from 1877 toured the country making rallying speeches about Art and Socialism. By the end of his life, having expended his enormous energies in the causes of art and political reform, he had come to feel that the changes needed in British society could not be achieved through art. In all his attempts to convince others, however, he had reached a sizeable number of people who became the most influential architects and designers of their generation. They in turn passed on Morris's ideas and ideals to their pupils and assistants and set up societies and associations to promote his principles.

In the first generation of followers were Arthur Heygate Mackmurdo, Herbert Horne and Selwyn Image, who established the Century Guild in 1882. Like Morris & Company, this was to supply the furniture and furnishings necessary for a house. It aims were to involve the artist in areas of work hitherto considered the realm of the tradesman, and to restore building, decoration, glass-painting, pottery, wood carving and metal working to a place beside painting and sculpture. Although fairly short-lived, the Century Guild produced influential work and published the first of the Arts and Crafts magazines, the *Hobby Horse*, from 1884.

Mackmurdo's work had a particular influence on C.F.A. Voysey, who also acknowledged a debt to Morris, though as an 'Individualist', Voysey rejected Morris's socialism as strongly as he disliked capitalism. In spite of his self-contained approach to life, Voysey did join the Art Workers' Guild when it was established in 1884 to provide a meeting point for architects and craftworkers, and he also exhibited with the Arts and Crafts Exhibition Society from its first show in 1888. These two organisations were essential to the development and spread of reforming ideas in the arts, and the Exhibition Society provided the name by which the

increasingly identifiable movement became known. This sense of cohesiveness was increased from 1893 by the publication of a new arts magazine, *The Studio*, covering predominantly domestic architecture, decorative painting and the applied arts, and using modern printing technology to provide numerous illustrations of the latest work.

Most of the early Arts and Crafts activity was London-based, and almost all the major figures in the 1880s and 1890s were architects. Their training encouraged them to study buildings and interior fittings in great detail and to take an interest in the trades and crafts involved in building. Morris and Webb also pointed the younger architects towards the practical crafts, with widely varying results. A few, such as Sidney Barnsley and John Paul Cooper, found the practice of making so congenial that they undertook relatively little architectural work in their careers. Some, including Ernest Gimson and Charles Robert Ashbee, became interested in running workshops where others were employed to execute their designs. For Gimson and for Ashbee, in their different ways, an important objective was to provide skilled and satisfying work in the country, to bring out the talents of the ordinary 'British Working Man'.[5] Yet others, such as Voysey and M.H. Baillie Scott, not only designed houses and all the furniture and furnishings within them, but also worked as freelance designers, producing textile patterns or ranges of furniture which were made and sold by specialist firms.

At the turn of the century, these many varied strands of practice flourished in Britain and had widespread influence abroad. The domestic architecture of the Arts and Crafts received high praise in Hermann Muthesius's book, *Das Englische Haus*, published in Berlin in 1904-5; British designers had a rapturous welcome at the Secession exhibitions in Vienna; workshops and guilds sprang up in Europe and the USA; and many new magazines spread the message in a variety of languages.

As the Movement became more widely known, and people like William Lethaby and Walter Crane gained in influence, colleges such as the Central School of Arts and Crafts were set up to teach the new ideas, and established institutions, including the Royal College of Art, began to change to reflect progressive ideology. It was probably partly as a result of this new input from art schools, and partly because the first spirit of discovery of the crafts was replaced by a desire for more detailed research, that the next generation of arts and crafts makers tended to be more involved in the process of making than most of their elders. In the early twentieth century, there was less emphasis on arguing for the social role of the crafts in revitalising work-

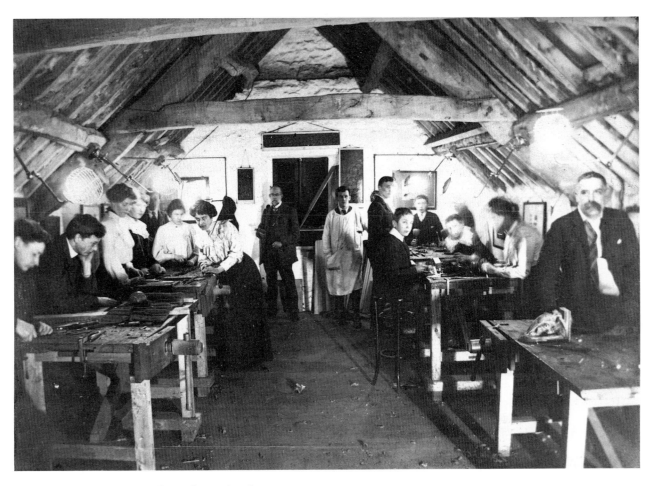

Fig.4 *A Guild of Handicraft carving class at Chipping Campden, 1906.*

ing life, and more concentration by individuals on experiments with glazes and dyes, weaves and construction techniques.

This apparent retreat out of the limelight and into the workshop added to the view held by its critics that the Movement was old-fashioned and unprofessional. It had always been inclusive in its aims and encouraged amateurs to participate (Fig.4). It provided many women with an outlet for their creativity and a respectable means of earning money, but the image of the Movement was compromised by the low standard of some of the work promulgated in its name. Young architects and designers of the twentieth century, still almost entirely men, were unlikely to have a high regard for the work of women and of those who had rejected London life for obscurity in country workshops. In fashionable terms, the Arts and Crafts Movement died around the time of the First World War.

In reality, a number of workshops struggled on, produc-

ing work for a small and generous group of clients, attempting to sustain the principles of Ruskin and Morris against the odds. As working conditions in factories improved as a result of campaigns and legislation, there was less to argue against, and Morris's criticisms of the effect on the individual of repetitive work, though still relevant, lost some of their bite. It became clear that some of the changes in society which inspired the Arts and Crafts pioneers to offer an alternative were now irreversible. The introduction of motor transport and the widespread availability of electric power made the dream of local workshops supplying everyday goods to local markets an economic impossibility. The Arts and Crafts had to find a new way to survive.

Some never gave up the dream. Edward Barnsley and Stanley Davies ran their furniture workshops as long as they were able, keeping their prices as low as possible so as not to deter clients. Bernard Leach and other potters made ranges of domestic wares as well as special individual pieces,

and many makers supported their own craftwork by teaching in art colleges and similar institutions. Those who worked through the lean years of the 1930s and the post-war period were eventually rewarded by a revival of interest which started in the 1960s, although some take the view that this owed nothing to the ideas of the Arts and Crafts Movement and see it instead as the result of allying the crafts with 'fine art'. Certainly makers today have to work within an economic framework which is not what the Arts and Crafts pioneers hoped for, albeit not very different from the reality of the situation in the 1890s. Crafts today are almost entirely luxury goods rather than the essentials of life. They compete in the marketplace with other goods and services, and although many small workshops in rural areas have local outlets for the sale of their products, much of the selling and buying is done nationally and internationally. Very, very few craft workshops offer training to unskilled local people, as did Ashbee and Gimson, and most present-day craft practitioners have undertaken some form of college course before starting work.

So, many of the ambitions of the Arts and Crafts Movement have remained entirely unfulfilled. This may be partly because changes in society more generally have removed the urgency of its aims. Education and the arts, for all their problems, are more widely accessible than they were in the nineteenth century, and the Arts and Crafts campaigners contributed towards such wider changes by making people aware of the issues. The Movement may not have changed the world in the ways originally defined as its objectives, but it can be seen to have had some effect.

Crafts practised within the Arts and Crafts Movement were very various and included skills connected with the process of building, such as plaster and leadwork, mosaic, tile-painting and architectural metalwork, and also free-standing crafts. In the pages of *The Studio* we can see the enormous range of jewellery and metalwork, ceramics and glass, embroideries, weaving and other textile arts, painting and carving, leatherwork and so on. Since so many architects were among the prime movers, and many of them had practices which specialised for various reasons in domestic and ecclesiastical buildings, furniture and furnishings were from the beginning essential elements in the Movement. A chapter by Stephen Webb on furniture formed part of the catalogue of the first Arts and Crafts Exhibition in 1888; *The Studio* in its first few issues concerned itself with both historic and modern furniture and continued to do so; and in 1894 the *Journal of the Royal Institute of British Architects* published Voysey's polemic which begins, 'The subject of "Furniture" is a most depressing one ...'.[6]

Fig.5 *Embroidery designed by Ernest Gimson, about 1900-5, photographed by Herbert Barnsley.*

Although Morris had defined the notion of 'good citizen's furniture', had himself designed a few pieces in the 1850s (Cat.1), and through his company sold a wide range of items of furniture, he told Sidney Barnsley in the early 1890s that he was not really much interested in the subject. He could probably muster little enthusiasm for the inlaid and metal-mounted later products of the firm, since he had always preferred simplicity, and now he suggested to Barnsley that furniture should be made of either sticks or beams.[7] Influential as was this view in encouraging radical thinking about developing plain forms, Morris had already laid out the agenda for the progress of late nineteenth- and early twentieth-century furniture design, and there was no getting away from the example of the firm's products and the many earlier opinions of its founder, which had been forged through frequent discussion and argument into a set of guiding principles.

As with all the media with which Arts and Crafts

6

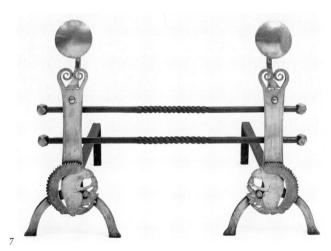

7

Fig.6 *Tooled and gilded leather panels by the Guild of Handicraft, 1892.*
Fig.7 *Polished steel fire dogs by Ernest Gimson, about 1905.*

designers engaged, methods of production remained of fundamental importance and the appearance of what became a recognisable style was based firmly on shared principles relating to making, materials and function, rather than to an agreed programme of aesthetic ideals. Varied approaches to making, from that of the dedicated handworkers at one end of the spectrum to the independent designers supplying retail firms at the other, were underpinned by the accepted idea that a knowledge of the craft was a prerequisite.

The actual techniques of manufacture favoured by the different designers, for their own ideological reasons, influenced the style of the work. Those who preferred hand methods, such as Gimson and the Barnsleys, Romney Green and Eric Sharpe, made furniture which overtly celebrates the woodworking crafts, developing methods of joining pieces of timber as decorative elements in the design, and showing off with light-catching chamfers and *tours de force* of intricately arranged inlay (Figs 8, 9). Their design work involved complex combinations of features from rural crafts and from high-class, usually urban, cabinet-making.

In small workshops, the frequent contact between designer and maker meant that the drawings did not have to give complete details because problems could be discussed, and some aspects were left to the discretion of the craftsman, as proposed by Ruskin. The designer, however, had to have a particular kind of personality to accept the risks of such freedom, and it was also sometimes difficult for the one in charge in this type of workshop to resist pressure from the makers to produce work which was as highly finished as their skills would allow. Frequently this was their major source of pride in the work, but it was not necessarily the prime aim of the designer.

There was probably less of a problem for those like Voysey and Baillie Scott, whose designs were executed in independent workshops, where they would have a more impersonal relationship with the actual makers. Voysey's drawings depict his requirements in clear and unambiguous terms, with full-size details of any parts that might be open to misinterpretation, and occasional written notes. As someone who believed that it was only sensible to use the avail-

able machine tools for cutting out and preparing timber, Voysey designed furniture which reflects the qualities of machine-cut wood, with flat, plain expanses of oak. He was not so concerned with the individual life and training of the maker as was Gimson, but he clearly was interested in aspects of the making, and took pleasure in methods of construction which used no nails or screws, and in finding the elegant solution to any design.

Ashbee's approach was a curious mixture of these two. He installed machine tools in the workshops at Chipping Campden (Fig.10) and produced some utilitarian designs which made the most of machine methods, but in his more elaborate exhibition pieces he was more concerned to exercise the varied talents of the Guildsmen by demonstrating their craft skills. In such pieces, he often seemed to be playing a game with the conventions of cabinet-making, using veneers to imitate framed and panelled construction, for instance (see Cat.15), perhaps because he had a fairly general contempt for trade practice and enjoyed subverting it.

Along with the influence of methods of production, Arts and Crafts style was formed by the absorption of features from old work found in museums, houses and churches (Fig.15), and by an awareness of contemporary design. Such elements were combined with the observation of natural forms and a constant awareness of function.

Largely because of its insistence on the value of studying earlier productions, the Arts and Crafts Movement has been readily dismissed in the twentieth century, and it is true that some of the Movement's furniture is not very far removed from reproduction. Late Morris & Company catalogues, in particular, often capitalised on the names of Sheraton and Hepplewhite to sell their wares. The interest in old work, especially the appreciation of country furniture, also appears to have been a major factor in promoting the trade in antiques, which Lethaby noted with dismay in 1922.[8] People who thirty years before would have bought their furniture brand new were now buying antiques and depriving modern designers of a market. A knowledge of the styles of the past was intended to provide a solid foundation for new work, as designers learned from the successes and mistakes of those who had worked on the same problems before them. Gordon Russell was not entirely successful in this, and when he applied to join the Arts and Crafts Exhibition Society in 1925, it set up a sub-committee to look at his work because the photographs he submitted reminded the members too much of Gimson.[9] Voysey was clearly aware of the dangers of becoming entrammelled in the ideas of others and wrote that 'What you can remember is your own, what you sketch you steal'.[10] His method resulted in strong original forms,

8

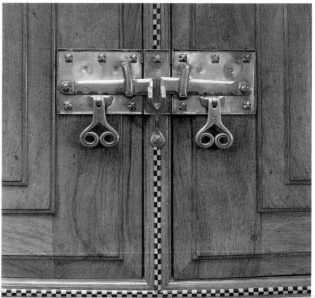

9

Fig.8 *Detail of the decorative chamfering on the plate rack of a sideboard by Ernest Gimson, 1915 (see Cat.33).*
Fig.9 *Hand-made brass latches on the same sideboard.*

which owe something to the works of Mackmurdo and others, but are distinctively Voysey's own.

It is less easy to pinpoint the sources for shapes and decoration used by Voysey than it is in the work of others, such as Ashbee and Gimson, though it would be untrue to suggest that they copied earlier work undigested. In Gimson's case, his range of sources is particularly well documented because not only his sketchbooks but also his photograph collection survive.[11] Echoes can be seen in his decorative inlays on furniture, in his plasterwork, embroidery and metalwork, of medieval carvings, fourteenth-century frescoes, Venetian chests and Indian boxes, embroideries in the V&A, and a catholic range of other visual stimuli (Figs 11, 12, 13). An element in the Arts

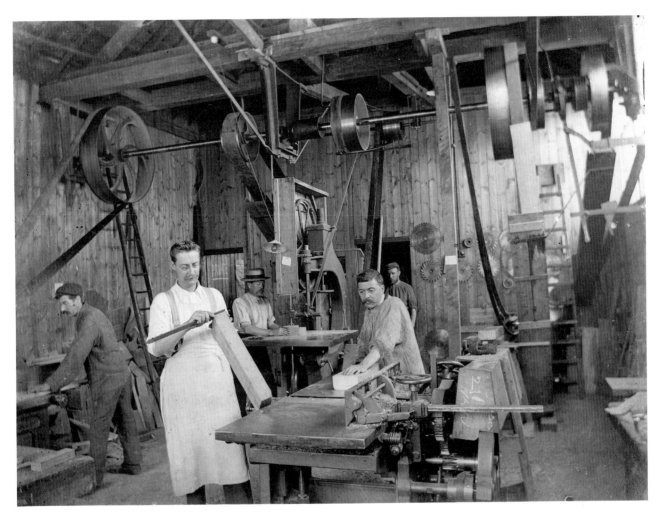

Fig.10 *Guildsmen in the machine shop of the Guild of Handicraft at Chipping Campden, about 1906.*

and Crafts Movement was the idea of revitalising the native English traditions, but for Gimson and others this was tempered by a variety of influences.

Apart from those features which can be identified with specific photographs, it is also clear from Gimson's work that he was aware of the furniture of Godwin, of Madox Brown and of George Jack; dark latticework and the occasional use of ebonising indicate a debt to Godwin, certain shapes and proportions suggest a knowledge of Morris & Company's work. Gimson made this multiplicity of sources his own by never copying them, but by observing the forms and the underlying structures of the patterns and translating them to suit the medium with which he was dealing. When asked by one of his craftsmen why the stems on a piece of inlay

were so stiff and straight, his response was that they were made of wood and should reflect the qualities of wood.[12] In contrast, when the stems of a floral design were carried out in silver, their fluid meandering line showed off the nature of the metal. In this, he followed the principles of Ruskin and Morris, principles which became known by the shorthand term 'truth to materials' and which, when applied pedantically, as they often were by serious Arts and Crafts people, irritated those with a lighter attitude to life.

Form and decoration were to suit the techniques of making and the materials used, but the designers also had to consider the function of the piece. Most of the furniture of the Arts and Crafts Movement was made for domestic buildings or for churches, though there were some exceptions to this,

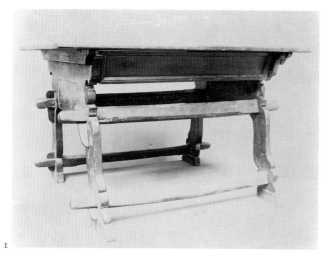

1

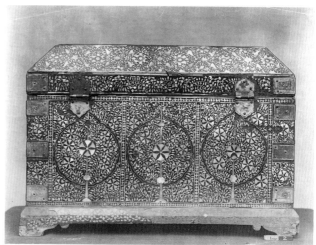

12

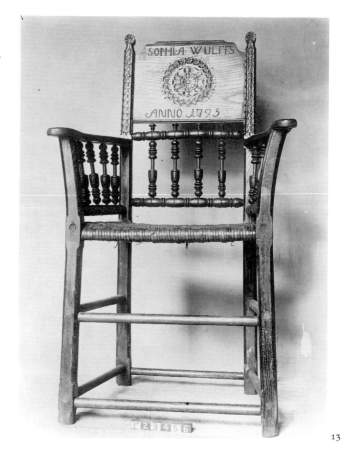

13

such as Voysey's work for the Essex and Suffolk Insurance
Company and furnishings by Gimson and others for village
halls, university settlements and other community buildings.
Just as few Arts and Crafts architects were asked to build
banks and business offices because the ethos of the Move-
ment was simply unsuited to such work, so the furniture
designers were also limited in their range. Multi-purpose
pieces with ingenious devices to transform their size or
character were of little interest to them.

Arts and Crafts furniture falls readily into the types
defined by Morris: the simple work-a-day furniture consist-
ing of solid tables, dressers, settles and similarly traditional
pieces, complemented by a variety of light turned chairs;
and the decorated sideboards and cabinets which Morris
regarded as the 'blossoms' and thought should be 'used
architecturally to dignify important chambers and important
places in them'.[13] One of the problems for the makers was
that those in a position to buy furniture were not
accustomed to paying for simple quality, and there was
fierce competition within the cabinet-making trade to satisfy
a taste for elaboration at the lowest possible prices. Some
mid-century designers, particularly Pugin, Talbert, Seddon
and Street, had pioneered the use of plain forms executed
in unvarnished oak, and the work of Webb and Voysey,
Gimson and the Barnsleys, Sharpe and others, followed this
lead and gradually gained acceptance, though critics were
not complimentary at first. Morris & Company's furniture
at the International Exhibition in 1862 was described as
'laboriously grotesque',[14] and The Builder's reviewer at the
1899 Arts and Crafts exhibition wrote of Sidney Barnsley's
dresser, 'The object now seems to be to make a thing as
square, as plain, as devoid of any beauty of line as possible,
and call this art'.[15] This was the type of work many of the

Fig.11 From Ernest Gimson's photograph collection, a seventeenth-century Swiss
table in the V&A.
Fig.12 Early seventeenth-century Gujerat travelling box in the V&A. Gimson
owned a photograph of this, and a similar piece appears in a view of the Daneway
showroom (see Fig.16).
Fig.13 Another source of inspiration for Gimson, from his collection of
photographs of objects in the V&A. The ash chair is German and the inscription
has been altered from 1825.

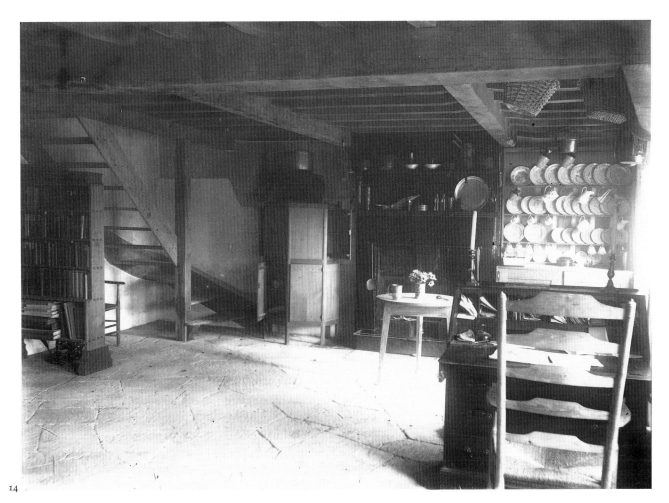

14

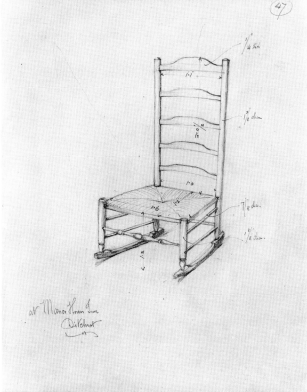

15

Fig.14 *Sidney Barnsley's cottage at Pinbury in the late 1890s, one of the photographs taken by his brother, Herbert.*
Fig.15 *A page from Ernest Gimson's sketchbook of about 1886.*

designers preferred for their own houses, where interiors were often startlingly simple to contemporary eyes (Frontispiece and Fig.14).

In photographs of such rooms, some items of furniture make a regular appearance. Large practical tables were frequently reminiscent of those found in medieval halls. Settles with high backs to protect the sitter from draughts were drawn near to the inglenook fireplace or, in the designs of Baillie Scott, were often built in as part of the fire surround. Such everyday pieces, from the eighteenth and early nineteenth centuries, could still be found at this time in country inns and farmhouses (Fig.32), as could the wooden dressers with plate racks, which were a particular favourite of Gimson and the Barnsleys. A wide range of different forms was used but they were almost all based on such functional, traditional designs.

Most of the Arts and Crafts enthusiasts also appear to have owned one or more of the light turned chairs made first by Morris & Company in several versions based on the 'Sussex' type, with ebonised timber and delicately turned spindles. A more robust form was the West Midlands style

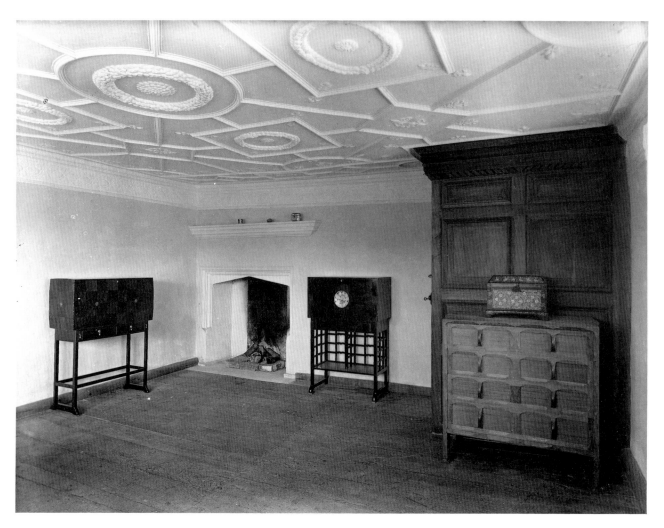

Fig.16 *A showroom at Daneway House with Gimson and Barnsley furniture, 18 May 1902. The box on the chest on the right is probably Indian (see Fig.12).*

of chair made by Philip Clissett, and numerous variations on this theme were devised by Gimson, Ashbee, Russell and Heal.

The simplicity of interiors furnished with plain furniture and rush-seated chairs was relieved by the occasional touch of richness provided by a few chosen antiques or by the elaborately decorated 'state' pieces (Fig.16). Even the puritanical Voysey designed richly painted or inlaid clocks and the occasional item like the Kelmscott 'Chaucer' cabinet, adorned with metal fittings beyond the requirements of function. Almost all the other Arts and Crafts designers welcomed the opportunity to demonstrate their skill with pattern or with materials such as mother-of-pearl or gesso, and much of this kind of work was done. It is difficult to estimate how much, in comparison with the more simple work, because the elaborate pieces received the most publicity through contemporary journals, were most likely to get into museum collections as they went out of fashion, and now are the most readily identifiable and collectable. Similarly, our appreciation of Arts and Crafts furniture is

hampered by the fact that much of it was installed as built-in fittings in houses, and these either remain *in situ* or have been destroyed. Little has been acquired by museums.

Elaborately ornamented furniture was particularly suited to church decoration, and this is often more accessible to the researcher since it normally remains in place. The clergy seat in the Museum's collection is an unusual prototype, and it is interesting to be able to compare it with the original designs; but in settings like St Andrew's Chapel at Westminster Cathedral, one can experience the powerful atmosphere created by a complete interior (Fig.17). Churches provided important commissions, probably partly because of the Movement's respect for the work of the past and high moral tone. Church authorities were accustomed to ordering work from specialist firms, often through the architect in charge of the work, so Arts and Crafts designers simply became part of an existing network for ecclesiastical projects.

In some cases this was also true for domestic furniture. Several firms, such as Morris & Company and George

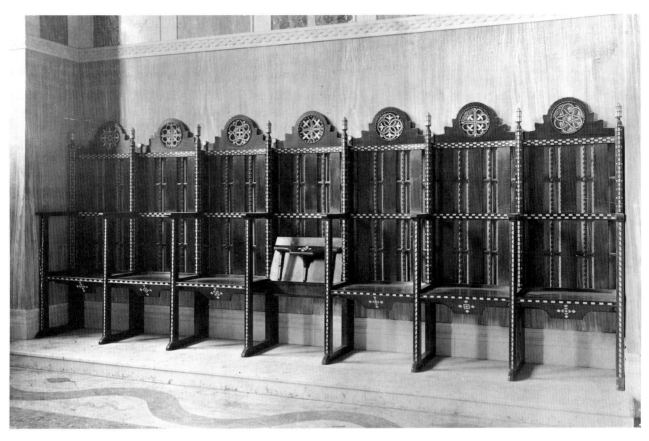

Fig.17 *Ebony and bone seats in St Andrew's Chapel, Westminster Cathedral, London, designed by Ernest Gimson and made in 1915 (see Cat.31).*

Walton & Company Limited, fitted quite neatly into the top end of the interior decorating and cabinet-making trade, taking West End showrooms and attracting a wealthy clientele. Established businesses such as Heal & Son and Liberty added Arts and Crafts ranges to their existing stock and seem to have gathered a largely middle-class following of people who liked the new ideas but could not afford bespoke prices or were unused to the idea of commissioning individual pieces. The architect-designers were able to offer suitable furniture and fittings as an addition to their buildings, and a large proportion of Voysey's furniture was made for such individual commissions, although he also produced designs for production by Story & Company of Kensington. A small number of retailers such as Story, Liberty, Goodyer, Norman and Stacey, Wylie and Lochhead and others sold contemporary furniture by a number of different makers, named and anonymous. The situation is confusing because many had workshops of their own and sometimes commissioned designs from people whose work they also bought in from other manufacturers. Other shops all over the

country marketed versions of 'artistic' furniture, usually imitating the most distinctive features of Arts and Crafts work, beaten copper handles and hinges, and panels of stained glass, but producing the furniture in normal trade conditions and varying very considerably in quality.

For the individual work of rurally based makers, there were few retail outlets. The Guild of Handicraft had its own shop in Brook Street in London, and later on, Gordon Russell opened a showroom in the West End. One of Sidney Barnsley's drawings is marked with the label of Montague Fordham's gallery in London, but it is not known if Fordham bought the piece or if he was acting as agent for Barnsley.[16] Small galleries such as the New Handworkers', run by Philip Mairet near the Tottenham Court Road, or Muriel Rose's The Little Gallery, provided limited display space in the inter-war period, but these were few and far between. The major method of attracting custom to the small workshops was through the Arts and Crafts exhibitions and coverage of them in *The Studio, The Cabinet-Maker and Complete House Furnisher* and other magazines, and a surprising number of

visitors found their way to the workshops of the Guild of Handicraft and the group in Sapperton (Fig.37). Later on, the Red Rose Guild provided the opportunity to show work in the north, with its regular exhibitions in Manchester.

Attitudes to marketing varied a lot. Morris & Company, the Guild of Handicraft, J. P. White's Pyghtle Works, Heal's and Stanley Davies produced illustrated catalogues showing their range of goods and explaining something of the background to their work. Romney Green's *Instead of a Catalogue* gave his philosophy without photographs, and Gordon Russell also produced a pamphlet of this nature, entitled *Honesty and the Crafts*. Gimson was apparently reluctant to send out prints, but employed Dennis Moss of Cirencester to take photographs for him regularly, as did Edward Barnsley and Gordon Russell.[17]

The use of makers' marks on furniture was also connected with marketing, though in some cases it began as a means of giving credit to those involved in the making of a piece. When the Arts and Crafts Exhibition Society started, it insisted that designers and makers should be credited in the catalogue, and it was perhaps because of this that Kenton & Company products were stamped with the names of the firm and the maker, and the initials of the designer (Fig.18). The method was the same as that used by Morris & Company, a simple metal stamp impressed into the timber with a hammer. This technique was commonly employed by craftsmen to identify their tools, and stamped marks can be found on the work of Russell & Sons, Harry Davoll, Edward Gardiner and Neville Neal, Edward Barnsley and Alan Peters. Some of these later makers only began to mark their furniture from 1948, when items of individual craftsmanship became eligible for exemption from Purchase Tax.

A more overt appeal to a sense of pride in ownership of a unique or limited-production piece was made by the attractively printed labels of Russell & Sons, which gave details of the timbers used and the date, as well as of the designer and makers (Fig.19). Since Russell's firm grew out of the hotel business, and he and his family made a conscious effort to attract the tourist trade, it is not surprising that his marketing was more organised than that of Gimson and the Barnsleys or Eric Sharpe. Russell was aware of the value of recognisable trade names, and sold a range of glass, leather and metalwares under the name of 'Lygon', associating these items with the image of the Lygon Arms Hotel in Broadway. Similarly, Heal's produced ranges of furniture with familiar names such as 'Kelmscott' and 'Lechlade', and Dryad's chairs rejoiced in the evocative titles of 'Jolly Friar', 'Abundance' and 'Virgin's Bower'.

All Dryad chairs were marked with a small metal name-

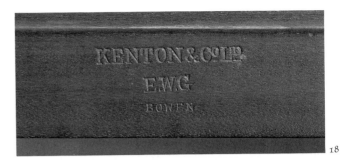

18

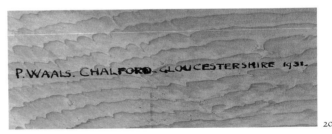

19

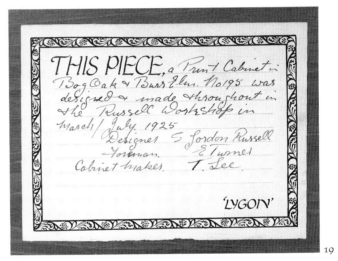

20

21

Fig.18 *Stamped maker's mark on a chair by Ernest Gimson, about 1891 (see Cat.19).*
Fig.19 *Printed paper label on a cabinet by Gordon Russell (see Cat.95).*
Fig.20 *Inscription under a drawer of a cabinet (see Cat.62).*
Fig.21 *Branded mark of M. H. Baillie Scott and J. P. White's Pyghtle Works, on a settle of 1901 (see Cat.16).*

plate as a guarantee of quality, and similar labels in plastic or metal were frequently applied to the work of other Arts and Crafts makers. J.P. White's distinctive branded mark on Baillie Scott's furniture was rather more unusual, and perhaps had some novelty value as a selling point (Fig.21).

Occasional items are also found with hand-written marks, usually on the undersides of drawers. Edward Barnsley is known to have signed pieces that particularly pleased him, but it is not clear why Peter Waals sometimes added his untidy inscriptions (Fig.20). A variety of other marks are also found underneath and inside pieces of furniture, some, for instance, to enable seats to be matched with their correct chair, others as part of the construction process. A more detailed study of these might help in attributing work to individual makers when there is doubt, as would more analysis of small differences in the methods of making (Figs 22, 23).

Who were the buying public for Arts and Crafts furniture? This is a difficult question and the subject deserves more systematic investigation, though the dispersed nature of the evidence makes such research more complex than the study of individual designers and workshops. It is clear that fine craftwork was not within the reach of everyone, but the issue was not simply one of price. Comparisons can be made between Arts and Crafts firms, such as Heal and Russell, and High Street retailers or manufacturers, such as Hampton's or Clozenberg & Company, showing that there was often little difference in the price ranges available,[18] but there was also a question of aspirations. It is one thing to choose simplicity when one has a choice, but for those with little money, elaboration is often preferred, especially if it is associated with traditional styles or made in imitation of high-class work. As Osbert Lancaster illustrated so graphically in line and text of *Homes Sweet Homes*, even in the country the 'ordinary cottager' preferred innumerable ornaments and buttoned upholstery to the plain walls and rush-seated chairs which the 'cultured cottager' had adopted from an earlier age.

When it comes to comparing prices between the different Arts and Crafts makers, the topic is even more complicated. There were enormous variations in the prices of different timbers and in the time needed to work them, resulting in a range of cost prices. Designs made to utilise machine tools could be much cheaper in terms of labour than those which had to be made by hand, but this would not necessarily be obvious to the buyer; and overheads in the different work-shops depended on the circumstances and aims of the owner. In his first years of business, Edward Barnsley simply did not know about charging overheads, because his father

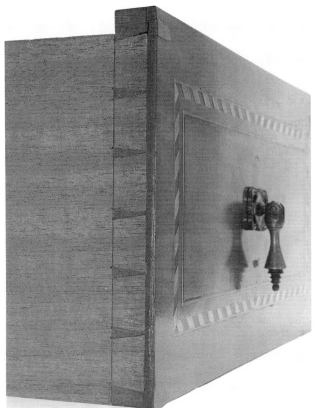

22

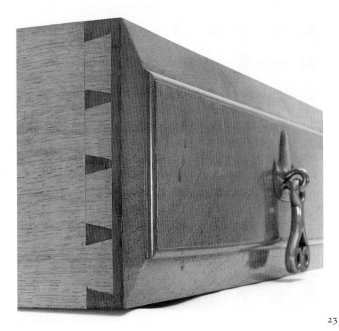

23

Fig.22 *Narrow English dovetails on a Morris & Company cabinet of about 1902 (see Cat.3).*
Fig.23 *Wide dovetails of the type used on European furniture and in England in the seventeenth century, on a sideboard by Ernest Gimson of 1915 (see Cat.33).*

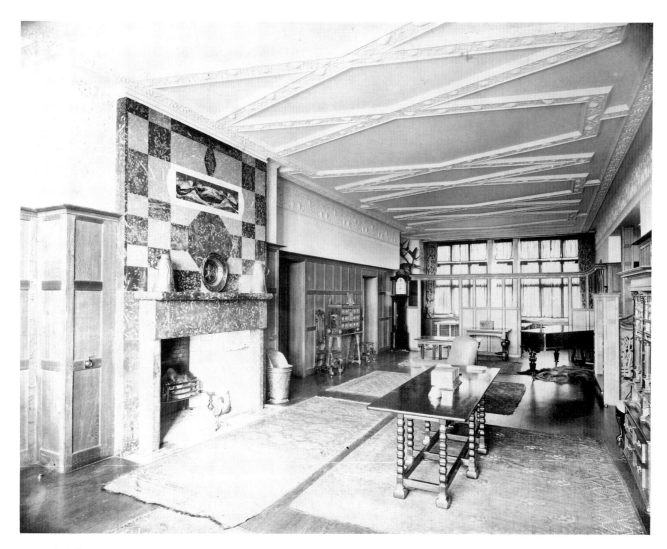

Fig.24 *The hall at Avon Tyrrell, with W. R. Lethaby's table of 1892-6 (Cat.18) and plasterwork by Ernest Gimson.*

did not do so. Ernest Gimson seems to have subsidised his workshop from his private income and so, later on, did Stanley Davies. This means that their prices were often no higher than those of firms which had showrooms to run or machine tools and printed catalogues to pay for, and the client benefited from their commitment to a certain way of life. Gimson in 1912 designed a bedroom suite in walnut at £54 which could not compete with much of Heal's production but was less than the top of Heal's range, while Sidney Barnsley's sideboard of 1923-4 at £30 (Cat.38) compares well with Gordon Russell's of 1926, which sold at £29.17.6d or £32.10.0, according to the timber (Cat.96).[19]

At the time, it was probably much easier for potential

Fig.25 *Interior at the house of William and Haydee Ward-Higgs, with fittings and furniture by C. F. A. Voysey (see Cat.7).*

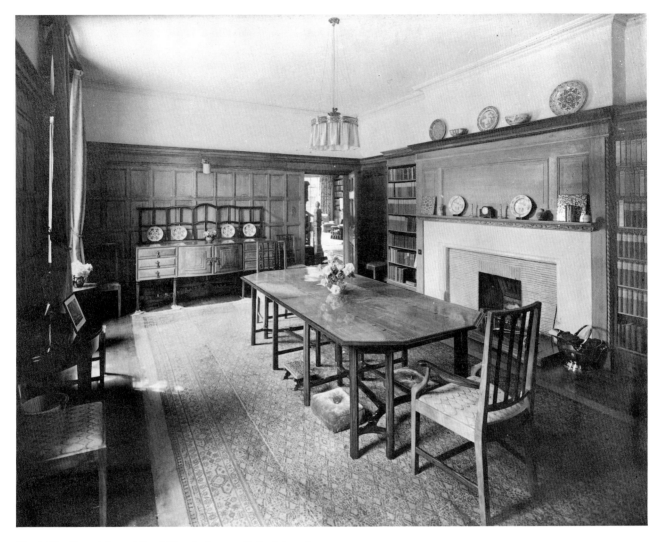

Fig.26 *Allan Tangye's house at Stourbridge, about 1930, with the dining suite by Ernest Gimson of 1915 (Cats 32 and 33) and chairs by Peter Waals of 1929.*

clients to evaluate the differences between the quality of the goods and the prices asked, and to compare with what was available in the mainstream furniture shops. In the end, their choice was undoubtedly made mainly on the grounds of preference for a particular style or a personal interest in the makers.

Within artistic circles, architects, artists, designers and craftworkers frequently bought from one another, or gave their work as gifts to celebrate some workshop meeting or occasion. The architect Charles Canning Winmill, for instance, valued in his home carvings and plaster casts by George Jack, as well as wedding presents from Jack of a carved oak corner cabinet and from Philip Webb of copper

candlesticks. He had curtains by Morris & Company, furniture, brass and steel work from Gimson and the Barnsleys, and among personal treasures, a pendant for his wife, Anne, by Arthur and Georgie Gaskin (Fig.27). Clients of Ernest Gimson and Sidney Barnsley included John Paul Cooper, the silversmith; Francis Dodd, Henry Rushbury, William Rothenstein, F.L. Griggs and other artists; William Simmonds, the carver; and Ambrose Heal, furniture designer.

Many of the relatives of these people also bought, and friends and relations of the designers themselves were generally very supportive. Innumerable members of the Gimson family owned work by Gimson and the Barnsleys,

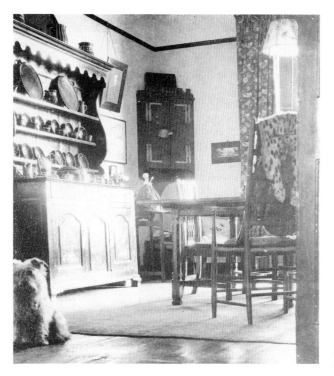

Fig.27 *The dining room at 2 Eliot Place, Blackheath, London, the home of Charles and Anne Winmill, about 1928. A portrait of Morris hangs to the left of the corner cupboard by George Jack and to the right are a Gimson table and chair.*

and many supporters of the Guild of Handicraft acquired pieces they did not necessarily want, often in lieu of dividends. People in this group were by no means all wealthy.

Among the most staunch supporters of Arts and Crafts makers were a number of people from industrial and business families, some of whom made a conscious decision to buy this type of work because they wished to promote the ideas involved. Often they were noted for running their own firms on enlightened principles and most were also concerned about design in their own business premises and equipment. C.H.St John Hornby, a director of W.H.Smith, the stationers, bought several pieces by Gimson and Sidney Barnsley as well as from Morris & Company, and himself joined the private press movement by setting up the Ashendene Press. Birmingham produced numerous important patrons. Arthur Mitchell (see p.111), spent some of the profits of his family's brewing firm on work by Sidney Barnsley and Peter Waals. William Cadbury not only commissioned work for his Birmingham house but also bought Througham Slad, a small manor house near Bisley in Gloucestershire, which was in great need of repair; he employed Norman Jewson as architect and the house

eventually became a family home. And Robert Best, manufacturer of the Best-Lite, had furniture from his old school friend, Edward Barnsley. The enthusiasm of this group of clients was also quite often transmitted to others in their families.

Members of the professions seem to appear as clients less frequently, though this may simply be that their names are less easy to recognise. William Ward-Higgs, one of Voysey's important early clients, was a solicitor, as was Allan Tangye (Figs 25, 26, 67). Claud Biddulph, who built Rodmarton Manor, was from the banking family of Cocks, Biddulph & Co, but was also part of a circle of families with landed interests in Gloucestershire. The construction of the Manor and the use of local labour was partly undertaken as a way of supporting the crafts in the country, and similarly, Lord and Lady Bathurst provided important help for Gimson and the Barnsleys. As well as commissioning architectural work for themselves and buying furniture (and even knitting needles), they also paid for the Village Hall, as a benefit to the inhabitants of Sapperton. The Beauchamp family at Madresfield in Worcestershire had interior fittings from the Guild of Handicraft and Birmingham artists, and also commissioned designs for cottages from Voysey and William Weir. Further afield, Lord Manners had a large house, Avon Tyrrell, built in Hampshire by Lethaby and then filled it with furniture and fittings by Lethaby and others (Fig.24). Architects employed on such projects frequently involved their friends and contacts from the Art Workers' Guild, and in this way Gimson had commissions via Weir Schultz for Lord Bute and through Prior for Roker Church, among many others. A few believed in the idea of the total artwork designed by one individual, but most favoured the collaborative approach.

Information about the original owners of the furniture has been included in this catalogue as far as possible, partly to assist in placing it in context with other evidence of the period and also as a reminder that the vitality of the Arts and Crafts Movement at its height depended on the enthusiasm of these clients for modern work. The emotional sig-

Fig.28 *Hoptonwood stone plaque with a carved inscription by Joseph Cribb, 1920.*

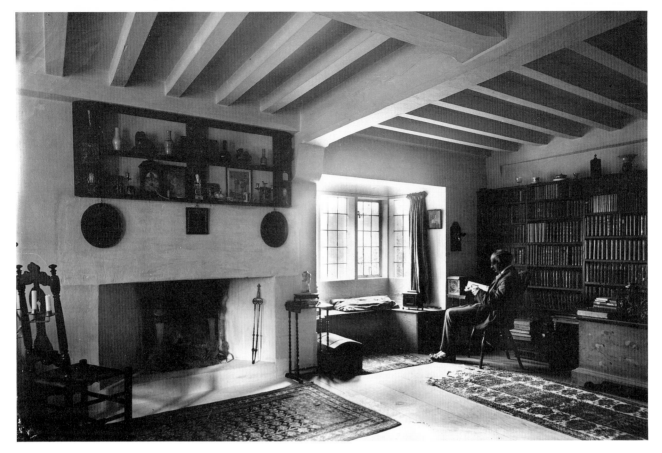

Fig.29 *Ernest Barnsley in his library at Upper Dorvel House, Sapperton, about 1910-20.*

nificance of objects is difficult to discern in retrospect, but it is clear that many of the makers thought and felt deeply about their work, and many of their clients responded in like manner. In his leaflet of 1930, which echoes ideas about domestic life held by Morris, Voysey and Gimson, Eric Sharpe wrote:

Just as a home is not merely a shelter from the weather, a place to eat and sleep in, but may by its form and proportions express ideas, may outwardly express a welcome, and inwardly a sense of rest, and year by year so mellow into the landscape as to become part of it, so the furniture within, the chairs, tables and cupboards, should not merely be things to sit on, have meals at, and stuff odds and ends away in; a real piece of furniture should appeal to the mind and emotions, and be something more than an article of daily use. And herein lies the real argument for hand made things. For the mind works through the hand, guiding the tool, more directly than through the machine, and the article made acquires a more human quality, and conversely the appeal is more direct back to the mind that uses and enjoys it.[20]

1. W.Morris, 'The Lesser Arts of Life', in M.Morris (ed) *The Collected Works of William Morris* Vol.XXII, London 1914, pp.261-2.
2. H.Mayhew, *London Labour and the London Poor*, Vol.III, London 1861-2, pp.221-31. Much of the information was first published in the *Morning Chronicle* in 1850.
3. W.Collins, *Basil*, London 1852 (p.61 in revised 1862 edition reprinted by Oxford University Press, 1990). C.Dickens, *Our Mutual Friend*, London 1864-5. Mr and Mrs Veneering first appear at the start of chapter II.
4. Quoted by E.P.Thompson, *William Morris*, London 1955, p.288.
5. Ashbee expressed his hope of bringing out the artistic talents of the 'BWM' (British working man), while Gimson was less romantic in his approach but had similar ambitions.
6. 'Domestic Furniture', *Journal of the Royal Institute of British Architects*, Vol.1, pp.415-18.
7. EBET, Edward Barnsley to Humphrey Gimson 10.10.69.
8. W.R.Lethaby, *Form in Civilization*, London 1922, p.35.
9. V&A AAD 1/60 1980, minutes of meeting 29.9.25.
10. C.F.A.Voysey, *Individuality*, London 1915, p.88.
11. CAGM 1941.226.
12. EBET, Donnellan interview.
13. W.Morris, 'The Lesser Arts of Life', in M.Morris (ed), *The Collected Works of William Morris* Vol.XXII, London 1914, p.262.
14. Quoted in J.Banham and J.Harris (eds), *William Morris and the Middle Ages*, Manchester 1984, p.124.
15. Vol.LXXVII, October 1899, p.335.
16. CAGM 1972.187.97.
17. Photograph collections at CAGM, Leicestershire Museums, and Gordon Russell Limited.
18. For example: an advertisement by Clozenberg & Co of 1905, reproduced in P.Kirkham, R.Mace & J.Porter, *Furnishing the World: The East London Furniture Trade 1830-1980*, London 1987, p.50, offered a bedroom suite in walnut for £10; a catalogue of Hampton's January sale, 1911 (CAGM Burrough Collection), has a walnut suite at £31.10.0 reduced to £15; Heal's catalogue of 1905 has a walnut suite at £12, Heal & Son, *Heal's Catalogues 1850-1950 in the Victoria and Albert Museum Archive of Art and Design*, Emmett Microform, 1985.
19. Gimson bedroom suite CAGM 1941.222.42; Heal's bedroom suites in March 1913 ranged from £5.15.0 to £88, Heal & Son, ibid.
20. E.Sharpe, untitled leaflet of 1930, AHAG AH 2904/93.

II The Arts and Crafts Movement in the Cotswolds

The Arts and Crafts Movement was both an urban and a rural phenomenon containing contradictory radical and conservative elements. The rural side of the Movement has sometimes been regarded as backward looking,[1] yet in many cases social and design conventions were more easily broken in the countryside. In *Craftsmanship in Competitive Industry*, C.R. Ashbee wrote that '… the proper place for the Arts and Crafts is in the country …'.[2] The Arts and Crafts Movement in the Cotswolds has been described in depth elsewhere.[3] This account is intended to draw together some of the main themes in this complex period.

The last thirty years of the nineteenth century also saw the emergence of the 'back to the land' movement which has remained a feature of English life. With the overwhelming encroachment of the city and its values on the countryside, there was a powerful rearguard action which both romanticised rural life and tried to preserve its surviving heritage. It was closely linked to a search for moral and spiritual values. The countryside provided an escape from the excessive repressions of Victorian society; it provided a relaxation of the constraints of Victorian dress, social etiquette and material possessions. William Morris typified the desire for a new way of life when he wrote: '… suppose people lived in little communities among gardens and green fields, so that you could be in the country in five minutes' walk, and had few wants, almost no furniture for instance, and no servants, and studied the (difficult) arts of enjoying life, and finding out what they really wanted: then I think that one might hope civilization had really begun'.[4] Above all there was the beauty of the English countryside and the inspiration of nature, the importance of which was reiterated time and time again by John Ruskin, William Morris, John Sedding and many others.

Craftsmanship and local traditions still survived in rural England and there was the belief that these imparted a natural dignity and moral superiority to country dwellers despite the physical hardships and deprivations which working on the land often implied. One such craftsman was the chair-maker, Philip Clissett of Bosbury, Herefordshire. From 1838 until his death in 1913, he provided the surrounding community with a wide variety of wooden-seated and rush-seated chairs ranging from ladderback chairs to spindle-back rockers each selling for between 2s 6d [12.5p] and 8s 6d [42.5p]. He used local ash and elm and the most basic piece of equipment, a pole lathe, to make up to six chairs in a week. In 1888, when Clissett was in his seventies, he was 'discovered' by an Arts and Crafts architect, James Maclaren, who brought his work to the attention of the Art Workers' Guild in London. Clissett's work became widely known, par-

ticularly as the Guild furnished its meeting hall with his rush-seated ladderback chairs (Cat.17). Clissett, described by Alfred Powell as resembling 'what the old aristocratic poor used to be',[5] typified the popular image of the country craftsman.

The main rural centre for the English Arts and Crafts Movement in its heyday was the Cotswolds. This range of hills bounded by the Severn valley to the west and lying mainly in Gloucestershire, although it also spreads to adjoining counties, is today classed as the second largest Area of Outstanding Natural Beauty in Britain. In the late twentieth century, the Cotswolds have become a popular tourist attraction and residential area, one of the wealthier parts of England with a veneer of status and glamour derived from the royal residences and blockbuster novels.

However, the Cotswolds certainly had their fair share of physical deprivations in the nineteenth century. The area had declined dramatically since trade in wool had brought prosperity to towns such as Cirencester, Chipping Campden and Northleach in the sixteenth and seventeenth centuries. During the Industrial Revolution, the wool trade had moved to new northern centres, while the crisis in agriculture in the 1870s had also hit farming, another traditional Cotswold activity. In the 1820s, the writer William Cobbett was commenting on the general cheerlessness, austerity and poverty of the Cotswold landscape. It was not an appealing prospect for most visitors. If they came at all, it was to marvel at the architectural monuments of an earlier age: the fine abbeys at Tewkesbury and Evesham and the magnificent cathedral at Gloucester. The immense wealth of vernacular architecture based on the style of the Cotswolds' prosperity, the Elizabethan, was largely ignored.

The Cotswolds first captured the interest of artists and designers in the last decades of the nineteenth century. In the 1880s, the picturesque north Cotswold town of Broadway was settled and popularised by a group of American artists and writers, including Edwin Austen Abbey, Frank Millet and Alfred Parsons. Their émigré colony received illustrious visitors such as the painter John Singer Sargent and the writer Henry James. A less obvious choice was made by William Morris and the Pre-Raphaelite painter Dante Gabriel Rossetti when they jointly rented Kelmscott Manor in 1871 (Fig.30). This typical stone-built manor house forms the focal point of the small village of Kelmscott near Lechlade on the southern borders of the Cotswolds. Morris and Rossetti wanted a spartan summer retreat for themselves, their families and friends rather than a country residence; it was therefore simply furnished with very few domestic conveniences. At Kelmscott, Morris found tempor-

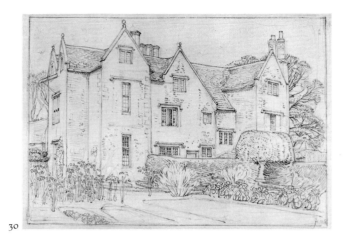

30

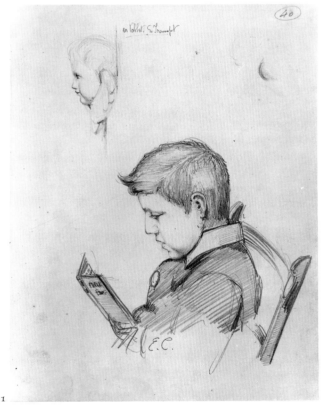

31

Fig.30 *Kelmscott Manor, Oxfordshire, drawn by Charles March Gere for William Morris, 1892-3.*
Fig.31 *Page from Ernest Gimson's sketchbook, about 1886.*

ary solace and joy in the flowers and plants, in the crafts-manship and orderliness of the local architecture, and in the relaxation of fishing. Its situation near the source of the Thames provided a constant juxtaposition with the capital, which he exploited in his utopian romance *News from Nowhere*, although his own feelings towards the countryside

could be ambivalent. On one occasion he wrote, 'I rather want to be in London again for I feel as if my time were passing with too little done in the country: altogether I fear I am a London bird; its soot has been rubbed into me, and even these autumn mornings can't wash me clean of restless-ness'.[6] Despite this, Morris's ideas about nature and the countryside had a tremendous impact on the next genera-tion of architects and designers.

London was at the centre of developments in the 1880s. New ideas were being formulated about the unity of the arts and the importance of creative manual work. New groupings were being formed, such as the Art Workers' Guild and the Society for the Protection of Ancient Buildings, dominated by William Morris and his friend and associate, Philip Webb. They provided a heady mixture of the arts, handwork, politics and social economics for the younger generation emerging from the major architectural offices — that of Richard Norman Shaw was considered particularly radical but both he and the ecclesiastical architect John Sedding pro-vided a sound grounding in architectural drawing and build-ing techniques for their students and assistants. Sedding laid particular emphasis on the interdependence of design and craftsmanship. His radical vision was of 'the ideal factory … where the artist-designer is a handicraftsman and the handi-craftsman is an artist in his way'.[7] Between the two of them, they provided an ideal starting point for many of the young architects of the Arts and Crafts Movement, including William Lethaby, Henry Wilson, Alfred Powell, Ernest and Sidney Barnsley, Ernest Gimson, Detmar Blow and Robert Weir Schultz. For Charles Robert Ashbee, also, architecture seemed to offer a way to combine art with a campaign for social change. After an inspirational period at Cambridge reading history and absorbing the ideas of John Ruskin, Walt Whitman and Edward Carpenter, he entered the London office of G. F. Bodley, where the emphasis on art and Ruskin and an uncommercial attitude provided a congenial atmos-phere. Architectural students were encouraged to look beyond the confines of the drawing board, to visit museums and churches, and to travel abroad. Ernest Gimson's sketch-books from the 1880s show details of traditional farm build-ings and furniture as well as measured drawings of churches (Figs 15, 31). In country houses such as Haddon Hall, Derby-shire and in the London museums he drew seventeenth- and early eighteenth-century furniture and metalwork which were to remain an inspiration.

Like Morris, Gimson believed in 'doing not designing'[8] and he sought first-hand experience of craftwork. He learned how to make decorative plaster panels with the London firm of Whitcombe and Priestley and spent a few weeks in Here-

fordshire with Philip Clissett making turned ladderback chairs like those he had seen at the Art Workers' Guild. C. R. Ashbee, based at the philanthropic university settlement at Toynbee Hall in the East End of London, was also becoming involved in the practicalities of the Arts and Crafts. As part of his social work, he read and discussed the work of John Ruskin with a group of local young men. By common consent they decided to put Ruskin's ideas about the importance of creative manual work into practice and produced a decorative mural for the dining room at Toynbee Hall. This group, inspired by the medieval idea of a closely knit group of craftsmen working for the greater good of the community, formed the basis for Ashbee's Guild and School of Handicraft, founded in 1888.

Another London-based group, Kenton & Company, was an attempt by Ernest Gimson and William Lethaby to put some of the new ideas about design and craftsmanship into practice. They were to produce innovative designs for furniture which would be made to high standards by professional cabinet-makers. Other architects were involved: Reginald Blomfield, Mervyn Macartney and Sidney Barnsley. A sixth business partner, Colonel Mallet, helped to finance the scheme. Premises were rented, stocks of materials were bought and several cabinet-makers employed, including men such as A. H. Mason who had already worked with Arts and Crafts designers.

The five architects designed furniture as individuals with no attempt to create a house style. Both Gimson and Lethaby designed a number of simple pieces relating to the English cottage furniture which Gimson's sketchbooks illustrate. Their approach to cottage furniture was exemplified in Lethaby's essay 'Cabinet Making' (Fig.32). He was trying to encourage '… carpenters and joiners, shipwrights, wheelwrights, waggon builders – in fact, all those who deal with the cutting and framing of wood' to use '… the hand and eye, individual judgement and experience … to make a thing beautifully and fitted for real service'.[9] At Kenton & Company, the two architects used their observation of traditional furniture to produce simple designs for tables, chairs, dressers and chests, which featured exposed dovetails, chamfering and simple inlays.

When Kenton & Company was dissolved in 1892, the participants went their own ways. Despite the fact that they both had architectural projects in hand, Gimson and Sidney Barnsley decided that they did not wish to pursue a traditional career in architecture with a London office and all that implied. Inspired by William Morris and Philip Webb, they decided to try an alternative direction; to move to the country and become totally involved in its working prac-

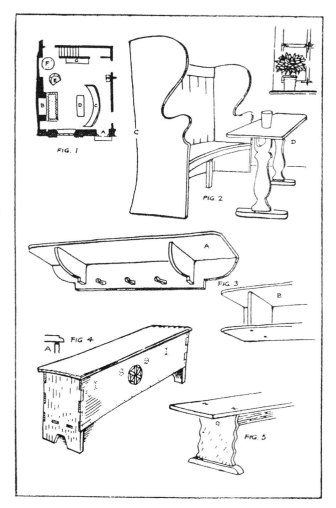

Fig.32 *Illustrations from Lethaby's article on 'Cabinet Making' of 1892, as rearranged for publication by Dryad in the 1920s, depicting the furniture of an old inn kitchen in Yorkshire.*

tices and traditions. This back-to-basics approach had been advocated by John Sedding and typified the philosophy of the Arts and Crafts Movement in the Cotswolds. Sedding encouraged young architects '… to dig the ground and dung the tree … and to grow our arts and industries as nature grows her trees – from the ground up'.[10] To help them in their new venture, Gimson and Sidney Barnsley managed to persuade the more outgoing and sociable Ernest Barnsley to give up the architectural practice he had started in Birmingham. Together with his wife Alice and two young daughters, Ernest Barnsley joined his brother and friend in the small hamlet of Ewen near Cirencester in 1893.

This was the beginning of the main influx of architects and designers to the Cotswolds at the turn of the century. Gimson and the Barnsleys settled in the Cotswolds, possibly influenced by Morris's example at Kelmscott, while C. R. Ashbee was introduced to Chipping Campden in 1901 by his friend and supporter of the Guild of Handicraft, Rob

Fig.33 *The shared workshop of Gimson and the Barnsleys at Pinbury, about 1895.*

Martin Holland, whose family home was at nearby Over-bury. For all concerned the move to the countryside was both romantic and practical. The Cotswolds were more accessible by train at the turn of the century than they are today. In 1890, there were still stations at Cirencester and Campden, and Ashbee regularly commuted to London to attend to his architectural practice. The Cotswolds were also relatively convenient for both Leicester and Birmingham, and the families of Gimson and the Barnsleys made frequent visits. The decline of the area in the nineteenth century had practical advantages for the new craft communities; it meant that cheap accommodation was readily available. For both Gimson and Ashbee, the revival of craftsmanship was closely involved with the revival of rural life. The period of decline had further repercussions, for it meant that the Cotswolds were relatively untouched by developments else-where. The area was under the control of a few wealthy landowners who were basically conservative in their tastes.

For this reason, any new building tended to follow the estab-lished style of the area and some traditions of craftsmanship had managed to survive the pressures of industrialisation.

There was also a strong romantic element in the move to the Cotswolds, which was an essential part of the Arts and Crafts Movement. The Cotswolds themselves had powerful mystical echoes born of the landscape. Alfred Powell described them as a 'mystery land of difficult hills and deeply wooded valleys',[11] whilst the writer Freda Derrick compared Pinbury to an '… unspoilt landscape in a romance by William Morris in which each common plant and tree had the rare beauty of such things in tapestry'.[12] Gimson and the Barnsleys wanted to live like country gentlemen, keeping livestock, making their own bread and cider. They had no practical experience of rural life, so persuaded Lucy Morley, Gimson's cousin raised on a farm in Lincolnshire, to act as their housekeeper. The same romantic approach to the prac-ticalities of life was shown by Ashbee. Based in a faded

Georgian mansion set in London's East End, the Guild of Handicraft had established an enviable reputation for innovative design. Despite his financial success and international recognition, Ashbee had become convinced that this squalid, violent neighbourhood, plagued as was most of London at that time by poor air and heavy choking smogs, must have an adverse effect on his Guildsmen and their work. When the lease to Essex House neared its end in 1901, a democratic decision to move was taken, with every man having a vote. Ashbee also wanted his Guildsmen to become involved with the practicalities of country life, to combine handicrafts with work on the land and thus become self-sufficient. For him, the idea of Chipping Campden was represented by the phrase 'City of the Sun',[13] an idyllic setting for 'happy work and sane play'.[14] The same quasi-religious fervour was expressed by Philip Webb who described the Gimson-Barnsley community as 'a sort of vision of the NEW Jerusalem'.[15]

The three young architects had become tenants of the main local landowner, Lord Bathurst, and moved into Pinbury Park, an Elizabethan farmhouse, on a repairing lease. Ernest Barnsley settled in the main house with his family while his younger brother and friend, both single men, moved into nearby cottages converted from farm buildings. All three became absorbed in country life, in the crafts and in the minutiae of traditional building techniques. They were a small community, different enough to be of interest and to provide local gossip, but not so different or so big as to provide a threat. Above all, they were finding their way as craftsmen and designers and were very open to new influences. Local craftsmen such as Richard Harrison, the wheelwright from nearby Sapperton, and William Bucknell, the blacksmith and general craftsman at Tunley, became important contacts for them: the source of raw materials and information on technical matters. Ernest Barnsley, as the eldest and most experienced architect, undertook most of the building and restoration work for the estate. Ernest Gimson also had architectural projects in hand in Leicestershire and put his craft experience into practice by turning out ladderback chairs and decorative plaster panels. Working alongside his brother and friend in the cramped outbuilding that served as their workshop (Fig.33), Sidney Barnsley concentrated on teaching himself the basics of carpentry and cabinet-making. His was a non-professional approach typical of the Arts and Crafts Movement. Craft skills were acquired not through books or formal classes but by observation and a process of trial and error.

When C.R. Ashbee's Guild of Handicraft moved to the Cotswolds in 1902, it was a large enterprise, with work-

Fig.34 *Janet Ashbee, painted by William Strang in 1910.*

shops for cabinet-making, wood carving, silversmithing, jewellery and a smithy. It had already established a distinctive style and a sizeable market for its products in London. About seventy craftsmen and their families were involved in the move to the old market town of Chipping Campden. Ashbee's utopian vision was somewhat dented by the suspicious reaction of the local residents. Their hostility was exacerbated by the greed of some landowners who, without Ashbee's knowledge, evicted local tenants from their cottages so that they could be offered to the Guild at a higher rent. It was the sympathetic Janet Ashbee (Fig.34), C.R. Ashbee's young wife, who often mediated between the Guild and the locals and helped settle the former in their new surroundings. The Campden School of Arts and Crafts, which opened in 1904 with a grant from the Gloucestershire County Council, was a personal triumph for Ashbee. He had deeply regretted the collapse of the educational aspect of the Guild in London and had seen the move to the Cotswolds as an opportunity to revive this side of his work. Together with popular entertainments and outdoor pursuits, the school was another factor which brought the town and the Guild closer together.

The families and friends of Gimson and the Barnsleys were introduced to the simple pleasures of country life. Alfred Powell recalled an early visit to Pinbury, describing Gimson as

one of the 'merriest men on ground' – singing & gardening & making chairs up in the workshop where Sidney & Ernest Barnsley also worked happily together. I used to go wanders with him in those paradise woods, & talk & talk! Once a party of 6 of us all the way to Painswick over the hills to lunch there at the Falcon. There is no more to say really except that it seemed the realisation of a dream to be in that life & company.[16]

They also saw themselves as playing a role in the social life of the community, whether it was by attending church regularly, as Sidney Barnsley did, or by selling home-brewed cider. Inspired by their friendship with Cecil Sharp and Arnold Dolmetsch, they encouraged the revival of folk songs and country dancing. Sapperton Village Hall, a gift to the community from Lady Bathurst, was designed by Ernest Barnsley in 1912. It provided an ideal venue for local amusements such as country dancing on Saturday evenings for boys and girls, with Emily Gimson playing the piano, mummers' plays and more slapstick dramatic entertainments.

In 1902, at a crucial stage in the development of the community, Gimson and the Barnsleys moved from Pinbury to the nearby village of Sapperton (Fig.35). Ernest Gimson and Ernest Barnsley had already decided to go into formal partnership together to design furniture which would be made by cabinet-makers. To this end they had rented a small workshop in Cirencester and employed an experienced Dutch cabinet-maker, Peter Waals, and another craftsman, Harry Davoll. Coincidentally, their landlord at Pinbury, Lord Bathurst, returned from an overseas posting with the army. At Ernest Barnsley's suggestion, he decided that Pinbury Park would make an ideal base for himself and his family. In return, he offered the fledgling craft community land in nearby Sapperton to build homes and the use of Daneway House and its outbuildings as showrooms and workshops. Sidney Barnsley chose to remain separate, working alone in an outbuilding in his garden. The partnership between the other two men was short-lived but, under Gimson's control, the workshops flourished. About ten cabinet-makers, ranging from skilled craftsmen to apprentices, were employed and a smithy and chair-making shop were also set up employing another six to eight men.

The first cabinet-makers to be employed at Daneway came from elsewhere but Gimson soon began looking locally for young men to train. Alfred Bucknell and Edward Gardiner were among the first local craftsmen in the Daneway workshops. Gimson was very much 'the Guv'nor' in the

35

36

Fig.35 *Sapperton village, photographed by Herbert Barnsley in about 1905.*
Fig.36 *Part of a letter from Ernest Gimson to Philip Webb, 23 December 1907.*

workshops but still open to suggestions from the craftsmen. In a letter of 1907 to Philip Webb, Gimson described how the design of a particular cabinet had evolved:

The cabinet we are talking about was originally drawn with four posts tennoned into a thick projecting top but my good foreman would take no pleasure in making it till I had changed it to its present bald outline. For my part I like it either way (Fig.36).[17]

Both the Guild of Handicraft and the craft community at Sapperton attracted a large number of visitors, some of whom ended up staying in the Cotswolds. Philip Webb was a frequent visitor to Pinbury and Sapperton and a great source of encouragement to the community. A visitors' book from Daneway House (Fig.37), covering short periods in 1904 and 1907, has survived and shows the numbers and range of visitors from Britain and further afield who made the difficult journey to Sapperton. Chipping Campden was more accessible and the Ashbees more extrovert than their south Cotswold neighbours. The attractions of the town and the novelty of Ashbee's enterprise brought many sightseers. Frequent visitors included the designer Walter Crane and the poet John Masefield. Among those who settled in Campden were the stained-glass artist Paul Woodroffe, and the Anglo-Sinhalese scholar Ananda Coomaraswamy, who had married Ethel Partridge, sister of the Guildsman Fred Partridge.[18]

In February 1901, Alfred Powell, a friend and fellow architectural student, was invited to stay with Ernest and Emily Gimson while recovering from a severe attack of pleurisy. He had remained in the architectural office of John Sedding until the latter's death in 1891 and then branched out into what was to be his life's work as an itinerant architect, craftsman and artist. In 1901, he expressed his feelings saying, 'I don't believe in offices any more than I ever did – which wasn't much for bringing work'.[19] He was an immensely practical and resolute character and had already acquired some basic craft skills in wood, metal and stone in the course of his architectural work. As his health improved, he rented a cottage at Edgeworth and took instruction from Ernest Gimson on using a pole-lathe. The Cotswolds, more than anywhere else, became Alfred Powell's home and he remained an important part of the craft community at Sapperton. He lived for a while at Oakridge Lynch before beginning work on the extension and restoration of a cottage at Tunley and then building himself a studio cottage at Tarlton in 1920. In 1906 he married Louise Lessore, herself a talented designer and fine craftswoman. After the marriage, he and his wife continued in an unconventional but very productive way of life that was rooted in fellowship and love of good workmanship.

Fig.37 *A page from the Daneway House visitors' book, 1904.*

Unlike the other craftworkers in their circle, the Powells became involved with industrial design through their interest in decorative ceramics. At the end of the nineteenth century, a number of manufacturers had established links with art schools to provide new designs in the expanding field of art pottery. The firm of Wedgwood followed this course rather late, at a time when its fortunes were low. In 1902, Alfred Powell sent Cecil Wedgwood some designs for decorative pottery. These were well received and Powell was invited to the Wedgwood factory at Etruria to learn the basic skills of ceramic decoration. This was the start of a relationship that lasted nearly sixty years until his death. The Powells worked together as a team; they would receive hampers of blanks for painting from Wedgwood, which would be returned to the factory after decoration. Their designs were closely inspired by nature, the landscape and buildings, with a rhythmic quality derived from Islamic art. As something of a sideline, they adapted some of their designs for painting on furniture made by Gimson, the Barnsleys and, later, Peter Waals. They taught a number of young designers, including Grace, the daughter of Sidney Barnsley, who had been a family friend from birth. She

Fig.38 *Wedgwood bowl painted by Alfred Powell with Gloucestershire scenes, including Daneway House, 1928.*

Fig.39 *Carved panel by Norman Jewson on a clock by Peter Waals of 1931 (Cat.61).*

carried on working in the 1920s and 1930s, developing her own distinctive style and occasionally producing pieces in collaboration with Fred Griggs, the artist and architect who was based at Chipping Campden.

Fred Griggs was one of the few to provide a solid link between the craft communities in the north and south Cotswolds. He had been captivated by Chipping Campden on a visit in 1904 to prepare illustrations for *Highways and Byways in Oxford and the Cotswolds*[20] and made it his home. As well as painting pottery, he produced a major body of work as an etcher: powerful, emotional landscapes which evoke his feelings for the importance of rural and architectural traditions. He was also an architect, working in partnership with Ernest Gimson for two years between 1917 and 1919, and above all a conservationist. In 1929, he and his friend and fellow-architect, Norman Jewson, were instrumental in setting up the Campden Trust. Like Griggs, Norman Jewson had not intended living in the Cotswolds. He had met Gimson on a walking tour in 1907 and became his architectural assistant, acting as foreman on numerous occasions and helping in the manufacture of decorative plaster panels. He married Ernest Barnsley's elder daughter Mary in 1913 and restored a cottage in Sapperton, Bachelor's Court, for himself and his wife. He also made a huge financial and emotional investment in the restoration of Owlpen Manor, near Dursley, Gloucestershire, until he could no longer afford it (Fig.40). As well as architectural work, he took up wood carving, stone carving, decorative plasterwork and leadwork. One of the delightful features of several Arts and Crafts houses in the Cotswolds, such as Rodmarton Manor and Cotswold Farm, is the leadwork enlivened with Jewson's decorative representations of the local flora and fauna.

The opportunity to live in surroundings which offered such a changing feast of natural beauty attracted a number of artists to the Cotswolds. The Birmingham School was represented from 1904 by Charles Gere and his two step-sisters, Margaret Gere and Edith Payne. Edith Payne produced exquisite watercolours of wild flowers and plants, working in her studio from examples which she dug up and then replanted. In 1911, she and her husband, the painter and stained-glass artist Henry Payne, moved to the village of Amberley where Sidney Barnsley had altered and restored the medieval Seynckley House for them. In this setting, Henry Payne continued to produce stained glass for many Cotswold churches and houses, working closely with his son Edward. It was Charles Gere who introduced the painter William Rothenstein to the Cotswolds in 1910. Two years later, on another visit, he was captivated by the poten-

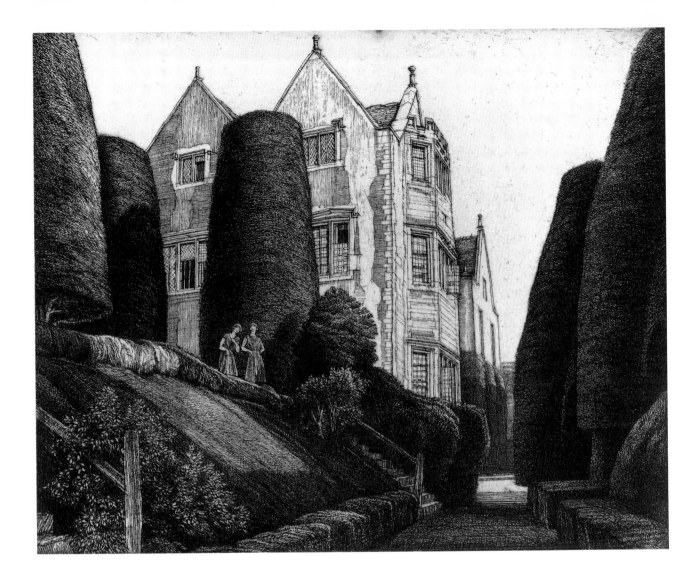

Fig.40 *'Owlpen Manor', etching by F. L. Griggs of 1931.*

tial of a rundown farmhouse in the village of Far Oakridge. The house was repaired and extended for him by Norman Jewson and became his home until the late 1920s. It features in a number of his paintings of Cotswold landscapes (Fig.41). He brought a new cosmopolitan element to rural life, with visitors such as Max Beerbohm and Rabindranath Tagore, but also encouraged local entertainments such as amateur dramatics and William and Eve Simmonds's puppet theatre.

The outbreak of the First World War in 1914 had a gradual but devastating impact on the craft communities of the Cotswolds. Those craftsmen who were too old for active service were gradually drafted into wartime occupations: aircraft construction, shipbuilding and munitions. In Sapperton, Ernest Gimson tried to keep his workshops open but most of the craftsmen had left by 1917. His reaction to an invitation to the capital expressed his growing isolation in the Cotswolds. He wrote:

London gets further and further away. Train fares for the rich only. No cart or car or byke (*sic*) to get me over the six miles of road to the station. No one to leave in charge except a lonely wife in

Fig.41 *'The Storm' by William Rothenstein, 1915. This house was restored for the artist by Norman Jewson and local craftsmen.*

a lonely cottage. No man, no woman, no dog or cat even. There are four acres of land to be farmed & gardened, hay to be stacked, potatoes to be sprayed and slugs to be slaughtered every evening from 10 to 10.30.[21]

Although the Guild of Handicraft had folded in 1908, C.R. Ashbee had remained in Campden and now felt the need to be actively involved in some sort of war work. Openings were few and far between; he embarked on a lecture tour of the United States with the additional but hidden agenda to build up support for an embryonic international regulatory body, the prototype for the League of Nations. Of the remaining Guildsmen, those young enough went into active service, others went into war production. Another bitter blow came in 1915 when Gloucestershire County Council closed down the Campden School of Arts and Crafts. Janet Ashbee was left rather isolated in Campden with two young children. Her reaction was to set up a school for mothers, a sort of baby clinic. It is questionable what provoked more distrust in Campden, Janet Ashbee's advocacy of breast-feeding or Ashbee's German relatives.

The political upheaval and uncertainty of 1914 brought considerations of rural development, which had always been present in the minds of men such as Ashbee and Gimson, very much to the fore. As Ashbee stated in *Craftsmanship in Competitive Industry*: 'Arts and crafts and the problem of the land in England, are complementary to each other'.[22] The question of rural depopulation had become part of the political agenda as well. Efforts were made by government to encourage the ownership of land for small-scale activities, such as market gardening, by the Small Holdings and Allotments Act in 1908. For C.R. Ashbee, the Guild estate at Broad Campden remained crucial to the future of the Guild of Handicraft despite the fact that by 1908 the tenants were predominantly locals rather than Guildsmen. To promote the cause of smallholders, Ashbee had served on the parish council and stood up for their rights against the local large landowners. In 1912 he had begun work on a housing scheme which would enable the smallholders to live and work on the estate.

Gimson, too, was planning for the future and the survival of the craft traditions he and his friends had worked so hard to establish. His marriage had been childless; this and possible intimations of his future illness may have spurred him into action. He had bought a piece of land near the village of Tunley and developed a scheme for craft villages which would put 'some muscle and backbone into the Arts and Crafts'.[23] The President of the Art Workers' Guild, the architect and designer Henry Wilson, wanted Britain to emulate the communal production centred on craft or industrial villages which existed in France and Germany, such as the handkerchief-weaving industry at Cholet. He wrote, 'I want to see the countryside alive again – thousands of Gimsons blossoming with sedate loveliness all around me'.[24] Gimson's scheme took shape as the Association of Architecture, Building and Handicraft. The initial report in 1917 envisaged a limited company with capital of £115,000. Its written aims were to work in close co-operation with architects and builders and to make the crafts an integral part of any building project. More specifically, Gimson wanted the crafts to be involved in industrial life, not by designing for industrial production, as advocated by the Design and Industries Association, but by establishing in the first instance a craft or industrial village on the Continental model where 200 handworkers would make '… in quantity things of common use within the reach of average incomes'.[25]

The development of the Association of Architecture, Building and Handicraft was overtaken by events, primarily Gimson's ill-health and the end of the War. Gimson had managed to re-establish his furniture-making workshop in a much reduced form with seven men by April 1919 and was also '… trying to get three smiths to start forges of their own in Sapperton and offering them the loan of any tools and small capital they may want'.[26] There was, however, a strong feeling that the old order had changed. The simple life was no longer as appealing as it had been. Higher wages had been paid in munitions factories and people's expectations had been raised with the influence of the cinema and the impact of inflation. Prices had roughly doubled during the War but wages had also increased. This inflationary spiral took off in 1919 with the post-war boom leading to the collapse in April 1920. All talk of reconstruction was forgotten as politicians, businessmen and trades-union leaders looked to short-term objectives.

Gimson's death in 1919 could have been the end of the story, but his foreman, Peter Waals, made the bold decision to carry on the workshops against the family's wishes. He moved to the village of Chalford, a more industrial setting in the Stroud valley, and took over a former silk mill. Many of Gimson's craftsmen moved with him and the work produced remained very close to the products of the Daneway workshops. About ten men were employed at Chalford, with local apprentices being taken on. The workshop (Fig.42) survived the hard inter-war years with some difficulty, for clients were not always prepared to pay the higher prices dictated by higher wages and material costs and Waals's lack of capital or a private income. However, the wholehearted support of a few individuals such as Alfred

Fig.42 *Peter Waals's workshop at Chalford, about 1925.*

James of Edgeworth, the brewer Arthur Mitchell, the Cad-
bury family and the Goddards of Leicester ensured the
survival of the workshop until Waals's death in 1937. The
blacksmith Alfred Bucknell continued working at Sapperton
and in 1930 his son Norman gave up woodworking to fol-
low in his father's craft of metalworking. A number of other
artists and craftworkers made their home in the south
Cotswolds after the First World War, including the sculptor
William Simmonds and his wife Eve, who moved to the vil-
lage of Far Oakridge in 1919. As well as a puppet-maker,
William Simmonds was a sensitive draughtsman and wood
carver who had an innate empathy with the animals which
formed his usual subjects. Eve Simmonds was a skilled
embroideress working closely with Louise Powell. Her other
close friends were the textile printers, Phyllis Barron and
Dorothy Larcher, who joined them in the Cotswolds in
1930. The move from London to Painswick enabled them
to extend their workshops and produce a wider range of

furnishing textiles and dress-stuffs, hand-printed with their
distinctive designs on good-quality fabrics.

In the north Cotswolds the Arts and Crafts tradition also
survived. The Guild of Handicraft silk mill provided
premises for Alec Miller to continue wood carving and for
two blacksmiths, Bill Thornton and Charley Downer.
George Hart, one of Ashbee's foremost silversmiths, suc-
cessfully returned to his craft there in the 1920s, working
with his brother-in-law, Reynell Huyshe, and a local lad,
Harry Warmington. This team also produced work for
Russell & Sons of Broadway, the craft workshops set up by
Sydney Russell as an adjunct to the Lygon Arms and
antiques business, and run by his son Gordon.

The Russell family were influenced by the craft traditions
of the Cotswolds. In turn both Sydney and Gordon Russell
nurtured many craftsmen and women through difficult years
in the 1920s and 1930s. Michael Cardew was one craftsman
whom they actively encouraged to settle locally; he set up

the Winchcombe Pottery on the outskirts of that small town in 1926. Through their retail outlet in Broadway and Gordon Russell's writing, the Russells raised a general awareness of the crafts. Towards the end of the 1920s, however, the firm of Russell & Sons was changing its emphasis. It had changed its name twice – to the Russell Workshops and then to Gordon Russell Limited – and had moved into serial production. New machinery developed for small-scale production was used to produce simple furniture with flush surfaces designed by Gordon's younger brother, Dick Russell. These pieces were sold alongside the one-off craft furniture but gradually pushed them to the back of the showroom. The success of Gordon Russell in marrying machine and craft production aroused hostility amongst the more traditional craft workshops, such as that of Peter Waals. Gordon Russell Limited could undercut their prices while the public did not distinguish between hand-made and hand-finished furniture. As he became less involved in the day-to-day running of the business, Gordon Russell began to write and lecture widely. He took on the role of propagandist for design and design education on a national level. During the Second World War he was given overall responsibility for the Utility Furniture Scheme to make simple furniture, well made and of good design, available for a mass market. It brought a version of the Cotswold style into ordinary homes throughout the country.

Peter Waals and Sidney Barnsley's son, Edward, also played a role in bringing the Cotswold style to a wider public through their work in education. Peter Waals began lecturing locally and in 1935 he was appointed Design Adviser at the East Midlands Training College in Loughborough. He visited the college regularly and produced designs for the students to make under the day-to-day supervision of Cecil Gough, a fine craftsman who had worked for Gordon Russell at Broadway. Waals's standards were demanding and there was very little opportunity for any design input from the students. They, however, were caught up in the certainties that he laid down and in the satisfaction of producing high-quality work. After his death, his role was taken by Edward Barnsley, who had set up his own workshop in Froxfield near Petersfield, Hampshire, in 1923. For Peter Waals and Edward Barnsley, as for many other craftspeople in the twentieth century, teaching provided a valuable regular income in conjunction with running a workshop. It also offered them the opportunity to clarify their ideas and pass them on to several generations of craft teachers.

The overwhelming impact of the Arts and Crafts Movement can still be felt in the Cotswolds, particularly in the areas round Stroud, Cirencester, Broadway and Chipping Campden. The ability that it gave ordinary people to produce work of an extraordinary quality immeasurably increased their job satisfaction and sense of achievement. The movement in the Cotswolds was dominated by the belief that 'some form of creative expression is essential to a healthy balanced life'.[27] This philosophy is still of relevance as craftspeople and artists try to make some sense of their lives in the approach to the next millennium.

1. For example by M. Weiner, *English Culture and the Decline of the Industrial Spirit 1850-1980*, Harmondsworth 1985.
2. C. R. Ashbee, *Craftsmanship in Competitive Industry*, London and Chipping Campden 1908, p.11.
3. See F. MacCarthy, *The Simple Life: C. R. Ashbee in the Cotswolds*, London 1981 and M. Greensted, *The Arts and Crafts Movement in the Cotswolds*, Far Thrupp 1993.
4. William Morris to Mrs Alfred Baldwin 1874, quoted by P. Thompson, *The Work of William Morris*, London 1977, p.43.
5. Alfred Powell to Emily Powell 1903, quoted in M. Batkin and M. Greensted, *Good Workmanship with Happy Thought: the Work of Alfred and Louise Powell*, Cheltenham 1992, p.11.
6. P. Thompson, ibid, p.42.
7. Quoted by G. Naylor, *The Arts and Crafts Movement*, London 1971, p.165.
8. W. R. Lethaby, A. H. Powell and F. L. Griggs, *Ernest Gimson, His Life and Work*, Stratford-upon-Avon 1924, p.4.
9. In A. H. Mackmurdo (ed), *Plain Handicrafts*, London 1892.
10. Quoted by M. Batkin and M. Greensted, ibid, p.4.
11. W. R. Lethaby, A. H. Powell and F. L. Griggs, ibid, p.15.
12. F. Derrick, 'Sapperton Today', *The Illustrated Carpenter and Builder*, 10.10.1952, p.1690.
13. A. Crawford, *C. R. Ashbee: Architect, Designer & Romantic Socialist*, London 1985, p.116.
14. F. L. Griggs in an obituary of Ernest Gimson in the *Wilts & Gloucestershire Standard*, 23.8.1919.
15. Quoted by W. R. Lethaby in *The Builder*, 4.12,1925, p.814.
16. Alfred Powell to Charles Bramley 1948, CAGM Burrough Collection, 1986.1283.
17. Ernest Gimson to Philip Webb 1907, CAGM Emery Walker Library.
18. Ethel Partridge is best known as a weaver by the name of her second marriage as Ethel Mairet.
19. Alfred Powell to his mother in 1901, quoted in M. Batkin and M. Greensted, ibid, p.9.
20. H. A. Evans, *Highways and Byways in Oxford and the Cotswolds*, London 1905.
21. Unpublished letter, Ernest Gimson to Henry Wilson, 27.6.1917, RCA, Henry Wilson Archive.
22. C. R. Ashbee, ibid, p.16.
23. Unpublished letter, Ernest Gimson to Henry Wilson, 15.6.1917, RCA, Henry Wilson Archive.
24. Unpublished letter, Henry Wilson to Ernest Gimson, 12.10.1915, RCA, Henry Wilson Archive.
25. Unsigned report by E. Gimson, *The Association of Architecture, Building and Handicraft*, dated 9.6.1917, RCA, Henry Wilson Archive.
26. Unpublished letter, Ernest Gimson to Geoffrey Lupton, 14.4.1919, Allan Lupton.
27. Edward Barnsley quoted by A. Carruthers, *Edward Barnsley and His Workshop: Arts and Crafts in the Twentieth Century*, Wendlebury 1992, p.63.

III Arts and Crafts at Cheltenham

The presence of so many Arts and Crafts designers and makers in Gloucestershire at the beginning of this century, and the status of their work at the forefront of contemporary art and design, was acknowledged early on in the history of Cheltenham Art Gallery and Museum, and the continuing interest in the Arts and Crafts has involved a range of different museum activities. Temporary exhibitions have provided makers with the opportunity to show and sell new work and, in recent years, have prompted the reassessment of some reputations; the purchase of work as library or museum equipment has furnished the galleries with fine-quality and long-lasting cases and fittings; and the collecting of objects and documentation over many years has made Cheltenham an essential reference point for anyone studying the Arts and Crafts Movement. As a medium-sized Local Authority museum service, Cheltenham has been able to achieve this only through the dedication of staff who recognised the interest and potential of the work, and through the generosity of donors and benefactors, without whom the collection would scarcely exist.

Cheltenham Public Library was opened in 1889 and an art gallery was added to the building in Clarence Street ten years later. The Museum was opened in 1907 in premises above the library. The institution was funded by the Borough Council and run by a Librarian Curator, and the earliest evidence of any interest in the Arts and Crafts Movement appears in the library collections. A bookplate with decorative figures symbolising the town's twin claims to fame, its spa waters and its schools, was designed in 1897 by J. Eadie Reid, an artist who was an early but short-term member of the Guild of Handicraft and who did a lot of work in the town, especially for the colleges (Fig.43). Private Press books and proof sheets of fine printing were collected, and these are still in the Cheltenham Reference Library, along with an excellent range of books on the local craft movement.[1]

In its early years, however, the Museum's collecting activities were focused on local history material and exotica, and its interest in contemporary work was concentrated on exhibitions. A temporary display of cartoons and photographs by Christopher Whall, the foremost artist in stained glass of his day, was arranged in 1903, not long after he had completed the beautiful set of windows in the Lady Chapel at Gloucester Cathedral. Three years later a selection from the Eighth Arts and Crafts Exhibition Society show was sent on from the Grafton Gallery in London.

Sydney Harrison, the second Librarian Curator, began from 1916 to make the Museum more lively by organising exhibitions of the work of the local Art School students and

Fig.43 *Bookplate by J. Eadie Reid, 1897.*

Cheltenham firms, but exhibitions really became a regular feature of the Museum's programme under Daniel W. Herdman, who came as Librarian Curator from Sunderland in 1922. Since he lived from 1907 in Roker, less than half a mile from E. S. Prior's great church of St Andrew, it is just possible that Herdman had met Ernest Gimson, who designed furniture and metalwork for the church in 1906, which was probably installed in the following year.[2] On arrival in Cheltenham, he immediately recognised the importance of the local crafts and industries. He saw craftwork as a means of preventing the depopulation of the countryside, and in March 1923 he put on a display of work

Fig.44 *1930s exhibition catalogues with cover illustrations by F.L. Griggs.*

CATALOGUE of
AN EXHIBITION of
COTSWOLD ART &
CRAFTSMANSHIP

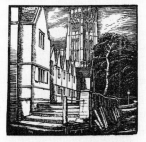

At Elm Tree House (late Alcuin Press)

CAMPDEN · Gloucestershire

August 1st to 31st, 1935

(Price 6d.)

AN EXHIBITION of
COTSWOLD ART &
CRAFTSMANSHIP
September 5th to 30th, 1936

OPEN DAILY, 10 a.m. to 5 p.m.
Wednesdays and Saturdays, 10 a.m. to 8 p.m.
ADMISSION FREE

Transferred from Campden, Glos.
(By courtesy of the Campden Exhibition Committee)

To Cheltenham Art Gallery

D. W. HERDMAN, *Curator.* [P.T.O.

CATALOGUE
OF AN EXHIBITION OF
GLOUCESTERSHIRE ART
AND CRAFTSMANSHIP

IN THE INSTITUTE HALL
PAINSWICK
GLOUCESTERSHIRE
31ST JULY—31ST AUGUST, 1937

PRICE 6D.

CATALOGUE
OF AN EXHIBITION
OF COTSWOLD ART
AND CRAFTSMANSHIP
29th JULY–27th AUGUST, 1939

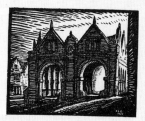

AT THE CHURCH ROOM
CHIPPING CAMPDEN
GLOUCESTERSHIRE

OPEN on Weekdays, 11 a.m.–7 p.m.
and on Sundays from 2.30–6.30 p.m.
ADMISSION: 6d. (CHILDREN 3d.)
SEASON TICKETS 2s. 6d.

CATALOGUE 6d.

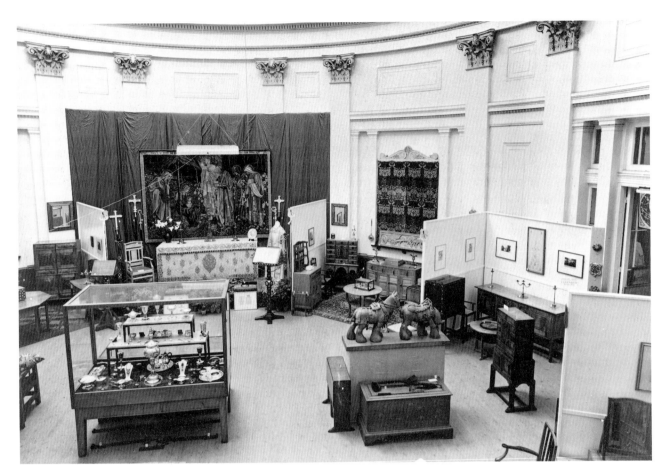

Fig.45 'Exhibition of Cotswold Craftsmanship' at the Montpellier Rotunda in Cheltenham, 1951.

predominantly by four local firms, H.H.Martyn & Company, R.E. & C.Marshall, R.L.Boulton & Sons, and Russell & Sons, but also of 'individual craftsmen working in the villages of the Cotswolds'. These included Grace Barnsley, Alec Miller, Paul Woodroffe and the Cotswold Co-operative Handicrafts, associated with the Whiteway Colony.[3]

A contemporary account in an educational journal describes the display as well arranged, an example to others in spacing and grouping, helpful and inspiring.[4] It was Gordon Russell's first opportunity to exhibit and he always said it had been a great encouragement in the early years of his family's business. The show deliberately coincided with a conference in Cheltenham of about 400 delegates from the Institute of Handicraft Teachers, at which Paul Fripp, a local artist and Director of Arts at Cheltenham Ladies College, gave a stirring speech on solid Arts and Crafts lines about design, the crafts and education.[5] For Herdman, at the beginning of his work in Gloucestershire, this must have been extremely encouraging.

After the first success, Herdman organised similar exhibitions in the following few years. At the same time, a small group of former members of the Guild of Handicraft and associated artists got together in Chipping Campden to arrange displays of work; and in Painswick, in the south of the county, another group of artists held regular shows. In 1933, through the efforts of the Gloucestershire Community Council in Gloucester, the two groups joined together to form the Guild of Gloucestershire Craftsmen. Two years later, Herdman brought the Guild's exhibition to Cheltenham, and until the prospect of war blighted the planned 1939 show, an 'Exhibition of Cotswold Art and Craftsmanship' was seen annually in Cheltenham and in either Campden or Painswick. Catalogues of these events in the Museum archives give only cursory information about the work but are a useful reference source for the names of many of the makers working in the Cotswolds (Fig.44). The Guild of Gloucestershire Craftsmen remains a thriving body which now holds three exhibitions a year.[6]

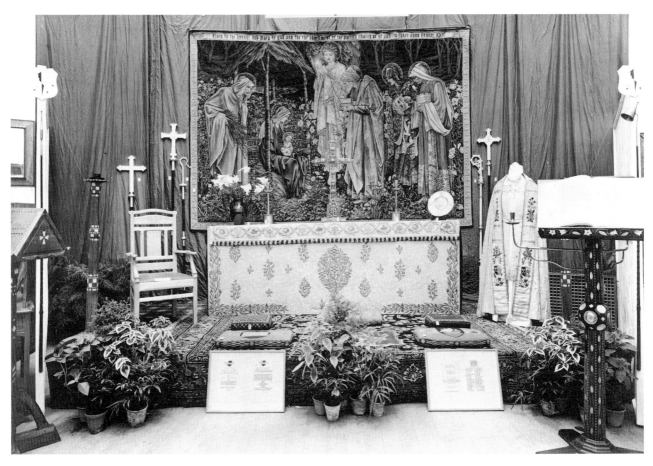

Fig.46 *Display of ecclesiastical furniture and furnishings at the 'Exhibition of Cotswold Craftsmanship'.*

Herdman's final triumph was the fine display at the Montpellier Rotunda, conceived by him and organised by his successor, Harold Fletcher, in 1951, shortly after Herdman's retirement (Figs 45, 46). This, he wrote in the catalogue, was 'centred on a regional glory', and it brought together a superb selection of pieces from public and private collections 'to mark half a century's achievement'.[7] Arthur Mitchell, a local collector and a generous friend of the Museum, paid for photographs to be taken as a record of all the exhibits, and these, together with the catalogue, provide much useful information.[8]

Exhibition activity diminished considerably after Herdman's departure. H.G. Fletcher, who had been Deputy Librarian in Cheltenham in the late 1920s, began collecting, slowly at first and then actively from the mid-1960s, but little public attention was given to Arts and Crafts work, which by this time appeared very old-fashioned. A renewal of interest was beginning, however, and the 1969 exhibition on Ernest Gimson, which was organised by Lionel Lam-

bourne at Leicester Museum, gave impetus to this revival. It also directly inspired an exhibition in Cheltenham in 1976, for Edward Barnsley had been concerned that due credit should be given to his father and uncle for their part in the development of the Cotswold style, and had proposed a commemoration of the fiftieth anniversary of their deaths. This suggestion was taken up by Mary Comino, the recently appointed Keeper of Museums, and she devised the exhibition, '*Good Citizen's Furniture*', which proved so popular that the catalogue sold out its second printing. As a result of the interest aroused, Mary Comino was commissioned by Evans Brothers to write a book about Gimson and the Barnsleys, the first comprehensive account of their work, which was published in 1980 and reprinted by Alan Sutton in 1991.[9]

'*Good Citizen's Furniture*' initiated a series of major and minor shows on local artists and craftworkers, including William and Eve Simmonds in 1980, C.R. Ashbee and the Guild of Handicraft in 1981, Margaret Gere in 1984, F.L.M. Griggs in 1988, and Alfred and Louise Powell in

1992.[10] Makers from wider afield have also been represented in exhibitions from the Crafts Council and in displays organised by the Museum, such as work by Alan Peters in 1985 and from the Edward Barnsley workshop in 1994. Efforts are made to provide a rich and varied programme of exhibitions on other subjects for the Cheltenham public, but this policy of presenting the work of craftspeople through temporary displays is set to continue.

D. W. Herdman's idea of acquiring items of museum equipment as examples of fine craftwork has also been taken up in recent years. The cases commissioned by Herdman are still in use in the Arts and Crafts display (Cats 50 and 65) and have been supplemented by display cabinets by Hugh Birkett and Tony McMullen (Cats 107 and 110). Bench seats and umbrella stands, made by William Hall and funded by the Summerfield Trust, have also been added to the furnishings of the Museum. From the earliest of these projects, funding has rarely been adequate, and the price of the work has had to compete with quotations for standard products from other firms. Through the interest and goodwill of the makers concerned, the Museum has received rather better quality than it paid for.

On a larger scale, there have also been impressive results from the policy of commissioning craftwork from local makers for the Museum extension, which was opened in 1989. Bryant Fedden's commemorative inscription carved in wood for the entrance hall, Chinks Grylls's stained-glass window in the Arts and Crafts gallery, and the metalwork grille by Alan Evans on the front of the new building have done much to improve the quality of the environment (Fig. 47, Col. Fig.50). Such commissions, designed to fulfil a specific purpose on or within a building, with well-defined parameters of size, location and cost, also provide a good way for the Museum to acquire work for the collections from craftspeople who work mainly to commission. Development of the ideas for these pieces was initiated with the practical and financial help of South West Arts, and the glass and metalwork were funded by the Friends of the Art Gallery and Museums.

Although Herdman purchased a few items by the Cheltenham firms from his first Cotswold Crafts exhibition in 1923, he bought nothing from Russell & Sons and seems not to have considered starting a collection of twentieth-century craftwork until many years later. He commissioned two display cases from Waals (Cats 50 and 65) and in 1935 bought a picture stand (Cat.64), probably also for practical use, and then in 1937 he purchased a single chair by Waals's workshop (Cat.66) and a door handle by Alfred Bucknell.

Some years later, in 1941, Herdman attended the sale of

Emily Gimson's effects, and fortunately saved Ernest Gimson's drawings from destruction or dispersal by carrying them back to Cheltenham.[11] Wartime petrol rationing made travel difficult, so at this sale he purchased several items on behalf of Leicester Museum as well as for Cheltenham, and he bought a few pieces for himself. A letter to the curator in Leicester indicates his thinking about what was suitable for the collection, since he bought for Cheltenham a fine bobbin-turned armchair in yew (Cat.22) and the oak coffer with gesso decoration (Cat.27), but felt that Gimson's kitchen dresser was 'not exactly a museum piece' unless the Museum could have a space set aside solely for work by the Cotswold group.[12] Time must have changed his views on this, or the prospect of a suitable space may have seemed more likely, for in 1962 the dresser was bequeathed to the Museum by his widow, presumably at his wish (Cat.21).

On Herdman's retirement in 1950, the collection was small but well balanced and included several items of furniture, a few pieces of metalwork, some ceramics, and numerous paintings and other works by local artists. It was mentioned approvingly in John Hooper's *Handcraft in Wood* as a 'small and unique collection',[13] though in fact Leicester Museum also had a good selection of pieces by this date. H. G. Fletcher concentrated at first on buying ceramics but he began to build up the Museum's Arts and Crafts holdings through an energetic collecting policy in the 1960s. This was a period when prices were low because the revival of appreciation had not yet begun in earnest, although the 1952 *Exhibition of Victorian and Edwardian Decorative Arts*, organised by Peter Floud, the Keeper of the Circulation Department at the Victoria and Albert Museum, had stirred a wider interest. Several groups of furniture became available when their original owners died, and thus the Museum purchased the dining suite of Mrs Edge (Cat.37), and the large selection of items which had belonged to Arthur Mitchell (see p.111). Fletcher's frequent grant applications received support from the V&A curators responsible for administering the funds, and he wrote very direct letters to friends of the Museum asking for money, resulting in generous contributions from individuals and trusts.

Delighted by the acquisition of so many fine pieces from Arthur Mitchell's house, Fletcher began to envisage a gallery of 'the Cotswold Tradition in Craftsmanship', which in 1967 was proposed as part of a planned new arts centre.[14] Although this did not materialise, Fletcher's ambitions sufficiently encouraged the trustees of Eric Sharpe's estate to donate in 1967 a fine selection of items made by him, widening the remit of the collection to include those who were influenced by the Cotswold tradition but worked outside the local area.

Fig.47 *Ash plaque with carved lettering by Bryant Fedden, 1989.*

45

While plans for a separate display gallery remained in the air, only a small proportion of the collection was on view to the public and much was put to use in the Museum and Municipal Offices. Lack of storage space made this necessary, and everyday wear and tear inevitably had a detrimental effect on the physical condition of some of the furniture; but criticism can perhaps be mitigated by consideration of the fact that most local museums avoid such problems only by declining to collect large objects, leaving some areas of material culture sadly under-represented.

Fletcher retired in 1973 and David Addison, the first professional Museum Director, had to deal with the rearrangement and expansion of the service when local government was reorganised in 1974. The Art Gallery and Museum was now split off from the Library, which became part of the County Council. Addison was a curator of fine art, whose particular enthusiasm was for contemporary work and educational initiatives. It is much to his credit, therefore, that after the success of the Barnsleys' exhibition in 1976, he put aside his own preferences and gave over a large gallery in the Museum to the Arts and Crafts collection. The new display was arranged by Mary Comino, who then began the process of expanding still further the scope of the collection, from one reflecting only the work of local artists and makers to one that begins to represent the Arts and Crafts Movement as a whole. She obtained grants and arranged the purchase of the group of Voysey furniture in 1981 (Cats 6-11), and this wider policy was continued enthusiastically by George Breeze from his appointment as Director in autumn 1981. His determination in raising large sums of money from external sources has resulted in the Museum acquiring some particularly special examples of the work of the Guild of Handicraft, Benson and Sumner, Kenton & Company, and recently, the exceptionally important library of Emery Walker. In 1982, the one Arts and Crafts gallery expanded into two, and the loan of Gordon Russell's personal collection in the same year prompted the opening of a separate room for this material. George Breeze also secured for the Museum the interest of Mrs Anne Hull Grundy, who between 1982 and 1984 donated more than 100 items of jewellery and metalwork by a wide range of Arts and Crafts designers.[15]

Annette Carruthers took over as Decorative Arts Curator in 1983. Her appointment reflected the importance placed on the Arts and Crafts collections, as she had already built up considerable specialist knowledge during her previous museum post at Leicester. Her particular interest was in collecting more humble objects with a documentary significance, such as the table made by Owen Scrubey (Cat.45),

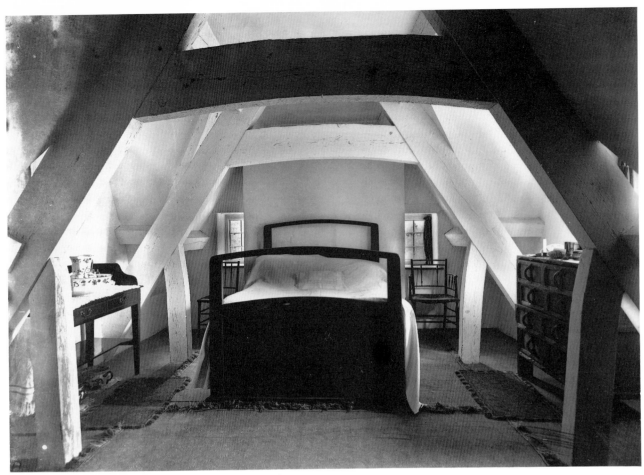

Fig.48 *A bedroom at Upper Dorvel House, Ernest and Alice Barnsley's home, photographed by Ernest's brother Herbert in about 1905.*

which indicates the standard of craftsmanship achieved by a seventeen-year-old apprentice in about 1922, a door from the cob cottage Gimson built at Budleigh Salterton (Cat.28), and the Heal's table formerly owned by F.L.Griggs (Cat.42).

It was also the Museum's policy to consolidate and expand the archive collection, which had already grown since 1941 through the acquisition of Sidney Barnsley's drawings in the early 1970s, the loan from Corinium Museum of albums of photographs of work by Russell, and the gift from Mrs Joyce Evans of glass-plate negatives taken by Herbert Barnsley of Gimson and the Barnsleys at Sapperton. More recent additions include the working collection of the late Max Burrough, drawings and documents of Paul Woodroffe, Norman Jewson, Norman Bucknell, Alec Miller and Harry Davoll, and individual designs given by Alan Peters and Tony McMullen. The Gimson and Barnsley drawings were microfilmed in 1984[16] and all the archive material is now more accessible to researchers than ever before, but the accommodation for it and the Emery Walker library will not be completely satisfactory until they can be housed together in a properly fitted study area when the Museum is able to expand again. In the meantime, the library, archive and information files on individual designers

can be studied by appointment in advance, and new material for the collections is welcomed. In addition, the Museum can act as an information exchange, providing a point of contact for researchers working on related topics.

The development of the collection, and its expansion in terms of range and depth, can thus be seen as the result of the work and different approaches of the curators involved in caring for it. After a time, a museum collection builds up a momentum of its own, providing a focus for enthusiasm and attracting more offers of interesting items for sale and more gifts from owners who know their donations will be appreciated.

Unfortunately, the growth of international interest in Arts and Crafts work over the past thirty years has resulted in rising prices, and the Museum often has to compete with collectors for increasingly valuable items. There are, however, still some owners who prefer their possessions to go to a museum rather than to the marketplace, and who are willing to donate pieces or offer them at low prices. There are also some generous individuals, companies and trusts who support the purchase of objects and whose names appear in the catalogue, except where they prefer to remain anonymous. Special mention should be made of the

W. A. Cadbury Charitable Trust, which since 1952 has helped Cheltenham to acquire thirteen items of Arts and Crafts woodwork, as well as other pieces. William Cadbury and his wife Emmeline, like Arthur Mitchell, were interested in helping craftspeople in a practical way by enjoying and buying their work, and Mrs Cadbury readily extended her help to the Museum when asked.

It is unusual for a local museum service to have a policy of extensive collecting of furniture, partly because of the obvious storage and display problems posed by large objects and partly because of the cost of individual items. Since 1962, however, the Museum has received numerous grants towards Arts and Crafts furniture from the Victoria and Albert Museum Purchase Grant Fund. In later years, essential assistance has also come from the National Art-Collections Fund and the National Heritage Memorial Fund. Of the furniture in this catalogue, two-thirds were donated or purchased with funds from outside the Museum itself, and of the remainder, only a small percentage involved any cost to the ratepayers of Cheltenham.[17]

Cheltenham Borough Council has in recent years affirmed its commitment to the Museum by providing the funding for the construction of an extension which was completed in 1989.[18] The four-storey building houses the Arts and Crafts collection on the first floor in a display devised by Annette Carruthers and designed by Alan Murray of Haley Sharpe Associates. This comes at the end of a sequence of historical galleries which indicate the range of the collections and give a flavour of the art, design, craft and social history of England, and particularly Gloucestershire, at different periods. The Arts and Crafts display begins with William Morris's reaction to mid-nineteenth-century art, and traces aspects of the Arts and Crafts Movement in a wide range of media, roughly chronologically up to the Second World War. A twentieth-century gallery, completed in 1992, shows more recent work by craftspeople, along with factory-made goods of the period. A large proportion of the collection is now on display, but periodic changes are made to show as much as possible, and objects in store can be seen by appointment.

Visitors from all over the world now come to Cheltenham to see the Arts and Crafts material. There is great interest in the philosophy of the Movement, and the idea of the 'simple life' has a continuing appeal. Much of the work is domestic and visitors readily appreciate its quality of construction and pleasing design, while students of practical cabinet-making or the history of design can often be found in the gallery, drawing and measuring. Occasionally, visitors have some personal connection with the work, were trained at Gordon Russell Limited or were taught by Edward Barnsley or Stanley Davies, and whenever possible their comments are noted and added to the Museum files for future reference.

Thus the collection continues to grow in size and richness. It has its oddities and deficiencies, and there are still a number of types of object that the Museum would like to acquire, such as a plain piece of furniture by the Guild of Handicraft, embroideries designed by May Morris or Gimson, furniture by Liberty and Spooner, or an example of the leatherwork of the Whiteway colony. This catalogue is an attempt to show what has been achieved over nearly 100 years of interest in the Arts and Crafts in Cheltenham, and to provide a marking point for future developments.

1. Cheltenham houses the Arts Reference Library for the whole of Gloucestershire, and this collection is available for study by asking at the desk.
2. We are grateful to Neil Sinclair, a former curator at Cheltenham, for much of this information.
3. Catalogue of 1923 exhibition in Museum records.
4. *Manual Training* (the Journal of the National Association of Manual Training Teachers) Vol.xx, No.229, July 1923, 135-8.
5. *Manual Training* Vol.xx, No.228, May 1923, 99-100.
6. Stuart Robinson, *A Fertile Field: an Outline History of the Guild of Gloucestershire Craftsmen and the Crafts in Gloucestershire*, Cheltenham 1983.
7. Catalogue of *An Exhibition of Cotswold Craftsmanship*, Cheltenham 1951, pp.3-4. Copies of this are still available from CAGM.
8. These photographs are contained in albums in the Museum archive, and the negatives, donated by the photographer, S. C. Scorey, are also available, so good prints can be obtained.
9. M. Comino, *Gimson and the Barnsleys: 'Wonderful furniture of a commonplace kind'*, London 1980.
10. Some of these catalogues are still available from the Museum.
11. See A. Carruthers, *Gimson and Barnsley: Designs and Drawings in Cheltenham Art Gallery and Museums*, Cheltenham 1984, for an account of the acquisition of the Gimson and Barnsley archive material.
12. Letter from Daniel W. Herdman to Trevor Thomas, 24.3.1941, CAGM object file 1941.222-225.
13. J. Hooper, *Handcraft in Wood*, London 1952, p.63.
14. H. G. Fletcher 1.6.1967, *Proposed Gallery of the Cotswold Tradition of Craftsmanship*, CAGM.
15. See A. Carruthers, *Ashbee to Wilson: The Hull Grundy Gift to Cheltenham Art Gallery and Museums, Part 2*, Cheltenham 1986.
16. The microfilm can be purchased from World Microfilms, London, and is available for study by appointment at CAGM and the Furniture and Woodwork Collection at the V&A.
17. The current policy on collecting Arts and Crafts work is that the Museum seeks especially to acquire craftwork from Gloucestershire and the surrounding area; to collect craft furniture from the whole of Britain; to represent designers whose work is not already included; to represent a wide range of media; and to find well-documented pieces.
18. Grants were also received towards the building costs from the Museums and Galleries Commission, the English Tourist Board, and the Area Museums Council for the South West. The new displays were grant-aided by the John Paul Getty Foundation, the Summerfield Trust and other generous donors.

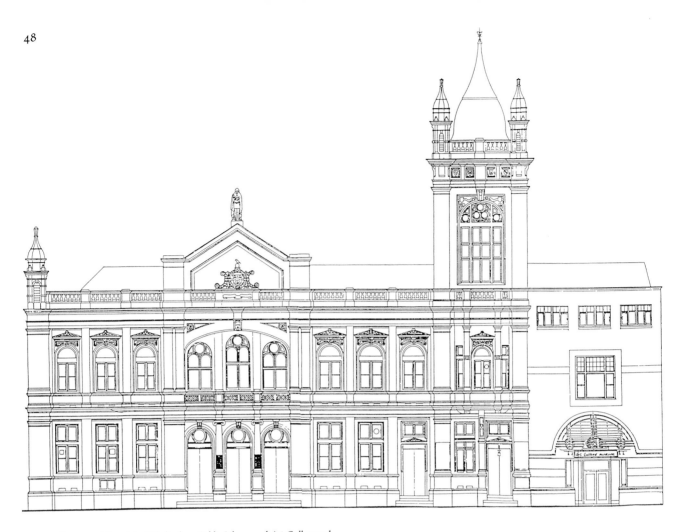

Fig.49 *Drawing of the original Cheltenham Public Library and Art Gallery and Museum with the 1989 extension to the right.*

Fig.50 *The 1989 Art Gallery and Museum extension by the Borough Council Architect's Department, with a stained glass window by Chinks Grylls and metal screen by Alan Evans.*

Fig.51 **Cat.1** *Table by William Morris, 1856, with other pieces associated with Morris & Company from the Museum's collection.*

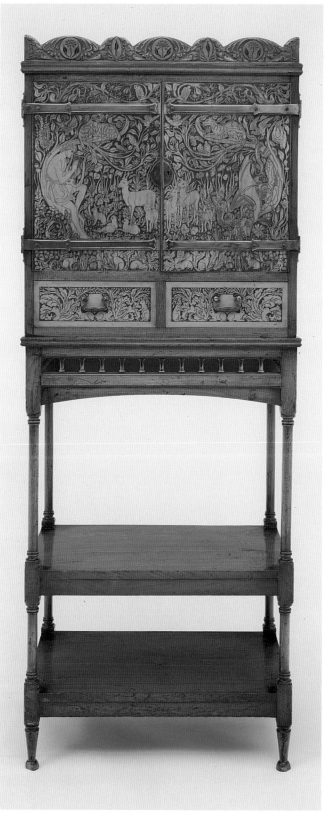

Fig.52 **Cat.4** *Music cabinet by Benson and Sumner, about 1889.*

Fig.53 **Cat.3** *Cabinet designed by George Jack and made by Morris & Company, about 1902, with a selection from the Museum's collection of Art Pottery.*

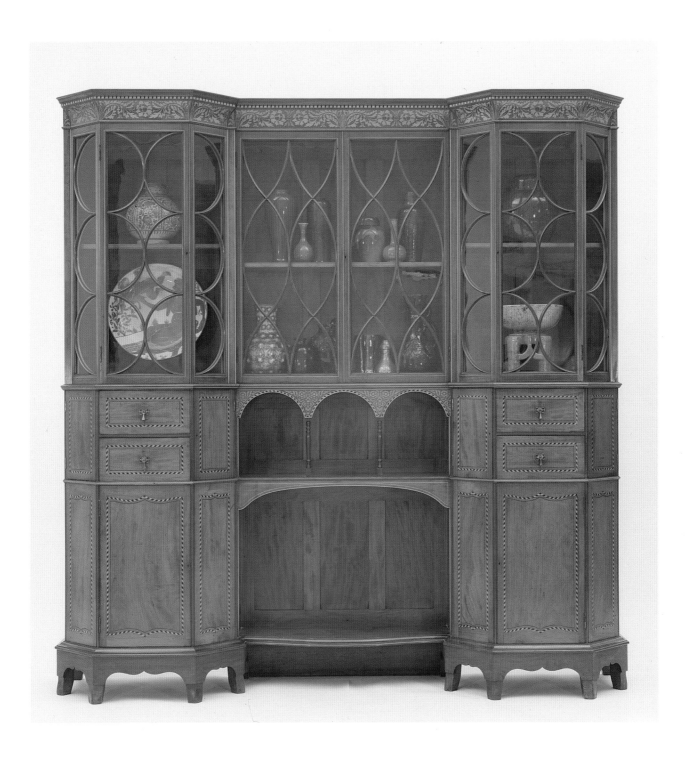

Fig.54 *Detail of the carved inlay on the Ashbee cabinet below.*
Fig.55 **Cat.13** *Cabinet by C.R. Ashbee and the Guild of Handicraft, about 1898-9.*

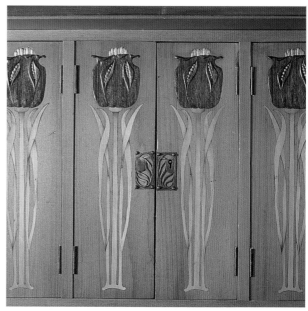

54

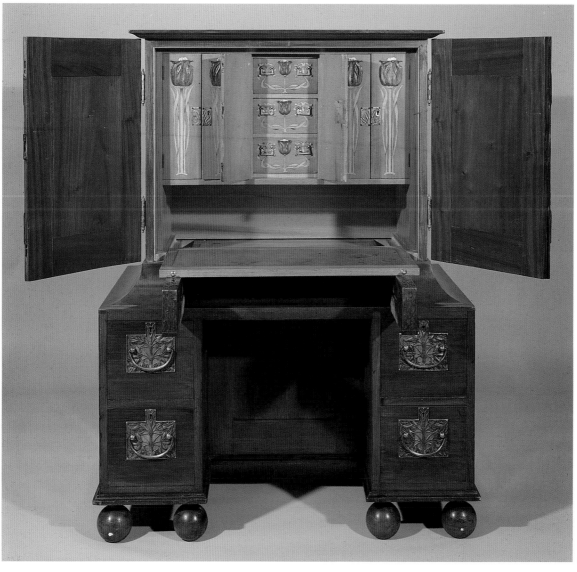

55

Fig.56 **Cat.33** *Sideboard by Ernest Gimson, 1915, with brass candlesticks by Gimson of about 1910 and painted plates by Grace Barnsley, about 1920.*
Fig.57 **Cat.25** *Cabinet of drawers by Ernest Gimson, 1903-7.*

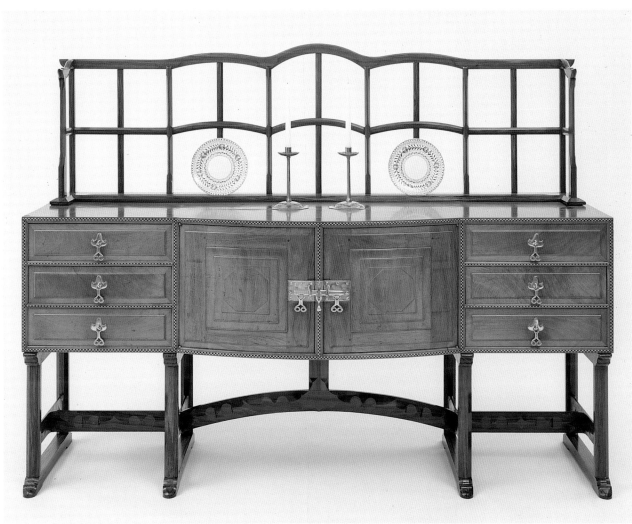

56

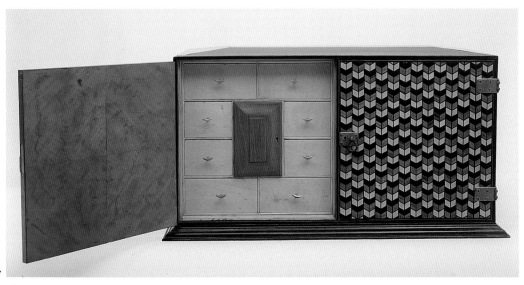

57

Fig.58 **Cat.95** *Print cabinet by Gordon Russell, 1925.*

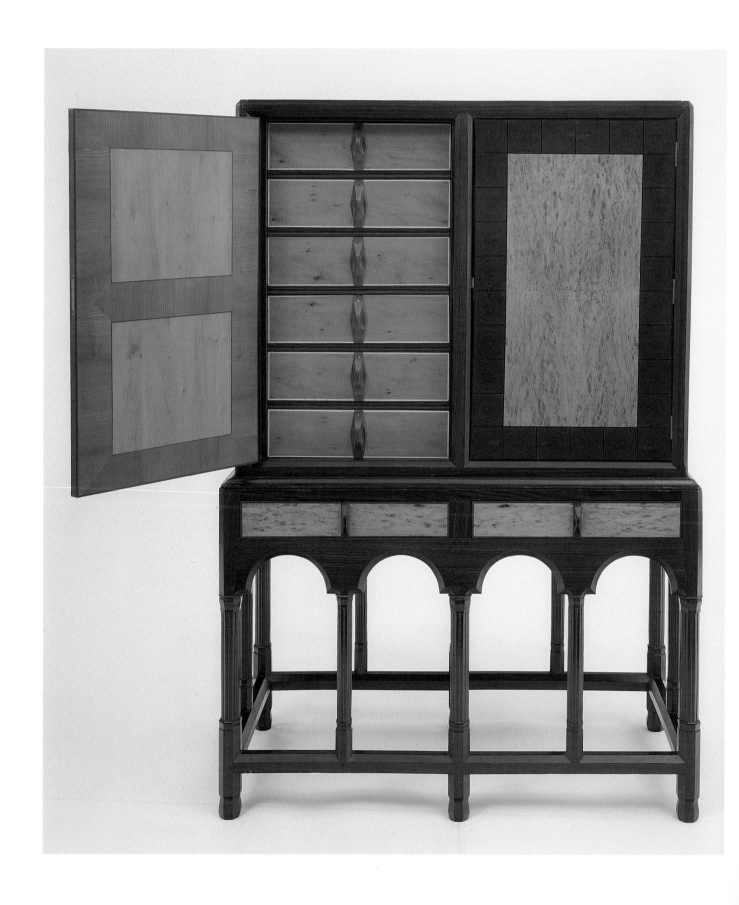

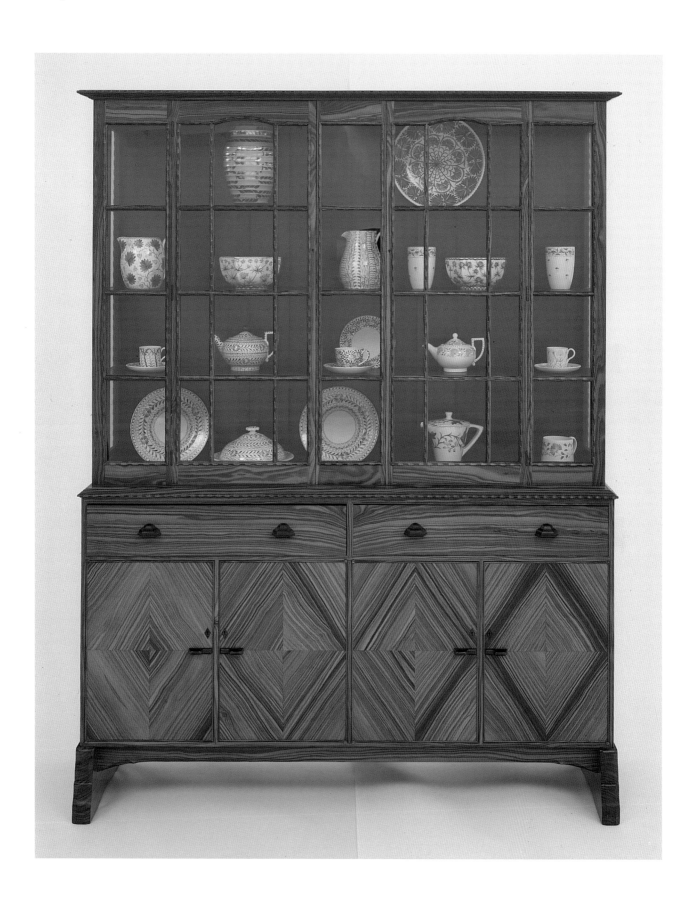

Fig.60 **Cat.76** *Settee by Eric Sharpe with a woven seat cover by Alice Hindson,*
probably 1929-30.
Fig.61 **Cat.108** *Serving table by Alan Peters, 1985.*

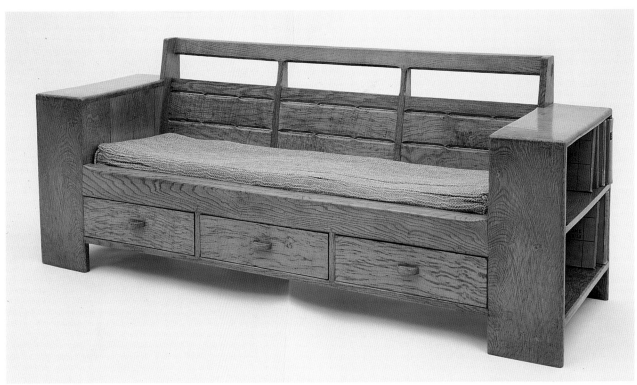

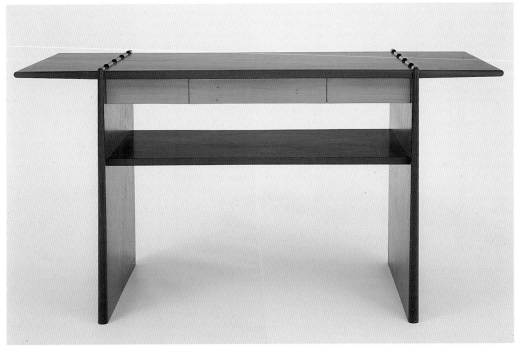

IV Catalogue

Note on the catalogue

Such is the richness of the Arts and Crafts collection that it has proved impossible to include catalogue details of everything and we have concentrated on the furniture. We hope we may be able to publish the rest at some future date, but to give an idea of the range represented we have included pieces in other media in our introductory chapters.

Details of individuals and groups of designers are arranged in roughly chronological order of when they became active in furniture design. Because many of them overlap, there is no single obvious order, but we hope that this rather loose arrangement will give a better sense of groupings and influences than an alphabetical one.

Within these headings, the furniture is in order of its date of design or execution. Even this has not been straight-forward, and although most of the collection dates from the present century, it has been surprising to find how quickly such basic information can be lost or obscured.

We have included as much information as we can about the original owners of the pieces, partly to acknowledge the importance of their support for the makers, and also to locate the furniture in the social background. This also gives first-hand evidence of the use of objects which might now seem precious because they have been preserved in a museum, but were once regarded as precious in a quite different way. Details of the hours taken to make a piece and the price, where known, have been included to enable further comparisons to be made.

Peculiarities of construction which might help in identifying other pieces have been included, but not in as much detail as would be desirable. Similarly, the names of suppliers of locks and other fittings have been added where known, since the type of lock on a piece could help with its attribution.

Dimensions are given in inches because most of the pieces were made in imperial measurements, but are followed by millimetres. The height is given first, then width and depth.

When reference is made to objects in museums or other publications, the accession number is usually given, since any enquiry about the object will be hastened by quoting the number. The Museum's accession numbers are given with the details of acquisition.

Many grants towards the purchase of objects have been received from the fund administered by the V&A. In April 1985 this changed from the Victoria and Albert Museum Purchase Grant Fund to the Museums and Galleries Commission/Victoria and Albert Museum Purchase Grant Fund, but the shorter version has been used.

The following abbreviations have been used:

*** Indicates that the object is illustrated in the colour plate section (pages 49-56)**

AHAG Abbot Hall Art Gallery, Kendal.
CAGM Cheltenham Art Gallery and Museums.
EBET Edward Barnsley Educational Trust, Froxfield, Petersfield, Hampshire.
GR Gordon Russell, Broadway, Worcestershire.
GRO Gloucestershire Record Office, Gloucester.
RCA Royal College of Art, London.
RIBA Royal Institute of British Architects, London.
V&A Victoria and Albert Museum, London.
V&A AAD V&A Archive of Art and Design, Blythe Road, London.
V&A P&D V&A Prints and Drawings Department.

Any numbers following these abbreviations are the accession numbers of objects.

William Morris (1834-96) and his circle

After William Morris's early attempts at designing 'intensely mediaeval' furniture, described below (Cat.1), Philip Webb (1831-1915) was responsible for a number of tables and cabinets produced by Morris, Marshall, Faulkner & Company, and decorated with colourful romantic scenes by Burne-Jones and Rossetti. Painting remained the favoured form of elaboration in the 1860s, not surprisingly given that several of the members of the firm were painters and that all had a passion for things medieval. Several of the reviewers at the 1862 International Exhibition criticised this early work and one in *Building News* gave his view that 'They would be all very well as curiosities in a museum, but they are fit for nothing else'.[1]

Cheap timber and painted decoration were soon abandoned in favour of solid oak and embossed leather, but some of Webb's simple and functional pieces remained in the firm's catalogues into the twentieth century. In the mid-1860s, the firm also developed one of its most enduring and successful designs, the Sussex chair (Cat.2).

Much of the early furniture was made in Great Ormond Yard, near Queen Square, and from 1881 large workshops at Merton Abbey in Surrey accommodated furniture manufacture as well as tapestry and wallpaper production. In 1890, a new furniture factory was acquired from Holland & Son in Pimlico, and this was managed by George Jack (1855-1932), who became Chief Designer for Morris & Company. Jack was also known for his work as a carver (Cat.5). On many of the elaborate pieces of this period, he worked with William Arthur Smith Benson (1854-1924), who also had independent interests, having set up a company in 1880 to manufacture innovative metalwork.

There was a major change in the style of the work in the 1880s and 1890s, probably primarily to ensure a market for it but possibly also influenced by a greater appreciation of

Fig.62 *Cartoon of 1856 by Edward Burne-Jones, depicting one of the rooms at Red Lion Square which he shared with Morris. The table in the background to the right could be Cat.1. From 'Memorials of Edward Burne-Jones' by Georgiana Burne-Jones.*

the skills and traditions of cabinet-making. The late furniture was closer to trade work of the time than the deliberately uncommercial pieces of the early years. Morris himself took little, if any, interest in it at this stage.

From the catalogues of the Arts and Crafts Exhibition Society, we know the names of some of the makers, who included A. Allam, W. Cook, W. Drummond, A. Dicks, H. Green, Turner Lawrence, H. Sidwell, William Thatcher, George Turner, and a carver, H. Dodd. Several printed catalogues of the firm's products also survive in the V&A Library, and these give details of prices.

In 1905, Morris & Company was purchased by F.C. Marillier and Mrs Wormald and it remained in business until 1940, but it had already lost its impetus before the death of Morris in 1896.

1. 8.8.1862, p.99.

1* Table

Designed by William Morris and made by a carpenter in London in 1856.

Pine (deal) with dark green paint on the edge, underside and base. The top is of five planks screwed together with a brace on the underside. Here and on the legs, the green paint covers a brown layer, which is not present on the edge. Exposed woodworm channels on the top suggest that the top was boarded at one time.

$28 \times 55\frac{1}{2} \times 54\frac{1}{2}$ ($711 \times 1409 \times 1384$)

Purchased in 1982 from the Trustees of Kelmscott Village Hall for £2000 with a 50 per cent grant from V&A Purchase Grant Fund and a contribution from a private charitable trust. 1982.1114

Record: G Burne-Jones, 'Memorials of Edward Burne-Jones', London 1904, Vol.I 1833-67, pp.147-9.
V&A, P&D PH29 1961, Photograph of a room at 8 Hammersmith Terrace, 1923.

This appears to be one of the few items of furniture designed by Morris himself and made for the rooms he shared with Burne-Jones at Red Lion Square in London in the mid 1850s. Rossetti described 'tables and chairs like incubi and succubi'[1] and Burne-Jones drew a cartoon of a room hung with medieval brasses, with what appears to be the table in the background (Fig.62). There is some confusion as to whether the maker was a carpenter or was Henry Price, a cabinet-maker, who recorded making some furniture for a 'gentleman who in after years became a noted Socialist, and Poet'.[2]

The table's later history is obscure, though it also features in a photograph of May Morris's house in Hammersmith, taken in 1923 (Fig.3).

It came from the village hall in Kelmscott, designed by Ernest Gimson for May Morris (1862-1938) in 1915 and finally opened as a memorial to Morris in 1934, the centenary of his birth. Writing during the Second World War, Freda Derrick described the table as eminently suited to the serving of refreshments at whist drives, dances and other gatherings held in the hall by the Women's Institute and the Home Guard. She believed that it '… came from an attic of the Manor House, but it may have been originally in the house May Morris had for a time at Hammersmith'.[3] It is just possible that it was in

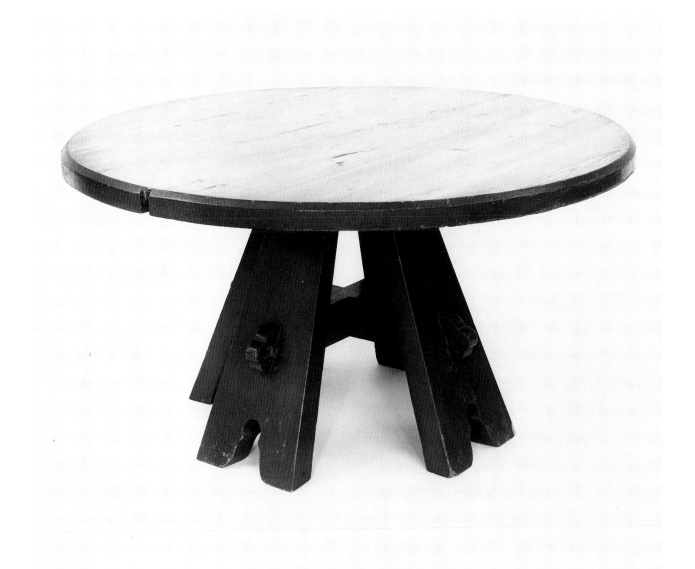

Fig.63 **Cat.1**

the sale at Kelmscott in 1939,[4] when a deal-top table with iron vice from the attics was sold to Vaisey Davis of Kelmscott, who might then have given it to the hall. This is a tempting theory because a notch in the edge of the table top could be related to the iron vice, but the fact that Derrick also records that it was painted on the instructions of May Morris might reduce the probability.[5]

The green paint is a different shade from that on the painted bedroom furniture at Kelmscott, but the underlying red-brown paint is similar to the base of the St George Cabinet in the V&A, and it may be that the table was originally brown. Clive Wainwright of the V&A has suggested that it may first have been stained in the fugitive green used by Morris & Co, and later painted because May Morris remembered it should be this colour but did not have the stain.

Morris was a pupil in 1855-6 of the Oxford architect, George Edmund Street (1824-81), who designed some plain oak tables for Cuddesdon College, Oxford, in about 1854.[6] The Cheltenham table clearly owes a debt to these, and is related to others designed by Philip Webb for Morris, Marshall, Faulkner and Company in the 1860s, as illustrated in a Morris & Company catalogue as late as about 1911.[7] Wainwright suggests that Webb may have drawn it out but the idea was probably Morris's, since it is closer to tables depicted in medieval manuscripts than to the Cuddesdon furniture, and Morris had an interest in such sources. A.W.N. Pugin also designed a table for Crace in 1849 related to images in medieval manuscripts.[8]

If this was the first piece of furniture designed by Morris, it seems curious that May Morris should not have valued it more. Morris himself probably regarded it as a youthful attempt in an area of design in which he took little interest later on, though it did fulfil his desire for furniture made of beams.

See Figs 3, 62, Col. Fig.51.

1. Quoted by J.W.Mackail, *The Life of William Morris*, London 1899, Vol.1, p.133.
2. See P.Kirkham, 'William Morris's Early Furniture', *The Journal of the William Morris Society*, Vol.IV, no.3, Spring 1987, pp.25-8.
3. F.Derrick, *Country Craftsmen*, London 1945, p.134.
4. Hobbs & Chambers, Faringdon, 19-20 July 1939, lot 747.
5. F.Derrick, ibid, p.134.
6. One of these is in the V&A, w88-1975.
7. V&A Library 57c67, p.23.
8. V&A P&D E1630-1912.

2 Armchair

Probably designed by Ford Madox Brown (1821-93) after chairs from Sussex in about 1864-5, and made for Morris & Company from about 1864 to 1940.

Ash, stained black. The rush seat has been replaced and is slightly coarser than it would have been originally.

$33\frac{1}{2} \times 21 \times 17\frac{3}{4}$; h. of seat $17\frac{3}{4}$
($849 \times 533 \times 451$; h. of seat 450)

Purchased in 1989 from Paul Reeves, London, for £350. 1989.886

Record: V&A Library 57c66 & 57c67, Morris & Company catalogues, about 1911.

Very large numbers of these chairs were made and the several different versions appear frequently in photographs of interiors of the period.

In the Morris & Company catalogue, this type of armchair was priced at 9s 9d. In comparison with Gimson's platform chairs for Mrs Pass (Cat.26) at 25s each, this was very cheap, and probably reflects the large numbers made. Other firms, such as Liberty and Heal, copied the design, and attribution to Morris & Co can only be

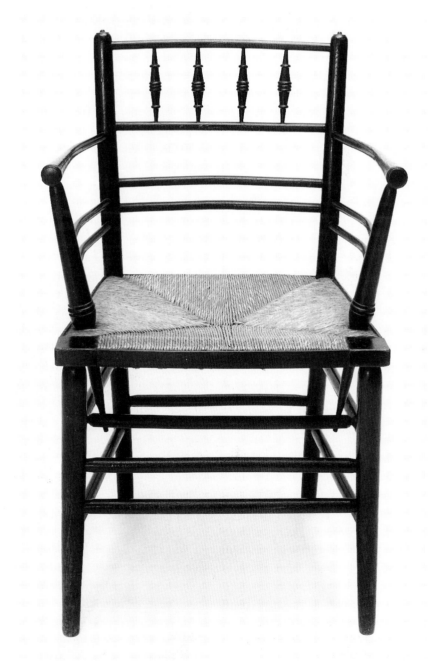

Fig.64 **Cat.2**

made by close comparison of the details of the turning with the catalogue photographs.

The origins of the design are uncertain, but it is thought to have been copied by Madox Brown from a type of chair found in Sussex, which may not have been rustic at all. Simon Jervis has described the prototype as 'unpretentious furniture in a Sheraton/Regency tradition',[1] and this ties in with D.G. Rossetti's known interest in Regency pieces and turned and ebonised seats. The Sussex chair fulfilled Morris's requirement for light, movable chairs made of sticks, and Warington Taylor, the strong-minded manager of the firm from 1865, liked it for its 'poetry of simplicity'. He must also have approved of the price, since he believed 'It is hellish wickedness to spend more than 15/- in a chair, when the poor are starving in the streets'.[2]

1. S. Jervis, '"Sussex" Chairs in 1820', *Furniture History*, Vol.10, 1974, p.99.
2. Quoted by P. Thompson, *The Work of William Morris*, London 1967, softback edition 1977, pp.83, 85.

3* Cabinet

Designed by George Jack, probably around 1888-90, and made by Morris & Company in about 1902.

Honduras mahogany inlaid with ebony and holly. Brass drop handles and hinges. Framed and panelled construction of high quality. The top can be unscrewed from the base for moving and all the cupboards have adjustable shelves inside. Locks by Hobbs & Co, London.

Stamped on top of the front of the two top drawers,

MORRIS & CO 449 OXFORD ST W 1375.

$80\frac{1}{8} \times 80 \times 16\frac{3}{4}$ (2035 × 2031 × 425)

Purchased in 1985 via B. G. Burrough, Colyton, for £4350 with a 50 per cent grant from the V&A Purchase Grant Fund and the bequest of Mrs F. M. R. Cooper. 1985.659

Record: V&A Library 57c66 & 57c67, Morris & Co catalogues, about 1911, pp. 8, 14.

The cabinet was acquired from Mrs P. F. Wyber and Mrs C. Macartney, the daughters of the original owners. Their parents, Edward (later Sir Edward) and Eleanor Penton probably received it as a wedding present in 1902 for their house at 2 Cambridge Terrace, Regent's Park, in London, and Mrs Wyber remembers it very distinctly from the early 1920s – 'The Morris Cabinet featured largely in my

young life. It stood in the drawing-room at home with the Temple edition of Shakespeare on the shelves as well as some lovely Chinese dragons, two pairs, and a green china frog. But in the cupboards were games and toys which were very strictly for use in the drawing-room when we came down from the nursery to see our mother after tea.'[1]

Their father was the only son of Mr and Mrs Edward Penton, whose names appear in the records of the Arts and Crafts Exhibition Society as the purchasers of several items.[2] Mr Penton had a successful wholesale boot and shoe firm and lived at Cavendish Square, near Oxford Street in London, and also in Lyndhurst, Hampshire. His son followed him into the family business.

George Jack probably designed the piece just before or at about the time he became chief designer for Morris & Co in 1890, and several are known to have been made. Cooper illustrates one supplied to William Knox D'Arcy at Stanmore Hall, Middlesex, in 1888-96[3] and says that it was shown at the Franco-British Exhibition of 1908.

In a Morris & Co catalogue of about 1911[4] it is described as a 'Mahogany inlaid cabinet of highest Sheraton finish. Designed by Mr George Jack. 6ft 9in × 6ft 8in high. £102.18.0'. Morris & Co showed inlaid cabinets by Jack at the Arts and

Crafts Exhibition Society exhibitions in 1888 and 1889, but it is not known if this was one of them.

See Fig.22, Col. Fig.53.

1. CAGM file, Mrs P. F. Wyber to A. Carruthers, 11.10.93.
2. V&A AAD, 1/99-1980, 1/101-1980.
3. J. Cooper, *Victorian and Edwardian Furniture and Interiors*, London 1987, pl.474.
4. V&A Library 57c67.

4* Music cabinet and stand

Designed by William Arthur Smith Benson and George Heywood Maunoir Sumner (1853-1940) in about 1889, with decoration executed by Sumner.

Mahogany and boxwood veneers on softwood carcase. Boxwood-veneered oak doors inlaid with blue wax and the cornice inlaid with black wax. The decoration on the doors depicts Orpheus charming the animals, among luxuriant foliage and flowers. The sides are decorated with stylised lilies, ivy and birds, and the cornice with ivy berries.

Brass hinges, handles and lock-plates. The ply construction of the doors, in combination with the engraving of the outer surface to receive the wax inlay, has caused warping. The doors appear to have been treated with brown

Fig.65 **Cat.4** *Detail of the hinges and wax inlay.*

boot polish at some time, presumably to tone down the colour, and the interior fittings for the storage of sheet music have been removed.

Initials 'HS' inlaid on right-hand door, on either side of a rabbit. The drawers are marked on the backs 'L' & 'R'.

$63\frac{1}{4} \times 24\frac{5}{8} \times 15\frac{3}{4}$ (1605 × 627 × 399)

Purchased in 1985 from Haslam & Whiteway, London, for £14,400 with grants from the V&A Purchase Grant Fund (50 per cent), the National Art-Collections Fund and the Friends of the Museum, and money from the Captain Wild Bequest. 1985.671

There is no information available about previous owners because the vendors purchased the piece at Christie's South Kensington. Since the internal fittings had been removed, it was presumably not being used as a music cabinet.

The inlay by Sumner is identical to that on another music cabinet of larger and more ornate form, exhibited at the 1889 Arts and Crafts Exhibition and entitled 'The Charm of Orpheus'.[1] This is now in the collections of the Nationalmuseum, Stockholm, Sweden. According to the exhibition catalogue, it was executed by C. Rogers with incised work by G.H. Walton, and it seems likely that they were also involved in the making of the Cheltenham piece. One C.H. Walton of Acton is credited in the 1896 Arts and Crafts Exhibition catalogue with prints for Sumner,[2] and G.H. must be a misprint. In view of Benson's connection with Morris and Co, it is possible that the firm was involved in the making of this piece, but there is no definite evidence.

Orpheus is an eminently suitable subject for a music cabinet, and Sumner has included many elements from classical legend, with natural motifs which are probably symbolic.

Heywood Sumner gave up a legal career to become an artist and illustrator, and was a founder member of the Art Workers' Guild and the Arts and Crafts Exhibition Society. He worked on designs for wallpapers and textiles, stained glass and large-scale mural decoration in a sgraffito technique, the effect of which is rather similar to that achieved on this cabinet. He described this method of inlaying with wax at a talk he gave with William Aumonier, published in 1901-2.[3]

Sumner's work on this method of incising wood and filling the lines with coloured stopping was inspired by his study of fourteenth-century Italian chests in the V&A. In his article in the *Art Journal* he

Fig.66 **Cat.5**

suggests that marriage chests were suitable as bearers of such decoration because of their 'romantic origin and memories', but that a 'front-hall coat and rug chest' would be unsuitable because too homely. He mentions several items which 'may give opportunities for a special touch of fancy', and presumably a music cabinet was considered to fit into this category.[4]

The lock-plate on the right door is functional but the one on the left is blind and is included for the sake of symmetry.

See Col. Fig.52.

1. V&A AAD 1/74 - 1980, Cat.282.
2. V&A AAD 1/803 - 1980, Cats 57 - 8.
3. 'A Forgotten Craft', *Art Journal*, July 1901, pp.209 - 12. *Journal of the Royal Institute of British Architects*, Vol.IX, 12 April 1902, pp.291 - 6.
4. p.212.

5 Panel

Designed and carved by George Jack in about 1890.

Italian walnut.

$15 \times 32\frac{1}{8} \times \frac{3}{4}$ (379 × 815 × 19)

Given in 1986 by the Fine Art Society, London, through the National Art-Collections Fund, in memory of Charles C. Winmill. 1986.1125

Record: Letter from C. C. Winmill to Maresco Pearce, quoted in J. Winmill, 'Charles Canning Winmill: An Architect's Life', London 1946, pp.23 - 4.

Bought by the Fine Art Society with other items from Miss Joyce Winmill, the daughter of Charles Winmill, and shown in their Spring Exhibition in 1986. Miss Winmill recalled that her father had wanted the piece to go to a museum and offered to buy it back, but the Fine Art Society

decided to donate it to Cheltenham in accordance with her wishes.

Charles C. Winmill (1865 - 1945), was a London County Council architect, working from 1892 in the housing section and later specialising in fire stations. He was a great admirer of Philip Webb and became friendly with him and with George Jack, Webb's chief assistant. He later wrote, 'George Jack was a great man … He was great in almost every way – a considerable carver – Lethaby said he was the best we then had – and an architect of distinction. I trusted his opinion nearly as much as I did Webb's, of course not quite, but Jack seemed nearer to me, and Webb so high above me. I have in my cottage a few things he did; one a carving that he gave me, at the time he left his job of teaching carving at South Kensington. It is a piece of dark walnut, carved in very low relief … a foliage of tulips and other flowers, so exquisitely carved one can almost feel the bloom on the flowers. It twice crossed the Atlantic to be shown in New York. In some lights it gives you the idea of leather.'[1]

The panel may have been one shown at the 1890 Arts and Crafts Exhibition.[2]

In his book on *Wood Carving*, George Jack stated his principle that 'We do not make carvings to hang on a wall and be admired altogether on their own account. They must decorate some object'.[3] This piece has been admired solely for itself ever since it was made, but it was intended to be the fall-front of a writing bureau and the small half-oval shape in the centre of the upper edge would have accommodated a key hole.

1. Quoted by J. Winmill, *Charles Canning Winmill: An Architect's Life*, London 1946, pp.23 - 4.
2. V&A AAD 1/75 - 1980, Cat.320a.
3. G. Jack, *Wood Carving: Design and Workmanship*, London 1903 (2nd ed, p.116).

Charles Francis Annesley Voysey (1857-1941)

After taking articles with J.P. Seddon and working for short periods as an assistant to Saxon Snell and then George Devey, Voysey set up his own office in 1881-2. He produced pattern designs for several companies while he built up his architectural practice, and by exhibiting with the Arts and Crafts Exhibition Society and encouraging the publication of his work in journals such as *The Studio*, he gradually attracted clients.

Voysey had very decided ideas about the nature of the home and the importance of repose as a quality of the interior. Simplicity of form, subtlety of proportion and the use of plain, good-quality materials made to high standards were fundamentals of his design work. His furniture was intended to be practical both for the user and for the person who had to clean it. It was also important to him to develop a style suited to English traditions and conditions, but he normally specified Austrian oak because it had a more even grain than English. When first made, the furniture was very pale, and Voysey wanted the brass fittings to be left unpolished, which would give a gun-metal effect. Oak darkens naturally unless regularly scrubbed, so the effect today is very different from when the pieces were new. Designs which he felt were successful were frequently repeated, often with small amendments to the proportions.

Most of Voysey's drawings are in the collections of the Royal Institute of British Architects, which also has his 'Black Book' and address book.[1] In them can be found the names of the makers who executed the work, including Frederick Coote of 187a Tottenham Court Road, H. Meunier of Moore Street, Fredrig Cristen Nielsen (who moved a lot), A. W. Simpson of Kendal and Peter Waals at Chalford. Metal fittings were made by Thomas Elsley & Company and by W. B. Reynolds Limited.

Voysey's work for the Ward-Higgs family

William Ward-Higgs and Haydee Nathalie Becker were married in the mid 1890s and leased a large house at 23 Queensborough Terrace, Bayswater. Ward-Higgs was a successful solicitor in the City of London, a sportsman and great shot, a skilled amateur musician and a lover of books. He was probably introduced to Voysey by Harold Tingey, and he put the furnishing of the house into Voysey's hands in 1898, according to the 'Black Book'.

On the outside, the ground-floor façade was painted a strong red and the white front door had a large heart-shaped letter box. Inside, Voysey's major impact was in the L-shaped drawing room on the first floor, where a low picture rail divided the walls, with pale paintwork above and gold leaf below. Blue and green silk and wool doublecloth

Fig.67 *William Ward-Higgs, about 1905.*

curtains in a design of birds and leaves (produced by Alexander Morton & Company from 1897) were used in this room (Fig.68) and the Blüthner grand piano, which Ward-Higgs played for half an hour every day as relaxation on his return from work, was covered with a cloth of the 'Daisy' design, also made by Morton.

Much of the furniture ordered by the Ward-Higgs family was in the drawing room, including one or two tall-backed chairs, a round table, the plant stand from Goodyer's, a tiered display stand, a plain cabinet, and probably the Swan chair and the desk made for Haydee Ward-Higgs (Cat.9). These items, predominantly of plain pale oak with minimal decoration, were mixed with an upholstered chair and sofa, a folding screen, fancy cane chairs and rococo mantelpiece ornaments which presumably belonged to Ward-Higgs already, and the room was clearly a comfortable focus for the life of the family. The idea that Voysey was a difficult purist, insisting on his own way with the entire decorative scheme, is refuted by photographs of this house (Fig.69).

Other rooms were similarly eclectic. The ground-floor library was lined with glass-fronted bookcases and contained the Kelmscott 'Chaucer' cabinet, at least two oak armchairs,

Fig.68 *Haydee Ward-Higgs on the 'Swan chair' at her writing desk, about 1908 - 10 (see Cats 6, 9, and 12).*

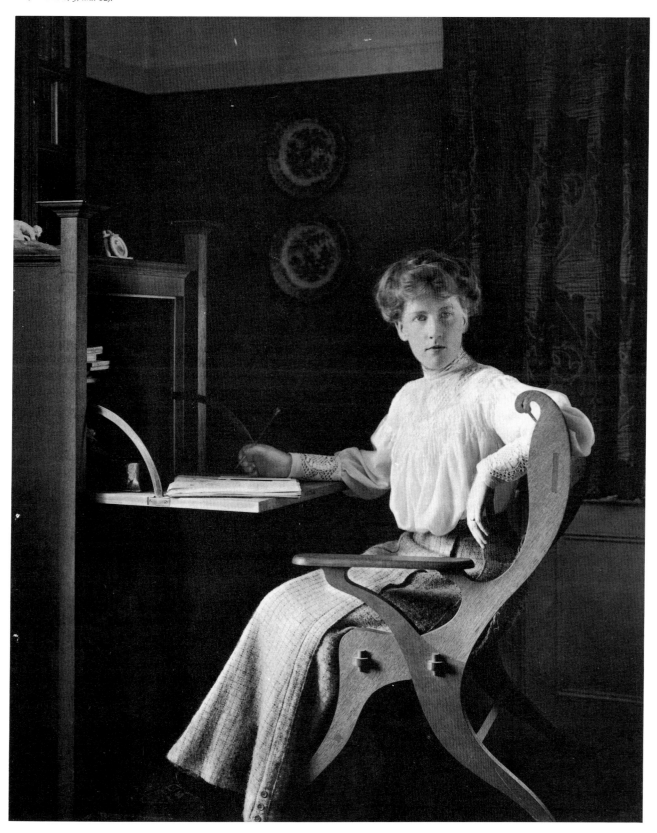

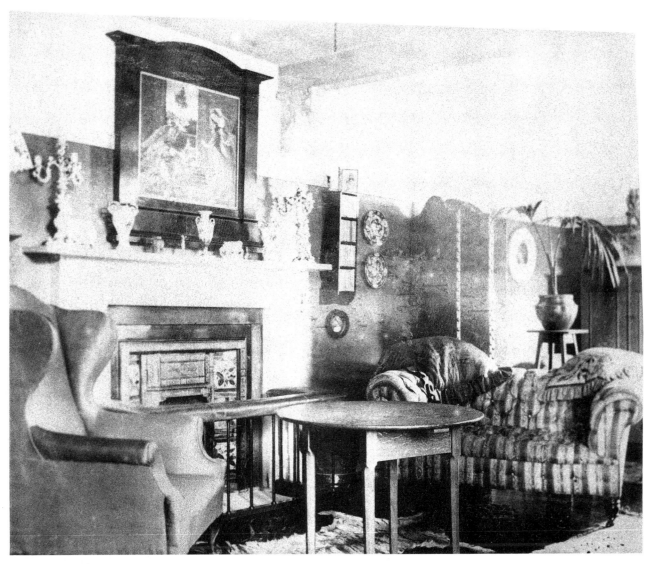

Fig.69 *The drawing room at 23 Queensborough Terrace, London, about 1900 (see Cats 10 and 11).*

a round table, and cane and upholstered chairs, while the dining room furniture included a set of chairs and probably the oak dresser now at the V&A.

William and Haydee Ward-Higgs moved in about 1902 to a rented house in Bognor Regis, Sussex, so that their children could grow up in the country, letting out Queensborough Terrace with most of the furniture to friends. Ward-Higgs stayed in town during the week and returned home at weekends, and he clearly considered having a house built for him, because a Voysey design of 1903 for a tower house at Bognor survives in the RIBA Drawings Collection.[2] In 1908, however, the family returned to Bayswater and stayed until just after the First World War, when they moved to a bigger house in Sussex Gardens.

The youngest daughter of the family was the only one interested in the furniture, so she inherited it and cared for it after the deaths of her parents. She sold this group to the Museum for less than it would have fetched if the pieces were sold separately because she wanted it kept together in a safe place as a memorial to her father and mother, who were among Voysey's earliest clients. Her mother had always insisted that it should not be polished with anything that would darken it and said late in her life that one day Voysey's work would be appreciated again.

Seven pieces of furniture and a metal pen tray were purchased in 1981 via the Fine Art Society and Michael Whiteway for £61,000. The acquisition was supported by a 50 per cent grant from the V&A Purchase Grant Fund, and contributions from the National Art-Collections Fund, the National Heritage Memorial Fund and the W. A. Cadbury Charitable Trust.

1. RIBA VoC/1/1, 1/3.
2. RIBA 20.

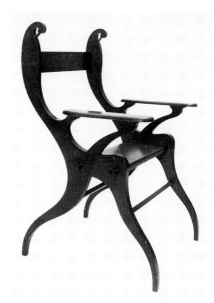

Fig.70 **Cat.6**

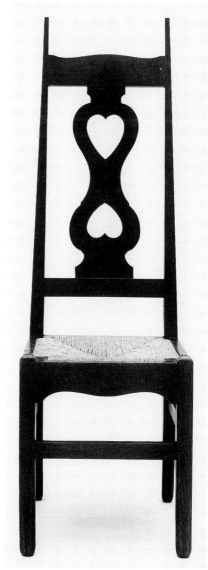

Fig.71 **Cat.7**

6 Armchair

Designed by C. F. A. Voysey in 1883 - 5 and made in or before 1898.

Oak. Made from flat boards of timber joined with dowels and tenons. The curve of the leg has been cut with the grain of the timber running downwards so that it is as strong as possible, though the shape is problematic and the back support of one arm has been broken at a weak point and repaired. Holes under the top rail and seat indicate that there was a covering at one time.

$38 \times 25 \times 24\frac{1}{2}$; h. of seat $17\frac{1}{8}$
($965 \times 635 \times 622$; h. of seat 434)

Purchased in 1981, see page 66. 1981.312

Design: RIBA 207, 'Oak chair for Reading Room, Writing Room or Hall', undated.

Record: Photograph of Haydee Ward-Higgs (Cat.12, Fig.76).

Commissioned by William and Haydee Ward-Higgs.

This is Voysey's earliest known furniture design and is often described as the 'Swan chair', though there is no evidence that Voysey gave it a title. The drawing is dated to 1883 - 5 by the watermark and by Voysey's address inscribed on the design, 'Broadway Chambers, Westminster'. According to Brandon-Jones et al., a note on the back of the design states that the chair was made for Ward-Higgs in 1896 and exhibited at the Arts and Crafts show in that year, but it is not included in the catalogue.[1] A photograph of it was published in *Dekorative Kunst* in March 1898.[2]

The spacing of darkened areas of wood on the seat in relation to the nail holes suggests that two separate coverings of different widths have been used. The photograph of Haydee Ward-Higgs seems to indicate a slung seat of coarse fabric. This was later replaced with a piece of fabric on the seat only. The design of the chair specifies a leather-padded seat and back with close nailing, but an added note instructs 'omit this cushion CFAV'. As executed, the chair is extremely uncomfortable.

One of Voysey's central principles of design was 'What you can remember is your own, what you sketch you steal'.[3] The Swan chair has elements of form and construction which Voysey may have remembered from the Glastonbury chair, a medieval piece from Glastonbury Abbey, which was owned by Horace Walpole in

the eighteenth century and was much copied in the nineteenth.
See Fig.68.

1. J. Brandon-Jones et al, *C. F. A. Voysey: architect and designer 1857 - 1941*, London 1978, p.81.
2. Vol.1, no.6, p.259.
3. C. F. A. Voysey, *Individuality*, London 1915, p.88.

7 Two chairs

Designed by C. F. A. Voysey in 1898 and probably made by C. H. B. Quennell.

Oak with rush drop-in seat. Re-rushed by Heritage Crafts, Haslemere, in the 1970s.

$52\frac{1}{4} \times 16\frac{1}{8} \times 17\frac{1}{4}$; h. of seat $17\frac{5}{8}$
($1327 \times 410 \times 438$; h. of seat 452)

Purchased in 1981, see page 66. 1981.313.1 - 2

Design: RIBA 210, dated 11.4.1898.

Record: Photograph of a room (Fig.25) probably at 23 Queensborough Terrace, but possibly at The Briars, Brewery Road, Bognor, Sussex.

There was a set of at least six of these chairs at Queensborough Terrace, some in the drawing room and some in the main bedroom, though one also appears in a photograph of a room with built-in cupboards (Fig.25). Ward-Higgs's daughter later used them as dining chairs.

As executed, the chairs are taller but have less attenuated finials than the design, and the side rails are straight rather than sloped backwards. A pair conforming to the design was sold at Sotheby's[1] and may have come from the Queensborough Terrace house since photographs show at least one with very tall finials in the drawing room. If so, this would suggest that they were made in groups for different rooms, with alterations to the later group.

The design shows that quotations were obtained from Quennell and from Coote, with Quennell's price being slightly cheaper overall at £3 without arms and £4 with. If this is C. H. B. Quennell (1872 - 1935), of 17 Victoria Street, Westminster, it is curious that Voysey should go to him for the execution of the work, since Quennell was also an architect and had furniture designs made by J. P. White of Bedford. When the chair seats were re-rushed, some indication was found to suggest that they were made by Heal's. This may possibly be related to the fact that Coote did a lot of work for Heal.

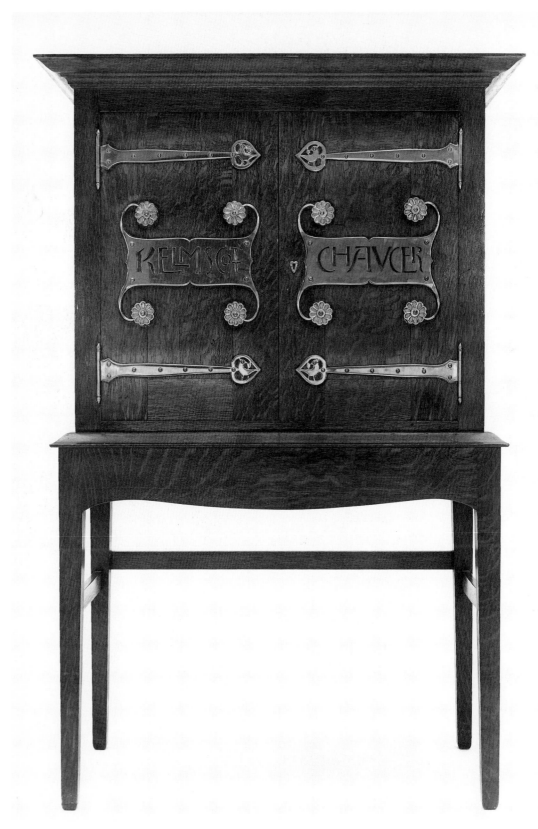

Fig.72 **Cat.8**

Voysey used this form of chair in several other interiors, including the dining room of his own house. One executed by Story & Co was illustrated in *The Studio* in 1899,[2] but has side rails conforming to the design rather than as used here.

See Fig.25.

1. 2.5.90, lot 245.
2. Vol.18, October 1899, p.43

8 The Kelmscott 'Chaucer' cabinet

Designed by C.F.A.Voysey in 1899 and made by F.C.Coote. Brass fittings probably made by Thomas Elsley & Company.

Oak and brass, with red suede under the lettering and red paint inside. The wood is considerably darker than when the piece was made. Lock by Hobbs, London, and patented fitting holding the door.

$52\frac{1}{2} \times 34\frac{5}{8} \times 18\frac{1}{2}$ (1332 × 879 × 470)

Purchased in 1981, see page 66. 1981.314

Record: CAGM, Photograph of the library at Queensborough Terrace.

Although made specifically for a copy of Morris's masterpiece of printing, the Kelmscott *Chaucer* published in 1896, the cabinet interior was rather too large for the book.

Ward-Higgs had a similar, but very plain, cabinet for music, which was designed in 1898[1] and this piece must date from the same time or shortly afterwards. It was shown at the 1899 Arts and Crafts Exhibition[2] and an illustration of it in *The Studio*[3] shows the very pale effect of the oak when new.

It is a typical example of Voysey's assured style of furniture design by the late 1890s, contrasting the utmost simplicity of the form with the idiosyncrasy of the decorative fittings and lettering.

1. RIBA 205.
2. V&A AAD 1/90-1980, Cat.438.
3. Vol.18, p.42.

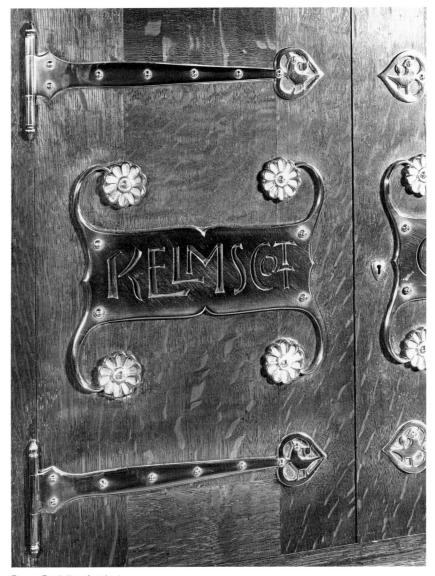

Fig.73 **Cat.8** *Detail of the doors.*

9 Bookcase and desk

Designed by C.F.A.Voysey in 1899. Maker unknown, but possibly F.C.Coote. Metalwork probably made by Thomas Elsley & Company.

Oak with brass fittings, and glass. The interior contains six pigeon holes. Lock by Hobbs & Co, London.

$86 \times 26\frac{3}{4} \times 24\frac{3}{4}$ (2185 × 680 × 629)

Purchased in 1981, see page 66. 1981.315

Design: V&A P&D E271 1913.

Record: CAGM Photograph of Haydee Ward-Higgs, (Cat.12, Fig.76).

Commissioned by William and Haydee Ward-Higgs and used with the Swan chair (Cat.6), as shown in the photograph, which was probably taken in the drawing room. Haydee Ward-Higgs found the desk inconveniently narrow but loved it anyway.

With its square-capped posts, this piece is closely allied to the work of Mackmurdo, who was an important contact for Voysey at the beginning of his career.

See Figs 68, 74.

Fig.74 **Cat.9** *Bookcase and desk by C.F.A.Voysey, 1899, with books from the Max Burrough Collection and a candlestick by W.A.S.Benson from the Summerfield Collection.*

10 Table

Designed by C.F.A.Voysey in about 1898-9. Maker unknown.

Oak. Of glued and screwed construction. The top has shrunk slightly across the grain.

$27\frac{5}{8} \times 30 \times 29\frac{3}{4}$ (702 × 762 × 755)

Purchased in 1981, see page 66. 1981.316

Record: CAGM, Photographs of drawing room (Fig.69) and library at Queensborough Terrace.

At least two tables of this design were made for Queensborough Terrace, one of which was later cut down by Mrs Ward-Higgs. This design was illustrated in *The Furnisher* in 1899.[1]

The subtle transformation of the leg from square to octagonal was probably derived from Mackmurdo's work. A settle by him of 1886 in the V&A has pillars at the front which change from square to round.[2]

See Fig.69.

1. Vol.1, p.109.
2. V&A W16.1967.

11 Plant stand

Possibly designed by C.F.A.Voysey in the late 1890s and made for F.B.Goodyer, London.

Oak with a brown varnish. The construction is odd. The rails vary in thickness from $\frac{5}{8}$ in to $\frac{7}{8}$ in and the underside of the top has a lot of glue on it and three added fillets of mahogany. It is not made to the standard usually demanded by Voysey.

Small plastic label pinned under rail

F. B. GOODYER
155, NEW BOND ST LON
174, REGENT ST DON
326, OXFORD ST W

$37\frac{1}{2} \times 18\frac{3}{8} \times 17\frac{1}{2}$ (952 × 467 × 444)

Purchased in 1981, see page 66. 1981.317

Record: CAGM, Photograph of the drawing room at Queensborough Terrace (Fig.69).

This appears in two photographs of the drawing room under a large jardinière and palm. It is thought to have been bought by William and Haydee Ward-Higgs on Voysey's instructions, and it is possible that he designed it for Goodyer.

F.B.Goodyer was a retail furnishing firm which frequently had work illustrated in *The Studio* at this period.

See Fig.69.

12 Photograph and frame

Frame possibly designed by C.F.A. Voysey in about 1900 and made by Gladwell Brothers, 8 Eastcheap, London. Photographer unknown, about 1908-10.

Black and white photograph of Haydee Ward-Higgs seated on the Swan chair at the desk designed for her by Voysey (Cats 6 and 9). In a painted softwood frame with a small gilt slip.

 Paper label on the back, of Gladwell Brothers, 8 Eastcheap EC, picture frame manufacturers.

$18\frac{1}{2} \times 16\frac{1}{4}$ (470 × 414)

Given in 1983 by Mrs Joan Bottard. 1983.164

It is clear from the fact that the photograph was taken at all that Haydee Ward-Higgs was pleased with her furniture. The picture can be dated by comparison with another of her and her daughters at Bognor, in which she is wearing the same skirt and blouse.

 In the background is a Voysey-designed curtain and two blue and white porcelain plates against the gold-leaf wall which was part of Voysey's decorative scheme. The low rail was also part of his design. On the shelf of the bureau is a white porcelain figure of *La Prairie et Le Ruisseau* by Raoul Larche, which the Ward-Higgses bought when they went to the 1900 International Exhibition in Paris.

 See Fig.68.

Fig.76 **Cat.12**

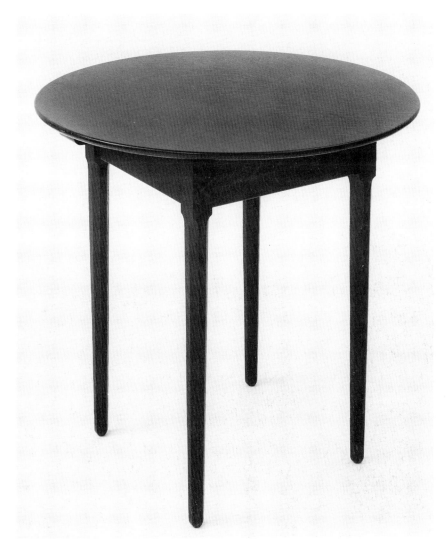

Fig.75 **Cat.10**

Fig.77 **Cat.11**

Charles Robert Ashbee (1863-1942) and the Guild of Handicraft

Furniture-making was only one among the many activities of the Guild of Handicraft, the history of which is described in some detail in the introductory chapters. Given the co-operative nature of the group, it is not surprising that the furniture reflects the range of these crafts, and often incorporates decorative metalwork, carving and embossed leather.

Most of the furniture was designed by C. R. Ashbee, but the Guild executed work by Baillie Scott, and its catalogues also include pieces by F. C. Eden, a fellow pupil with Ashbee in the office of the architect G. F. Bodley. In the beginning, the influence of historic furniture can be easily identified from ball and claw feet, frame and panel construction and the occasional historic form, such as the convertible chair/table or the 'Cromwellian' chair with leather seat and back. Mostly it was joiner made, in timbers such as oak, walnut and basswood, which were sometimes stained a pale olivey-green. Painted decoration and coloured gesso were also favoured.

In the mid 1890s, the Guild took on more cabinet-makers and at the 1896 Arts and Crafts exhibition showed five pieces of furniture, including a very plain music cabinet which represented a new direction for Ashbee. The cabinet in the Museum's collection (Cat.13) is an elaborate reworking of the form of this. Collaboration with Baillie Scott on furnishings for the Grand Duke of Hesse resulted in changes in the work of both men, and Ashbee's furniture became more rectangular both in shape and in construction techniques. His earlier, almost Art Nouveau, decorative carvings and inlays were replaced by linear motifs so highly stylised that it is difficult to interpret them as flowers and foliage (see Cat.15).

As well as the sumptuous cabinets and magnificent piano cases made by the Guild, a range of much plainer furniture was also produced, sometimes with carved decoration, usually with hand-made handles, but generally very close in style and price to commercial work of the period by Heal or Liberty. Little, if any, work of this type has found its way into museum collections but surviving catalogues of the Guild give an idea of the range (Fig.79).

For a full discussion of the Guild's furniture, see Alan Crawford's *C. R. Ashbee: Architect, Designer and Romantic Socialist*, London 1985, chapter 11.

Fig.78 *From a collection of pieces of inlay in wood and metal by the Guild of Handicraft, about 1900-8.*

Fig.79 *Illustration from a Guild of Handicraft catalogue of about 1905. One of the more ordinary products of the workshop.*

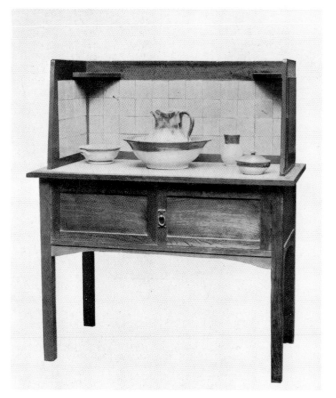

Fig.80 *C. R. Ashbee, photographed by Frank Lloyd Wright in 1910.*

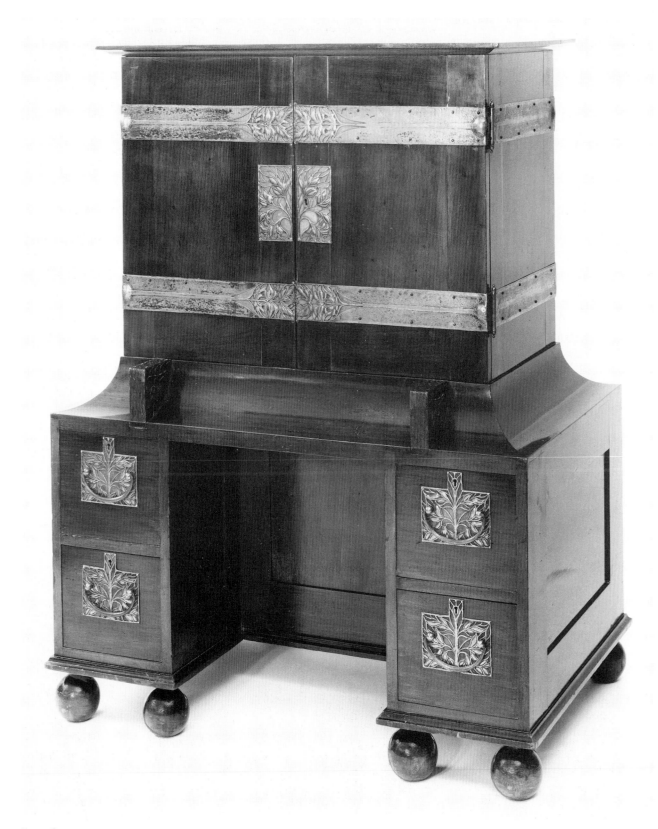

Fig.81 **Cat.13**

13* Writing cabinet

Designed by C.R. Ashbee and made in the Guild of Handicraft workshop in London by Tom Jeliffe, W. Stevens and Jim Pyment, with metalwork by William White and Jack Baily, in about 1898-9.

Mahogany with interior fittings of holly inlaid with carved and coloured mahogany, now faded. The drawer linings are probably of holly. Hinges and external handles of a metal alloy, and internal handles and lock-plates of silvered metal. Buff leather under pierced hinges and handles and also on the writing flap. The construction is of frame and panel type.

Inside are three sets of two doors, of which the central pair open on to three drawers. In the left cupboard is a flat board which draws forward and originally had a light fitting suspended from it.

$53\frac{1}{2} \times 41\frac{5}{8} \times 28\frac{1}{8}$ (1361 × 1058 × 715)

Purchased in 1984 from Fischer Fine Art Limited, London, for £50,000 with grants from the V&A Purchase Grant Fund (50 per cent), the National Art-Collections Fund, and two anonymous local charitable trusts. 1984.51

Record: Photograph at the Vienna Secession Exhibition in 1900, in 'The Studio', Vol.22, p.265.
CAGM, G. of H. catalogues.

Probably made as an exhibition piece, the cabinet was shown at the Arts and Crafts Exhibition Society in 1899,[1] and sent to Vienna for the eighth Secession Exhibition in 1900. Here it was given pride of place in the centre of the display. Bought by a Viennese family at or after the exhibition, it remained in their possession until purchased by Fischer.

In *Craftsmanship in Competitive Industry*, Ashbee illustrated this piece and stated that it represented about three months' work for a skilled maker at a wage of £2. 10s per week.[2]

Like other cabinets by the Guild, it gives a contrast between the dark exterior and the lighter and highly decorated inside. It also displays the range of crafts the Guild could offer, with its carving, inlaying, pierced metalwork and sophisticated cabinet-work. From the point of view of design, this combination may be considered to have been overdone, since the inner metal drawer fittings interfere with the pattern of the inlaid work. Ashbee abandoned the type of carved inlay on the inner doors after producing two cabinets in 1899 with this decoration.

The form is related to a music cabinet by Ashbee of about 1896,[3] and the overall proportions and the heavy ball feet were probably inspired by late seventeenth-century pieces.[4] Alan Crawford regards this cabinet as evidence of Ashbee's increasing sureness as a designer of furniture at this date.

See Col. Figs 54, 55.

1. V&A AAD 1/90-1980, cat.235.
2. p.30.
3. Illustrated by A. Crawford, *C.R. Ashbee: Architect, Designer & Romantic Socialist*, London 1985, p.283, pl.139.
4. For example, see V. Chinnery, *Oak Furniture: the British Tradition*, Woodbridge 1979, p.375.

14 Clock

Designed by C.R. Ashbee and probably made by the Guild of Handicraft in London, about 1901.

Oak with veneers of beech, ebony and elm, with some green stain. The clock face is framed in brass.
Inscribed inside door at back
pty cl. 2/08 Pt 5288 106 DG 6883
15-6
and 101 28P

$11\frac{1}{8} \times 7\frac{7}{8} \times 5\frac{3}{8}$ (283 × 200 × 136)

Given in 1983 by Mrs Anne Hull Grundy. 1983.193

Nothing is known of the provenance of this piece. Mrs Hull Grundy frequently purchased items for the Museum at auction or from dealers and rarely sent any information about this.

Fig.82 Cat.14

An almost identical clock was shown by Wylie and Lochhead at the Glasgow Exhibition of 1901 and was illustrated in *The Studio*.[1] Although it is possible that Wylie and Lochhead had the clock made in its own workshops, it seems more likely that it was retailing the Guild's work.

Ashbee seems to have adapted the shape from similar pieces designed by Voysey in about 1895.[2] The decorative motif of a galleon in full sail was one of Ashbee's favourite symbols, representing the 'craft of the guild'.

1. Vol.23, 1901, p.170.
2. See D. Simpson, *C.F.A. Voysey: An Architect of Individuality*, London 1979, p.57.

15 Writing cabinet

Designed by C.R. Ashbee and made by the Guild of Handicraft in about 1901-2. The makers were probably Tom Jeliffe and E. Johnson (or Jackson), with metalwork by Bill Thornton and Fred Brown.

Veneered in ebony and holly on a carcase of mahogany, with carved oak feet painted red, and wrought iron fittings. Drawers of pencil cedar. Interior drawer handles silver-plated, and placed over red morocco. The panelled appearance is anomalous since the piece is veneered.

Inside the cabinet are six short drawers flanked by two small cupboards, above two sets of four pigeon holes above two trays for stamps and so on. The writing flap, which is part of the upper section, comes forward when the handles on the base are pulled.

Each door is attached by two large hinges and has a drop handle on a rectangular plate. A long carrying handle is attached to each side and inside the cabinet are two candle holders with protective caps above.

Damage caused by wear and tear has been repaired in the Museum, and a split across the writing surface has been reglued. A small silver knob on the left door inside has been replaced. The interior was probably originally fitted with two Powell glass inkwells mounted in silver with chrysoprase.

Marked with pencilled numbers 1-6 on the backs of the drawers and the rails below the drawers.

$53\frac{1}{8} \times 42\frac{3}{4} \times 21\frac{3}{4}$ (1350 × 1084 × 551)

Purchased 10.12.1981 at Sotheby's Belgravia, Lot 200, for £32,400 with grants from the V&A Purchase Grant Fund, the National Art-Collections Fund, the National Heritage Memorial Fund, the William A. Cadbury

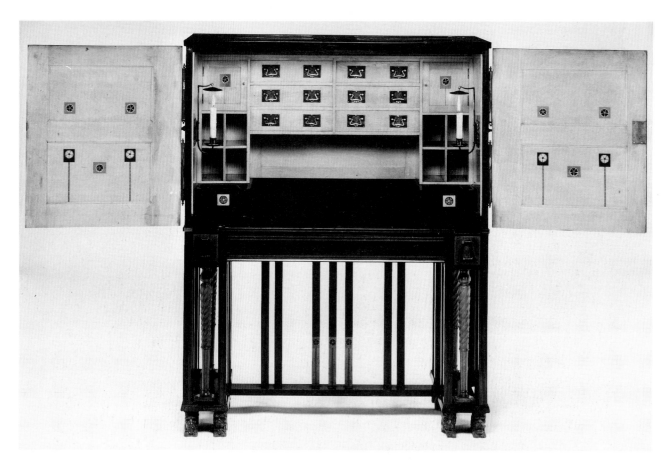

Fig.83 **Cat.15** *Writing cabinet by C. R. Ashbee and the Guild of Handicraft, about 1901-2, with open doors.*
Fig.84 **Cat.15** *Detail inside the cabinet.*

Charitable Trust and two other charitable trusts. Funds from the Captain Wild and Leslie Young Bequests were also used.
1982.194

Record: V&A AAD 1/99-1980, Cat.395.
Jagger Library, University of Cape Town, letter from secretary of Guild of Handicraft to Mr F. Masey, 21.8.1903.
V&A, Photograph of drawing room at Mrs Ashbee's house, 37 Cheyne Walk, London.

This cabinet was first exhibited at the Woodbury Gallery, London, in the autumn of 1902, but its actual date of making, and whether it was executed in London or in the new workshops at Chipping Campden, is not known. In the catalogue of the Arts and Crafts Exhibition of 1903 it was attributed to the makers named above. It was probably intended as an exhibition piece and was housed in the drawing room of Mrs H.S.Ashbee at 37 Cheyne Walk in London.[1] A letter from the Guild's Secretary to Mr Masey in South Africa appears to be about this piece, offering it

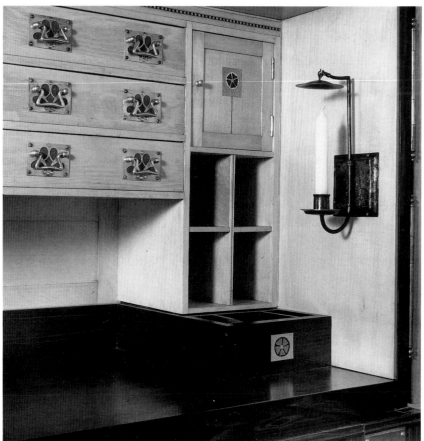

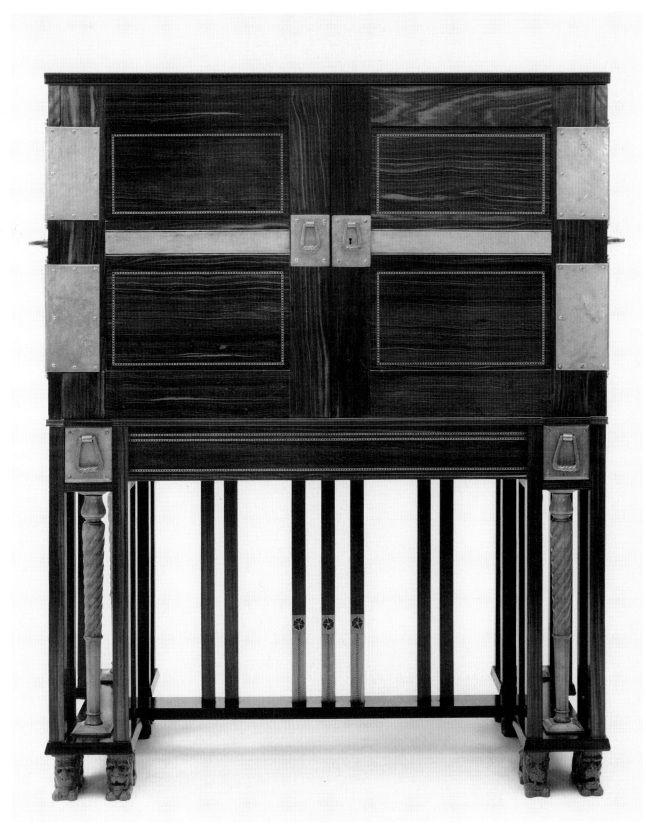

Fig.85 **Cat.15**

for sale in 1903 at £80. But it seems that it remained unsold when the Guild of Handicraft Limited went into liquidation in 1908 and that it was then purchased, or accepted in lieu of debts, by Rob Martin Holland, a banker who had been the main backer of the Guild for many years and whose family came from Overbury Court, Tewkesbury, Gloucestershire. The subsequent history is obscure but it was apparently bought at a sale in the 1940s of the effects of another member of the Holland family and sold by an antique dealer, Rainbows of High Street, Stourbridge in about 1952 to Arthur Moore of Great Witley. Mr Moore owned a garage and the cabinet was kept there, since his wife did not like it. It was subsequently given to a local policeman.

Based on the Spanish *vargueno* (see Fig.86), this type of elaborately decorated cabinet on an openwork stand was popular with Arts and Crafts designers, giving an opportunity for the display of fine craftwork. The element of surprise as the relatively sombre piece is opened to reveal the bright and decorated interior was something Ashbee particularly enjoyed.

The design is also indebted to Baillie Scott's rethinking of the piano and production of the 'Manxman' upright from 1896. The Guild of Handicraft worked with Baillie Scott on the interiors for the Grand Duke of Hesse at Darmstadt in 1897 and this experience had a stimulating effect on Ashbee's furniture. Ashbee himself designed at least one Manxman type of piano himself in 1900. Alan Crawford gives a very full account of the complexities of the design and construction of this cabinet.[2] An undated design for a similar piece is in the collection of Ashbee designs at Chelsea Public Library.[3]

Fig.86 *'Vargueno' cabinet of carved walnut, Spanish, seventeenth century, in the V&A collections.*

1. A. Crawford, *C. R. Ashbee: Architect, Designer and Romantic Socialist*, London 1985, p.73.
2. pp.291-4.
3. Chelsea Public Library, Ashbee designs, p.60.

Mackay Hugh Baillie Scott
(1865-1945)

One of the most prolific and successful of Arts and Crafts architects, Baillie Scott trained with the reputedly incompetent Major Charles Davis, City Architect in Bath, and then moved to the Isle of Man in 1889. He became well known for his suburban houses in red brick or stucco, and for the highly decorated interior designs, which were rarely executed as planned but made attractive illustrations in books and magazines. He emphasised the cosiness of inglenook and settle, and often designed houses with a large communal space based on the notion of the 'house-place', or hall. Some of his earliest ideas for furniture were the result of designing such complete schemes, and in 1897 he published an article in *The Studio* 'On the Choice of Simple Furniture',[1] illustrated with numerous line drawings. In this he explained the advantages of fixed furniture and of simplicity, with the observation that 'many people appear to imagine that they cannot afford to have artistic surroundings, whereas the wonder is that they can afford so much expensive ugliness'.[2]

In this same year, Scott received a commission from the Grand Duke of Hesse for the decoration of his palace at Darmstadt, most of which was executed by the Guild of Handicraft. Scott's work was much appreciated in Europe and he had commissions for complete houses and for furniture and interior schemes in Romania and Switzerland.

From 1898, John P. White made furniture to Baillie Scott's design at the Pyghtle Works in Bedford, and in 1901 Scott moved to Bedford, presumably in order to supervise the work more conveniently. A catalogue produced by White in 1901 contains some highly decorated and ebullient examples of Scott's most ornate style, and also the more restrained pieces, such as the settle in this collection, in oak with inlay of formalised plant and flower motifs. The intro-

Fig.87 'Hall in an Artist's House' by M. H. Baillie Scott, from 'The Studio', 1897.

duction to White's catalogue states that the items included are the nucleus of a stock range, and that special designs could be prepared for those who wanted something different, such as a particular flower as the leading motif in a room.

Little work has been done on the firm at Bedford, which also produced garden furniture to designs by C. H. B. Quennell and others, and chimneypieces by Quennell, Voysey and Jack. The catalogue of Baillie Scott's designs is hard to find in libraries, and although several items have come up for sale in recent years, there seems to be little in public collections. It would be interesting to know more about J. P. White and his business. The use of the distinctive brand suggests a well-organised commercial operation, as does the extensive catalogue.

Baillie Scott's architectural practice flourished until well into the 1920s, when most of the other Arts and Crafts pioneers were short of clients, and he retired in 1939.

1. Vol.10, pp.152-7.
2. p.153.

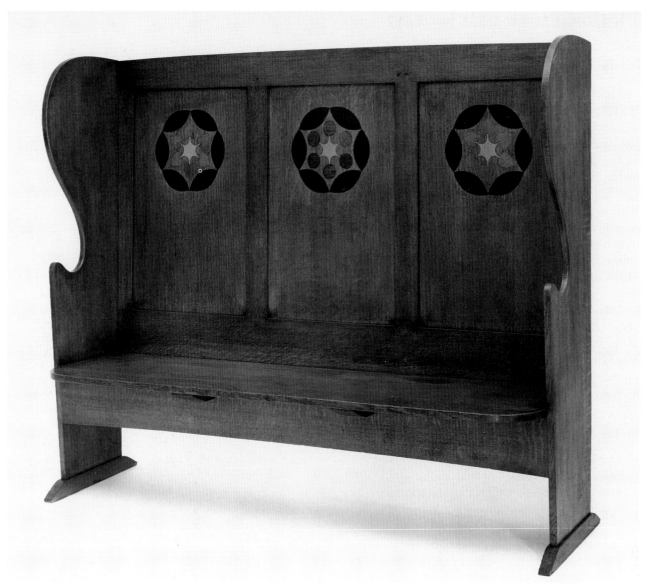

Fig.88 **Cat.16**

16 Settle

Designed by M.H. Baillie Scott and made at J.P. White's Pyghtle Works in Bedford in 1901.

Oak with inlay of macassar ebony, cherry, chestnut and pewter.
 Branded on the frame at the back (Fig.21).

$53\frac{7}{8} \times 66\frac{1}{2} \times 21$; h. of seat $16\frac{1}{8}$
$(1368 \times 1689 \times 534$; h. of seat 410)

Purchased in 1987 from the Fine Art Society, London, for £12,000 with a 50 per cent grant from the V&A Purchase Grant Fund. 1987.545

Record: 'Furniture Made at the Pyghtle Works Bedford by John P. White Designed by M.H. Baillie Scott', No.2.

The provenance of this piece is not known, except that it was in a West Country collection. An identical one is illustrated in J.P. White's publication, priced at £10. 10. 0. Another version of the design is also known, with a hinged seat and storage space, more elaborate inlay and different feet. This appeared in a Wylie and Lochhead catalogue of about 1902, and presumably most of the furniture from the Pyghtle Works was sold through such large retailers.[1]

Arts and Crafts architects and designers particularly liked the settle as a type of furniture, for its associations with a vanishing past.[2] Baillie Scott designed many, both as free-standing pieces and as built-in fittings. The form of this settle is comparable to one illustrated by W.R. Lethaby in his chapter on 'Cabinet Making' in *Plain Handicrafts*[3] of 1892. See Fig.32.

1. See G. & C. Larner, *The Glasgow Style*, London 1980, pl.7.
2. For a fascinating account of the interest in the settle as a type, see M. Harper, 'Here's to the Ingle where True Hearts Mingle: The Revival of the Settle and Inglenook by Nineteenth-Century English Architects', *Journal of the Decorative Arts Society*, No.12, 1988, pp.10-17.
3. A.H. Mackmurdo (ed), London.

Philip Clissett (1817-1913)

Neither Philip Clissett nor James Maclaren (1853-90) was strictly a part of the Arts and Crafts Movement, but Clissett's traditional chairs, as amended by the Scottish architect, were highly influential. They were seen by almost everybody involved in art and design from the late 1880s, because they were used in the hall of the Art Workers' Guild, and in later years they were sold at Heal's. In addition, many of the furniture designers of the Movement made their own versions of the rush-seated ladderback chair, including Gimson, Ashbee, Heal and Russell. Even Voysey, whose own chair designs were made by cabinet-makers rather than turners, had some turned ladderback chairs in his dining room at The Orchard.[1]

The design of the 'Clissett' chair was a traditional one, handed down through generations of anonymous craftsmen in the West Midlands and made for a local market. It seems that Maclaren met Clissett in about 1886 when he was making additions to a house at Ledbury for the MP and banker, Michael Biddulph. He suggested some changes to Clissett's usual spindle-backed model, making it rather more like chairs by the Kerry family of Evesham in Worcestershire.[2] The success of the new chair, at a higher price than the old, resulted partly from its wide exposure through the Art Workers' Guild and partly from the romantic idea of the long-lived Clissett, singing as he worked.[3]

1. Illustrated in C.Holme (ed), *Modern British Domestic Architecture and Decoration*, The Studio Special Number, London 1901, pp.184, 189.
2. See B.D.Cotton, *The English Regional Chair*, Woodbridge 1990, pp.288-301.
3. Edward Gardiner quoted in M.Comino, *Gimson and the Barnsleys: 'Wonderful furniture of a commonplace kind'*, London 1980, p.43.

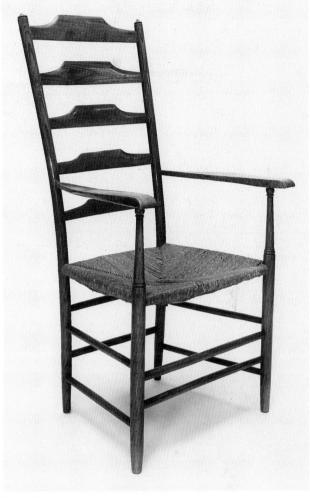

Fig.89 **Cat.17**

17 Armchair

Traditional design, probably refined by James Maclaren and made by Philip Clissett, about 1890-1913.

Ash with a rush seat. Uprights and stretchers turned; splats, arms and seat rails shaped with a draw knife.

$45 \times 23 \times 19\frac{1}{4}$; h. of seat $17\frac{1}{4}$
($1143 \times 584 \times 489$; h. of seat 438)

Purchased in 1953 for £4.10.0 from the Thomas Bequest. 1953.33

Bought from Freda Derrick who acquired it at the sale in Sapperton of the effects of Ernest Barnsley's widow, Alice, held by Ovens and Sons, Cirencester, 18.9.52. It was lot 137 and cost £4.10.0.

In an article in the *Illustrated Carpenter and Builder*[1] Derrick illustrated this chair and described how she had bought it by mistake at the auction.

Freda Derrick was an early enthusiast for the work of William Morris and the Arts and Crafts Movement and did much cycling around the Cotswolds in the 1930s and 1940s in search of information, making evocative sketches of features which caught her eye. Many of these were published in a series of articles she wrote for the *Illustrated Carpenter and Builder* and in several books, among them *Country Craftsmen* in 1945, *Cotswold Stone*, 1948, and *A Trinity of Craftsmen*, 1950. Derrick's particular interest was in the traditional skills of the countryside and she saw her work as her contribution to the cause of keeping such crafts alive and vital in the twentieth century.[2] She also illustrated children's

books and the Museum has a collection of her work.[3]

Ernest Barnsley could have acquired the chair at almost any time from around 1890 until Clissett's death in 1913. Photographs of the Kenton and Company exhibition at Barnard's Inn in 1891 show such chairs, and it seems likely that these are by Clissett because they are very different from the examples known to be by Gimson (see Cat.20).[4] Clissett's armchairs are said to have cost between 8s 6d and 10s 6d.

1. 17.9.54, p.2555.
2. F.Derrick, *A Trinity of Craftsmen*, London 1950, p.ix.
3. CAGM 1969.211.
4. Exhibition photographs reproduced in M.Comino, *Gimson and the Barnsleys: 'Wonderful furniture of a commonplace kind'*, London 1980, pp.56, 60.

William R. Lethaby (1857-1931)

Lethaby is known today primarily for his small number of architectural gems, such as the Church of All Saints at Brockhampton in Herefordshire, and for his dedicated work in the cause of art education. He also made an important contribution to Arts and Crafts furniture design, however, both through the example of his executed work and through his expressions of theory.

After training in Barnstaple, Lethaby worked in the Midlands and then joined the office of Norman Shaw, where he met Sidney Barnsley, and through him, Ernest Gimson. The short history of Kenton & Company is described above (p.30). In its two years of existence, it produced a remarkable number and range of pieces, and many of the distinctive features of the work of the Cotswold group originated in this London firm, and with Lethaby. His traditional oak chests with inlays of ships and sheep (some private joke?) have corners joined with cogged dovetails forming a decorative pattern; and his Bishop's chair is lightly chamfered on the back with more dramatic cuts on the stiles, to catch the light. Later work by Lethaby includes bold dark and light inlays, which must have influenced Heal, and inlaid dots, such as Gimson also used (see Cat.24).

Lethaby and Gimson clearly collaborated very closely, but Lethaby's furniture has an assured character of its own, which derives partly from his frequent use of flat expanses of thick plain oak, often scrubbed to give a pale silky finish.

Fig.90 **Cat.18**

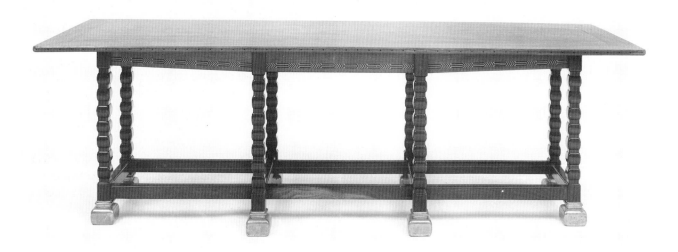

18 Hall table

Designed by W.R.Lethaby in about 1892-6 and possibly made by Farmer and Brindley, London.

Mahogany with inlay of ebony and holly, and feet of brass. The top is of framed construction.

$29\frac{5}{8} \times 96 \times 30\frac{7}{8}$ (752 × 2438 × 784)

Purchased in 1987 from the Fine Art Society, London for £26,000 with grants from the V&A Purchase Grant Fund (50 per cent) and the Eugene Cremetti Fund of the National Art-Collections Fund. 1987.544

Design: A. B. Waters collection (photograph in CAGM file).

Record: CAGM, photograph of interior at Avon Tyrrell (Fig.24).

Commissioned by Lord Manners for the hall at Avon Tyrrell, near Ringwood, Hampshire, Lethaby's first major building project. Planning started in 1890 and the house was completed by 1893. Writing to Lord Manners in 1890, Lethaby said, 'In the ground plan of the house, availing myself of your suggestion to take the Hall through from front to back, I have planned a long and somewhat narrow hall, the part where you enter being cut off from the rest by a screen like an old hall.'[1] The long and narrow table was clearly designed to suit the space.

Since it is not marked with the stamp of Kenton & Company, it seems likely that the table was made after the demise of the

Other pieces were made of mahogany and have a rich urbane presence, which also comes through in some of Gimson's early work (Cat.19). Although they remained friends for life, Lethaby and Gimson later disagreed about the way forward for furniture design, and Lethaby became an important figure in the Design and Industries Association, promoting the idea of using machines to provide well-designed work at lower prices.

Apart from the Kenton & Company episode, Lethaby's furniture was usually designed for specific architectural projects and was made by numerous cabinet-makers, mainly in London, but also including Marsh, Jones and Cribb of Leeds.

firm in 1892. It is quite possible that it was executed by one of the craftsmen who had been employed by Kenton & Co, though Lethaby also had established working relationships with a number of other furniture makers, and showed a piece at the 1890 Arts and Crafts Exhibition made by Marsh, Jones and Cribb of Leeds. In *The Studio* of 1897, however, there is an illustration of another table by Lethaby with a marble top, X-framed stretchers, and with the same unusual brass feet. The caption on this, and the catalogue description from the 1896 Arts and Crafts Exhibition,[2] indicate that it was made by Messrs Farmer and Brindley. Several other photographs in the same article show marble fireplaces by this firm, and it is possible that they only supplied the marble for the table top.

The comments of *The Studio*'s writer on this marble-topped table could almost be applied to the one in Cheltenham: '… the very beautiful table with cipollino marble top … shows how rarely Mr Lethaby fails to secure a certain reticent splendour which is equivalent to suppressed emotion in design'.[3]

See Fig.24.

1. Quoted by G.Rubens, *William Richard Lethaby: His Life and Work 1857-1931*, London 1986, p.113.
2. V&A AAD 1/82-1980, cat.181.
3. Vol.9, p.199.

Ernest Gimson (1864-1919) and Ernest and Sidney Barnsley (1863-1926 and 1865-1926)

Of the many Arts and Crafts designers who involved themselves with furniture making, Ernest Gimson and Sidney Barnsley were probably the most dedicated and consistently productive, and their work laid the foundations for others to build on in the twentieth century. It was an influence for handworkers in small workshops using similar methods of production, and also for larger concerns, such as Heal's or Gordon Russell's firm.

The history of the group and the development of their style has been described in some detail above (pp.29-37). They evolved a range of forms suited to different ways of life, from simple chests built of planks to highly sophisticated cabinets with exotic veneers and inlays. They favoured native woods, but did not employ these exclusively, and their work always shows their knowledge of woodworking techniques, derived from cabinet-making and from rural crafts, such as wheelwrighting. Because of this deep appreciation of skill, their pieces were almost entirely made by hand. Gimson's objections to Lethaby's request for designs suitable for machine production were that such a scheme could destroy the market for his work and make it impossible for him to carry on employing people to do skilled work of this nature, a task he felt was valuable. Interviews conducted in the 1950s and later with craftsmen who had worked at Sapperton indicate that they appreciated the opportunity to do quality work.[1]

Sidney Barnsley generally worked alone. Because he had little need for paperwork, there are few records of his production, but the Museum has a collection of his drawings.[2] There are some differences between his furniture and Gimson's, mainly in the arrangement of proportion and in small details, such as the lines of decorative gouged carving, which are more immediate and less perfect in Barnsley's pieces (see Cats 29 and 38). In addition, where Gimson enjoyed inlays of natural forms, such as flowers and leaves, Barnsley's decoration was often of geometric shapes. There is much work still to be done on differences of technique in the making of structural elements and drawers and so on, which would help with the separation of work by the different members of the group.

Ernest Barnsley designed little furniture after about 1905, and it is difficult to assess his contribution before this because the known drawings from the period of his partnership with Gimson are all by Gimson. In the Museum is a collection of over 700 of his designs, as well as sketchbooks, photographs and a workshop job book. Unfortunately, this fascinating document, an essential record for a business employing a number of people, covers only the years 1914-19, but it is an invaluable source of information about

Fig.91 *Ernest Gimson.*

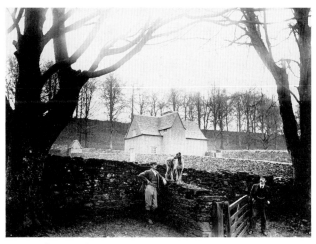

Fig.92 *Sidney Barnsley (centre) and an unknown man, about 1900-2.*

makers, clients, time spent and prices charged, cost of materials and so on.[3] (Fig.112).

The Museum is fortunate in having a fairly representative selection of the work of this group of designers.

1. CAGM Burrough Collection 1986. 1245.6, and EBET Donnellan interview.
2. Some given by and some purchased from Edward Barnsley, see A.Car-ruthers, *Gimson and Barnsley: Designs and Drawings in Cheltenham Art Gallery and Museums,* Cheltenham 1984, p.5.
3. Acquired by the Museum in 1941 from the executors of Mrs Emily Gimson, see A.Carruthers, ibid, p.4.

19 Two chairs (from a set of six)

Designed by Ernest Gimson and made at Kenton & Co, London, by Bowen in about 1891.

Mahogany with French polish. Drop-in rush seat. The seat rails have no corner blocks.

Stamped inside the back rail (Fig.18). One marked III and one IIII inside the seat rail and on the underside of the seat.

$39\frac{1}{8} \times 20 \times 19\frac{3}{8}$; h. of seat 18
($993 \times 506 \times 492$; h. of seat 457)

Purchased in 1986 for £2000 with a 50 per cent grant from the V&A Purchase Grant Fund. 1986.1135

Record: CAGM 1941.226.232.62 Photograph of Kenton & Co exhibition, 1891.

The chairs were inherited by the vendor from Margaret Gimson, Ernest's sister. She probably had them from her mother, though it is just possible that she bought them herself from the Kenton & Co exhibition. She was only twenty in 1891, so it is more likely that Mrs Gimson or her eldest daughter, Sarah, purchased the chairs to encourage Ernest.

They were 'town chairs' and were used in the Gimsons' town house in New Walk, Leicester, and only moved to Margaret Gimson's country cottage, Rockyfield, shortly before she died in 1967. This was the house she commissioned from Gimson in 1908 and used as a summer residence only, until the 1950s when it was modified for round-the-year living. Margaret Gimson also involved herself in her brother's work by executing his embroidery designs, and several examples are in the collections at Leicestershire Museums. She was an energetic woman, one of the first in Leicestershire to ride a bicycle, and later well known as the Secretary of the Local Charities Association and of the Literary and Philosophical Society.

A photograph in Gimson's own collection shows a chair which was almost certainly from this set, at the Barnard's Inn exhibition of December 1891, with an inscription '6 Mahogany Chairs £15. 15' (Fig.94). The use of wavy lines and rich dark mahogany is much closer to Lethaby's work than Gimson's later designs.

The rest of the set of six are in the Holburne Museum at Bath and in the V&A.

See Fig.18.

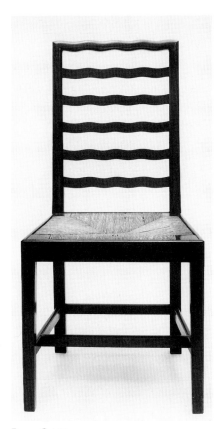

Fig.93 **Cat.19**

Fig.94 *A few items in the Kenton & Co exhibition at Barnard's Inn, 1891 (see Cat.19).*

20 Armchair

Designed and made by Ernest Gimson in about 1895.

Ash, turned on a lathe, with splats of riven ash shaped by a draw knife. The seat is of woven willow. The chair frame and seat have been attacked by woodworm and are extremely fragile.

$48\frac{3}{8} \times 22 \times 21$; h. of seat 18
(1235 × 558 × 533; h. of seat 458)

Purchased in 1971 from Edward Barnsley for £50 with a 50 per cent grant from the V&A Purchase Grant Fund. 1971.49

Design: CAGM 1971.61.2 (undated) and 13 (dated 6.4.04).

Record: EBET Probate of household furniture etc of Sidney H. Barnsley, 23.10.1926, 'Workshop', 'Ash elbow chair'.

According to Edward Barnsley, the chair was given by Gimson to Sidney and Lucy Barnsley as a wedding present (though he was not positive about this) and was later used in Sidney's workshop. 'It was always in the workshop at Sapperton, and several times during a working day my father would knock off and roll one of his untidy cigarettes, and smoke it in peace.'[1]

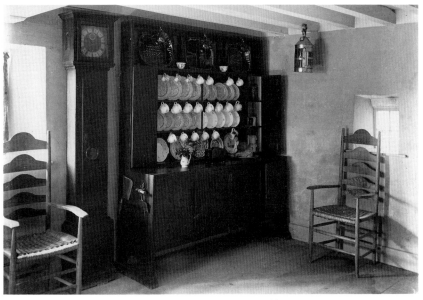

Fig.95 *Interior in Gimson's cottage at Pinbury, late 1890s, with chairs like Cat.20.*

Gimson probably worked from sketches and templates when he was making the turned chairs himself, but he had to produce detailed drawings when he handed over the work to Edward Gardiner in 1903-4, so the surviving drawings are unlikely to be the first versions of the design.

It is usual for chairs of this type to have curved back poles, slightly bent by steaming. Although the finished chairs are more stable in use with curved backs, and Gimson was presumably shown how to do this by Clissett, he seems usually to have left them straight, as can be seen in the photograph of the Pinbury workshop

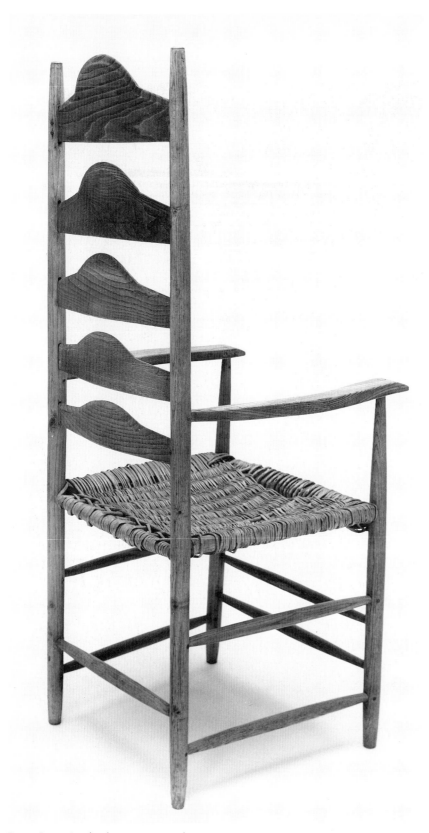

Fig.96 **Cat.20** *Armchair by Ernest Gimson, about 1895.*

(Fig.33). Edward Gardiner later said that he did not consider Mr Gimson to be very good at chair making,[2] and Gardiner's chairs have a more finished, less immediate, feel to them.

The woven willow seems to have been experimental during the early years in Gloucestershire. A photograph of an interior at Pinbury shows several chairs similarly seated, so this is not an isolated example (Fig.95).

For full instructions on how to make this chair, see an article by Vic Taylor in *Woodworker*, October 1983.[3]

1. CAGM, Edward Barnsley to Harold G.Fletcher 7.4.71.
2. CAGM 1986.1245.6, account of an interview with John Gregory, April 1954.
3. 'A ladderback by Gimson', pp.603-4.

21 Dresser

Designed by Ernest Gimson and made at Daneway, about 1902-5.

English oak, stained black, with oak drawer sides and linings. Brass hinges and lock, and steel sprung-ball fasteners on doors. The top section is separate from the base.

Dovetails, tenons and dowels are exposed and the dovetails on the drawers are narrower than usual on Gimson-Barnsley furniture. The drawer stops are made from the tenons of stiles rising through the rails. The stain is unusual in Gimson's furniture other than on the turned chairs, and has worn off on the front and handles.

$66\frac{1}{8} \times 55\frac{1}{4} \times 25$ (1679 × 1403 × 633)

Bequeathed in 1962 by Mrs Mary Agnes Herdman. 1962.114

Design: CAGM 1941.222.280 'Wash Stand in English Oak', signed and dated 'B&G May 17 1902'.[1] See also 1941.222.279 'English oak sideboard and washhand stand' for variations.

Record: CAGM photograph 1941.226.232.30, showroom at Daneway House in about 1902-7.

Purchased by D.W.Herdman at the sale of Mrs Gimson's effects, Hobbs and Chambers, Cirencester 20.3.1941, lot 17 for £7, and left to the Museum by Herdman's widow.

The sale catalogue shows that this was the Gimsons' kitchen dresser and that there was another in the living room. Like the settle, the dresser was a type of piece much loved by Arts and Crafts designers for its homely associations, and Gimson and the

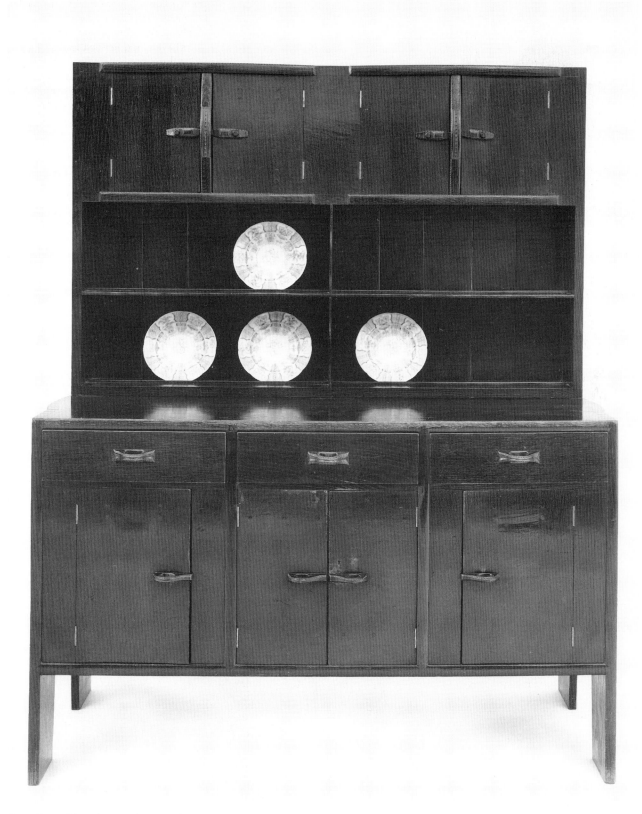

Fig.97 **Cat.21** *The mid nineteenth-century plates
are from the Museum's collection.*

Barnsleys designed many different versions. These ranged from extremely simple pieces in cheap timbers such as chestnut, to massive dressers of two-inch-thick oak. Some were intended for everyday use in the kitchen, while others could equally be described as sideboards and were for use in the living or dining room.

The design shows some variations in the handles and decoration but is essentially the same piece. Although signed 'B&G', it is clearly by Gimson.

One of the several photographs of the showroom at Daneway House shows a similar piece with a larger superstructure and different handles. This photograph is inscribed on the back 'Sideboard in Darkened Oak £21 4'6" wide'.

1. Illustrated in M. Comino, *Gimson and the Barnsleys: 'Wonderful furniture of a commonplace kind'*, London 1980, p.104, Fig.67.

22 Armchair

Designed by Ernest Gimson in about 1904 and made by him or by Edward Gardiner, probably 1904 - 10.

Yew with a rush seat.

$49\frac{3}{8} \times 22\frac{1}{4} \times 20$; h. of seat $18\frac{1}{2}$
($1254 \times 563 \times 508$; h. of seat 470)

Purchased in 1941 at the sale of Mrs Emily Gimson's effects, for £4 from the Friends Fund. 1941.41

Design: CAGM 1941.222.184, signed but undated.

Record: Sale catalogue of Hobbs and Chambers, Cirencester, 20.3.1941, lot 214.

The catalogue of 1941 indicates that the chair was in a bedroom at this date.

Edward Barnsley in a letter said that Robert Weir Schultz started Gimson off on bobbin-turned chairs.[1] A similar chair in the V&A has turned arms instead of the flat ones seen here.[2]

1. EBET, Edward Barnsley to B. G. Burrough 22.12.70.
2. V&A Circ.231 - 1960.

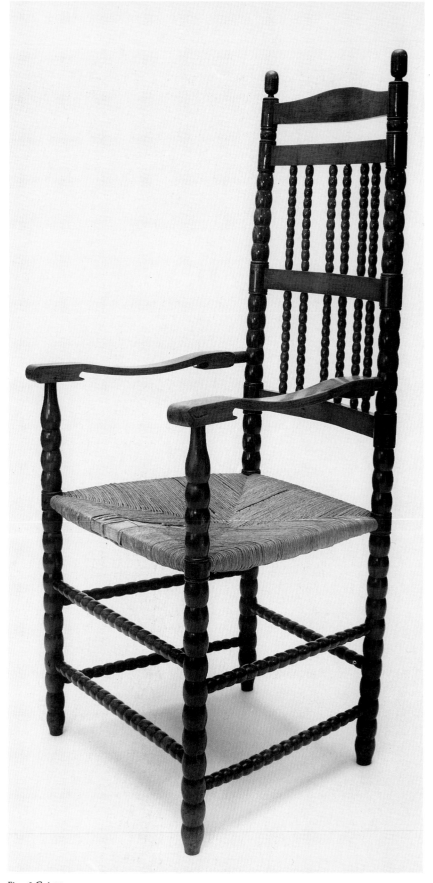

Fig.98 **Cat.22**

23 Armchair

Designed by Ernest Gimson after Philip Clissett in about 1904 and made by Edward Gardiner, probably in the 1920s.

Yew with rush seat. Turned and pegged construction with scored lines to indicate the position of the joints.

$34\frac{5}{8} \times 24\frac{1}{8} \times 18\frac{7}{8}$; h. of seat $17\frac{1}{2}$
$(880 \times 612 \times 480$; h. of seat $445)$

Given in 1984 by the Gordon Russell Trust, see pp.145-6. 1984.144

Bought by Gordon Russell as part of a set of seven or eight and used at his house, Kingcombe, near Chipping Campden, Gloucestershire, in the dining room, the office and the study. The date of purchase is not known but was presumably after the building of Kingcombe in 1925-6.

It is possible that the chairs were made at the Russell workshops by Ron Pepper rather than by Gardiner, though turned chairs made in Broadway were usually more ornate than this. The seats are in such good condition that the rushing might have been replaced, but others from the set in the collection of the Gordon Russell Trust have red tie-on pads, which must have protected them from wear.

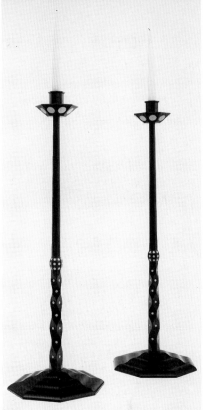

Fig.100 **Cat.24**

24 Pair of candlesticks

Designed by Ernest Gimson and made at Daneway, probably about 1905.

Macassar ebony inlaid with discs of bone.

$27\frac{1}{4} \times 8\frac{3}{4} \times 8\frac{1}{2}$ $(692 \times 222 \times 215)$

Purchased in 1983 from Paul Reeves, London, for £3850 with a 50 per cent grant from the V&A Purchase Grant Fund and a gift from an anonymous donor. 1983.211

Design: CAGM 1941.222.610, undated.

These items were formerly on loan to the Museum from someone who had purchased them from an antiques sale in Bristol, and nothing further is known of their history. In Gimson's workshop book in the Museum's collection, there is an entry for some ebony candlesticks made for M de Selincourt in 1917, but the book only covers 1914-19, and we do not have full evidence for the earlier period.

The form and decoration seem to be related to the lectern designed by Gimson for Roker Church in Sunderland in 1906,[1] and the candlesticks have been dated by comparison with this.

1. See M. Comino, *Gimson and the Barnsleys: 'Wonderful furniture of a commonplace kind'*, London 1980, p.178, Fig.140.

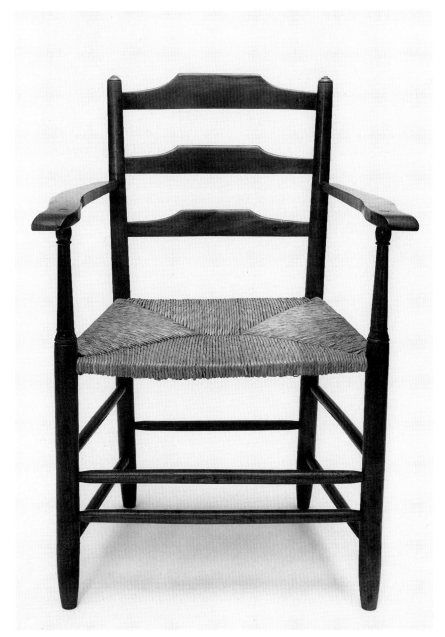

Fig.99 **Cat.23**

25* Cabinet of drawers

Designed by Ernest Gimson and made at Daneway by Ernest Smith, around 1903-7. Handles inside made by John Paul Cooper and outside by Alfred Bucknell.

Mahogany carcase veneered with ebony, walnut and holly. Inside of the doors veneered with quartered mahogany. Drawer fronts veneered with whitebeam and cupboard doors of solid mahogany. Exterior fittings of wrought steel and interior handles of silver.

The piece was badly damaged by a bomb blast in the Second World War and the small separate stand is not original. The table-type stand was beyond repair and was discarded, though a small part of a drawer survives, and a handle. During reconstruction some original material from the back was moved to the front, new doors were made for the interior cupboards, quartered mahogany was simulated by paint techniques for the inside of the right door, and the new stand was made. Missing areas were made up to match.

$14\frac{3}{8} \times 24\frac{7}{8} \times 11\frac{1}{4}$ (365 × 632 × 285)

Purchased in 1970 from Edward Barnsley for £50 with a 50 per cent grant from the V&A Purchase Grant Fund. 1970.213

Design: CAGM 1941.222.591, unsigned and undated on paper watermarked 1902.

Record: CAGM object file, photographs with inscriptions by EWG and SHB, 'Table Cabinet 2' × 1' £35'.
CAGM 1941.226.240, photograph with inscriptions by EWG.

Edward Barnsley was given this piece by Russell Gimson, in the hope that he would be able to repair the damage (Fig.102). Barnsley believed this was impossible and it was stored in an attic for a long time. It came to the Museum contained in a carrier bag and was reconstructed by Alan Morrall, the Senior Technical Officer.

From the inscriptions on the photographs in the Museum's files, it seems likely that the cabinet is the one shown at Debenham and Freebody in 1907, for sale at £28. 10. 0. This had a small base and handles on the sides, but it appears that a table stand was later made for it and the side handles removed, probably in an attempt to make it saleable. The prices given on the photographs are £35 on its own and £70 with the stand. The fact that Sidney Barnsley's writing is on these suggests that the cabinet was unsold at the time of Gimson's death, when several members of the family bought items from the executors.

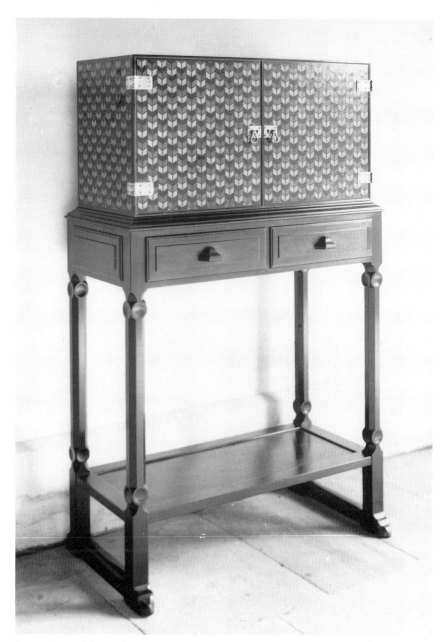

Fig.101 **Cat.25** *Cabinet of drawers on a stand now destroyed, from Gimson's photograph collection.*

The cabinet belongs in a series of elaborately decorated pieces beginning with a cabinet on stand made by Kenton & Co in 1890-1, which is now in the Musée d'Orsay in Paris.[1] Like Ashbee, Gimson was partly inspired by Spanish *varguenos* (see Fig.86) and the seventeenth-century type of spice cabinet with small drawers. Two boxes in the collections of Leicestershire Museums display similarities of shape and proportion, and all owe something of a debt to an Indian travelling box in the V&A, of which Gimson had a photograph (Fig.12).

In an interview, Ernest Smith remembered that he had to use veneers of slightly

Fig.102 **Cat.25** *The cabinet when it first arrived in the Museum.*

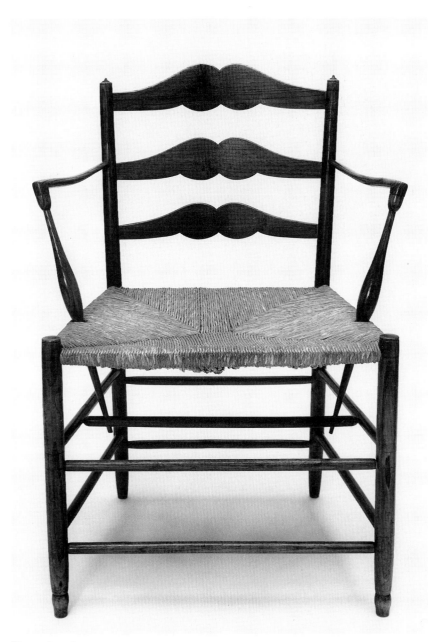

Fig.103 **Cat.26**

different thicknesses and he wanted to sand them off level but was not allowed, so each of the 500 to 600 pieces had to be cleaned of glue individually. Gimson explained to him that he had been to a castle where the floor had been partially repaired, beautifully level, but when the sun shone, the new area looked dead. The old part was worn and waving and looked beautiful, so he thought he would have these little bits of wood uneven to catch the light.²

See Col. Fig.57.

1. Illustrated in L. Lambourne, *Utopian Craftsmen*, London 1980, p.167.
2. EBET, Donnellan interview.

26 Two armchairs

Designed by Ernest Gimson in 1907 and made by Edward Gardiner in about 1907-30.

Ash and rush.

$35 \times 25\frac{3}{8} \times 18\frac{3}{8}$; h. of seat $17\frac{1}{2}$
($889 \times 645 \times 467$; h. of seat 444)

Given in 1988 by Mr John Crowder. 1988.336

Design: CAGM 1971.61.7 signed and dated Aug 8 1907.

These chairs belonged to the donor's father-in-law, B.J. Fletcher, Head Master at

the Leicester School of Art and then at the Birmingham Municipal School of Art. Fletcher is known for the designs he made for Harry Peach of Dryad (see Cat.43) and for his espousal of Arts and Crafts ideals. He lived at Daneway House for some years and acquired these chairs after the death of Squire James of Edgeworth, who presumably bought them direct from Gimson or from Gardiner.

This design was used for the platform chairs for a church hall at Wootton Fitzpaine in Devon which was commissioned from F.W. Troup by a Mrs Pass, and it is known as the 'Pass' chair. A high-backed version was made as the Chairman's chair. The platform chairs cost 25s each.

The shapely form of the splat is one also found in French country chairs.

27 Coffer

Designed by Ernest Gimson and made at Daneway, probably about 1910. Decorated with plasterwork which was probably executed by Gimson himself.

English oak with modelled decoration in gesso, four steel strap hinges inside, and a brass lock. Made of planks with cogged dovetails at the corners, rows of dowels fixed to arched ribs inside the lid, chamfered tenons on front and back, and butterfly-shaped double dovetails on the ends. Simple gouged decoration at each end of the lid and chamfered line below main front panel. Lock by Hobbs & Co.

$23\frac{7}{8} \times 49 \times 17\frac{1}{2}$ ($608 \times 1245 \times 443$)

Purchased in 1941 at the sale of Mrs Emily Gimson's effects, for £12. 10. 0 from the Friends Fund. 1941.42

Record: Sale catalogue of Hobbs and Chambers, Cirencester, 20.3.1941, lot 207.

The sale catalogue indicates that the coffer was in a bedroom in 1941.

Freda Derrick illustrated this piece in *Country Craftsmen*¹ and suggested that the gessowork would have been painted had Gimson finished it. She implied that he was working on the piece around the time that he died. Without evidence from designs or exhibition catalogues, the dating of this kind of simple oak furniture is fairly difficult. It cannot be assumed that because it is simple it is early, since dated designs exist for similar pieces from the middle of Gimson's career.²

The stylised decoration of plant forms is typical of Gimson's pattern design, based

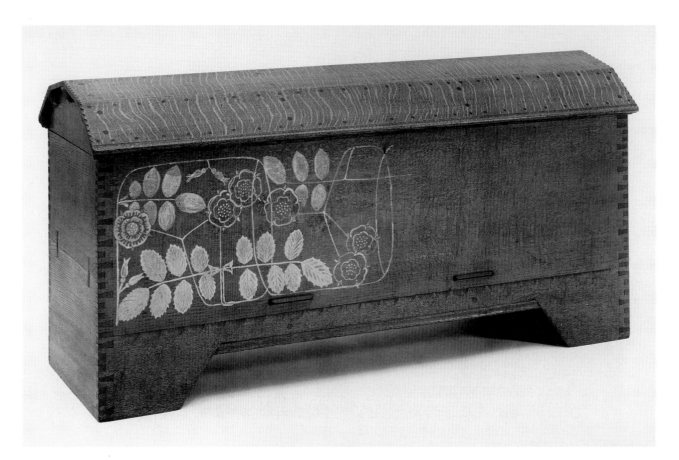

Fig.104 **Cat.27** Coffer by Ernest Gimson, about 1910.
Fig.105 **Cat.27** Detail inside the lid of the coffer.

on his study of nature combined with a knowledge of earlier work, especially embroidery of the sixteenth and seventeenth centuries. Gimson's collection of reference photographs in the Museum's archive contains several prints of embroideries from the South Kensington Museum.

A copy of this coffer, without plasterwork, was made in 1985 by Sally James at Rycotewood College, and a photocopy of her plan is in the Museum file.

1. London 1945, p.137.
2. For example, CAGM 1941.222.407, of 1912.

105

28 Door

Designed by Ernest Gimson and made at Daneway in about 1910. Metal fittings made at the Sapperton smithy under Alfred Bucknell.

Softwood with iron strap hinges and latch fitting with a handle decorated with incised lines. A lock added at some date has been removed.

$75 \times 30\frac{5}{8} \times 2$ (1905 × 776 × 51)

Purchased in 1985 from Leicestershire Museums, Art Galleries and Records Service for £10. 1985.656

One of two doors purchased by Leicestershire Museums from B.G. Burrough in 1983, it was acquired by Burrough from the owners of Coxen, Budleigh Salterton, Devon, when no longer wanted. Coxen is a thatched cottage built of cob, designed by Gimson for his erstwhile architectural assistant, Basil Young, in 1910 (Fig.107).

This type of simple, traditional door was used often in buildings by the Cotswold group.

Fig.107 *Coxen, the cob cottage in Devon designed by Gimson in 1910 (see Cat.28).*

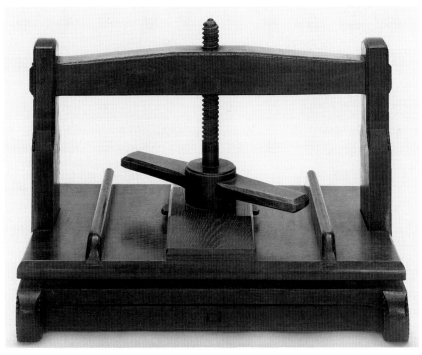

Fig.108 **Cat.29**

Fig.106 **Cat.28**

29 Printing press

Designed and made by Sidney Barnsley in about 1910.

Oak with gouged decoration.

$15\frac{1}{4}$ (plus height of screw) × 23 × 16$\frac{1}{2}$ (387 × 584 × 419)

Purchased in 1993 for £500. 1993.347

Acquired by the vendor from Edward Payne (1906-91), the stained-glass artist, who had been given it by Charles March Gere (1869-1957). Gere was a painter who lived in Painswick in south Gloucestershire. He was a good friend of Sidney Barnsley and had designs made by him for additions to his house.

The line of gouged decoration was a feature Barnsley particularly liked. It was economical of effort, with each shape achieved by two cuts with a chisel.

30 Picture frame

Moulding designed by Ernest Gimson in about 1910-15 and frame repaired by Harry Davoll in 1949.

Macassar ebony.

$20\frac{1}{4} \times 22\frac{1}{2} \times 1$ (514 × 571 × 25)

Acquired by D.W.Herdman in 1941. 1986.1376

Design: CAGM 1941.222.501, 641, similar but not identical, undated.

A label on the back states that Herdman acquired this at the Gimson sale in fragments, and it seems likely that it was handed over by the auctioneers along with the drawings rescued by Herdman.[1] Eight years later, he asked Harry Davoll to reconstruct and repair it, which was done at a cost of £2.5.0 (15 hours at 3s). Herdman specifically intended it for an etching by F.L.Griggs.

In Gimson's workshop book there is a reference to an ebony frame made for himself in 1914, which could be this one.[2]

1. See A.Carruthers, *Gimson and Barnsley: Designs and Drawings in Cheltenham Art Gallery and Museums*, Cheltenham 1984, pp.4-5.
2. CAGM 1941.225.121. p.8.

31 Clergy seat

Designed by Ernest Gimson in collaboration with Robert Weir Schultz in 1914 and made at Daneway by Percy Burchett, Fred Orton, Ernest Smith and Ward, supervised by Peter Waals, in November 1914 to January 1915 in $502\frac{1}{2}$ hours.

English walnut inlaid with bleached bone. The flat seat can be raised on brass hinges and has a misericord seat beneath.

$71\frac{5}{8} \times 28\frac{5}{8} \times 23\frac{1}{8}$ (1820 × 727 × 586)

Purchased in 1970 for £450 with a 50 per cent grant from the V&A Purchase Grant Fund. 1970.47

Design: CAGM 1941.222.11 by EWG; 11a signed EWG and dated Nov 7 1914; 58; 59 signed RWS and dated March 1914; 60 signed RWS and dated Aug 1914; 138 by EWG.

Record: CAGM 1941.225.121 Gimson's workshop book, p.14.

The seat was commissioned by the Fourth Marquess of Bute via Robert Weir Schultz as a prototype for seats in St Andrew's Chapel at Westminster Cathedral, London.

Fig.109 **Cat.30** *The etching by F.L.Griggs, 'Lone End', 1930, was given by Arthur Mitchell.*

It was kept by Weir Schultz and used at his house, The Barn in Hartley Wintney, Hampshire. After the wedding of Edward Barnsley and Tania Kellgren in 1925, the wedding breakfast was held at Weir Schultz's house and the bride sat in state in this chair. It was inherited by the vendor, a distant cousin of Weir Schultz.

Bentley's Byzantine brick cathedral was built from 1895 to 1903 and was furnished over many years by a variety of firms. Bute was from one of the most prominent Catholic families of Britain, so it was almost inevitable that he should have been involved in this great project, especially as the family had also been important patrons of art and design of a progressive kind. Schultz had worked extensively for the family from 1891 and his interest in Greek and Byzantine architecture was of long standing, since he had visited Greece with Sidney Barnsley in the 1880s. Gimson's work, too, had features clearly derived from such work.

The sequence of dates of the designs suggests that Schultz sent Gimson some rough sketches of his ideas for the seats in March 1914 and a plan of the chapel in August, and that after discussion, a final version was prepared by Gimson in November.

A set of seven seats in ebony and bone was made in Gimson's workshop in Febru-ary to September 1915, taking $3218\frac{1}{2}$ hours of work. The prototype would have been necessary partly to assess the design and partly as an aid to estimating the cost of production, since the workshop could have lost a great deal of money on such a job if a mistake had been made. Walnut was used because it is cheaper than ebony, but in working out the price Gimson had to take into account the difference and to allow for the longer time needed to work ebony.[1] The workshop record shows that this seat took $502\frac{1}{2}$ hours to make and the price of £25.2.6 given for time reflects an hourly rate of 1s. Because it was a job for an architect, Gimson charged 10 per cent for the design element as well as 15 per cent for the workshop. The cost of the chair was £44.13.0.

There is a clear relationship between this piece and the design of a Bishop's seat by W.R.Lethaby of 1891 which was made by Kenton & Co.[2] Lethaby's chair has the same high back within strictly vertical lines, with a central roundel in the top rail flanked by tall finials. The proportions are similar, the back is also divided into horizontal panels, and use is made of chamfered decoration to reflect light. Lethaby's interest in Byzantine art and symbolism influenced Weir Schultz's decoration of the chapel at Westminster, which has a 'pavement like the sea'.

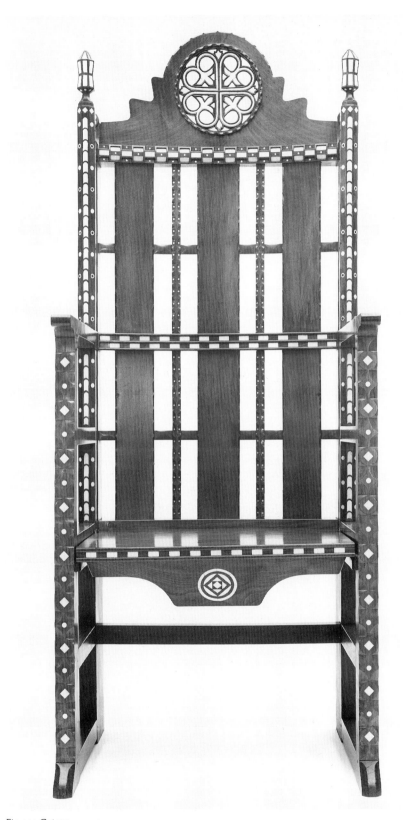

Fig.110 **Cat.31**

32 Dining table and cupboard containing spare leaves and centre supports

Designed by Ernest Gimson in September 1915 and made in October/November 1915 by Harry Davoll and Peter Waals, assisted by Percy Burchett and Ernest Smith, in 688 hours. The cupboard was made by Waals in 75 hours.

English walnut table top with a reeded edging of macassar ebony and legs and stretchers of ebony. The top is decorated with two inlaid lines of chequered ebony and holly and two rows of double dovetails (Fig.113). There are runners of cedar and ebony stands to support the three leaves. These can be added to extend the table to 13ft 9in, and two x-frame supports fit in underneath; they are kept in the rect-angular panelled box made for them.
The original wax finish (and possibly an undercoat of shellac polish, according to Edward Barnsley) was replaced in 1953 with a cellulose varnish when the table was repaired in Edward Barnsley's workshop. 'We had to dismantle the large table completely and re-align and re-adjust the guides underneath … and have the whole thing down, as regards the various parts … in addition to the general touching up and re-doing of the tops …'[1] The repairs took 138 hours and Barnsley charged £47.2.9 plus carriage. The solid walnut of the top has cracked because of faults in the timber and the top is faded by comparison with the spare leaves.
English oak cupboard for the leaves, with green baize on the runners.

Table $29\frac{1}{2} \times 99\frac{1}{4} \times 49\frac{1}{4}$
$(749 \times 2521 \times 1251)$
Cupboard $57\frac{3}{4} \times 28\frac{1}{2} \times 13\frac{7}{8}$
$(1466 \times 724 \times 357)$

Purchased in 1971 for £750 with a 50 per cent grant from the V&A Purchase Grant Fund. 1971.43

Design: CAGM 1941.222.409, dated 18.9.1915.

Record: CAGM 1941.225.121 Gimson's workshop book, p.23.
CAGM 1971.43 Correspondence between Gimson and Allan Tangye, July 1915 to March 1917.
EBET Workshop book 3, p.32, Job 28, 1953.
EBET M52/7-8 letters between Barnsley and Arthur Mitchell.
CAGM Glenfall House sale catalogue, lot 617, £190.

Commissioned by Allan Tangye for his house in Birmingham at a cost of £61.18.0.

The circular motif at the head of the chair has been used as Cheltenham Museum's logo since 1982.
See Figs 1, 17.

1. £35 instead of £25.2.6, based on 700 hours instead of 502½.

2. S. Backemeyer & T. Gronberg, *W. R. Lethaby 1857-1931: Architecture, Design and Education*, London 1984, p.91, no.130, St John the Baptist's Church, Aldenham, near Radlett, Hertfordshire.

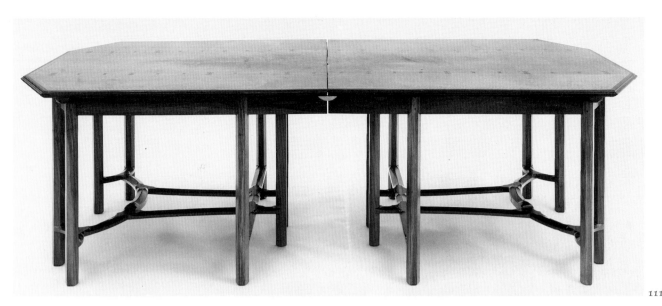

111

112

Fig.111 **Cat.32** *Table by Ernest Gimson, 1915.*
Fig.112 *A page of Gimson's workshop job book, showing details of the suite made for Allan Tangye in 1915 (see Cats 32, 33 and 34).*

Allan Tangye was a solicitor in Birmingham and was introduced to Gimson by William Cadbury when he wanted furniture for Park House in Edgbaston. The Tangye family had an important engineering firm in Smethwick and two earlier Tangye brothers had played a major role in the founding of Birmingham Art Gallery and the School of Art, by giving collections and large donations of money.

Gimson's letters to Tangye are in the Museum's files and indicate the careful consideration given by the designer to practical and aesthetic points raised by the client. The name of Dixon is also mentioned, and it seems likely that the house or the decoration of the dining room were carried out by Arthur Stansfield Dixon, the Birmingham architect. As well as furniture, Gimson supplied metal fire irons and a fender for the house.

A later photograph of the table and sideboard at Broome House, Stourbridge, where Tangye moved in 1928, shows a panelled room with a formal arrangement of furniture (Fig.26). The chairs were supplied by Peter Waals in 1929.

Arthur Mitchell (see p.111) purchased

the table and sideboard at the sale of Tangye's effects in 1953 and was delighted to have acquired such a fine set of furniture. He discussed with Edward Barnsley the idea of having a set of chairs made to suit, but ultimately decided against this. Lawrence Mitchell remembers his father's

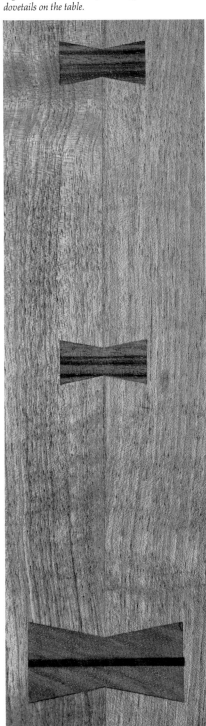

Fig.113 **Cat.32** *Detail of the wedged double dovetails on the table.*

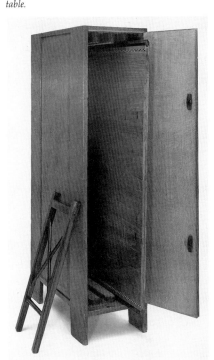

Fig.114 **Cat.32** *Cupboard and spare leaves for the table.*

friends being somewhat shocked at his modern furniture.

The vendor purchased the suite at the sale of Mitchell's effects in 1965 and used it in his own house in Cheltenham.

Gimson frequently used this rich combination of walnut and ebony in furniture of this period.

See Fig.26.

1. EBET, Edward Barnsley to Arthur Mitchell, 23.7.53.

33* Sideboard with plate stand

Designed by Ernest Gimson and made in October/November 1915 by Ernest Smith and Percy Burchett in 453½ hours, supervised by Waals. The plate rack took 152 hours. Handles made by Alfred Bucknell in the Sapperton smithy in 98½ hours.

Made of walnut from the same tree as the table (Cat.32), with ebony and holly inlay on the stiles and rails. Separate plate rack and base of macassar ebony, and handles of brass. Wax polished.

Sideboard 37 × 80⅝ × 25¾
(940 × 2047 × 654)
Plate rack 23½ × 79 × 10
(597 × 2007 × 254)

Purchased in 1971 for £750 with a 50 per cent grant from the V&A Purchase Grant Fund. 1971.44

Design: CAGM 1941.222.298, 300.

Record: CAGM 1941.225,121, Gimson's workshop book, pp. 23, 33, 71.
CAGM 1971.43 Correspondence between Gimson and Allan Tangye, July 1915 to March 1917.
CAGM Glenfall House sale catalogue, lot 618, £320.

The sideboard, which cost £47.8.0, is en suite with the table (Cat.32), and the price of the rack was £13.6.0. The sideboard alone was shown at the 1916 Arts and Crafts Exhibition, where it was damaged, and it was illustrated in *The Studio*.[1] Gimson's work was highly praised in this review of the exhibition.

Arthur Mitchell bought the sideboard for £80 at the sale in 1953 of Mrs Tangye's furniture and used it with the walnut sideboard screen (Cat.34) in front of the ebony rack.

See Figs 8, 9, 23, 26, Col. Fig.56.

1. Vol.69, 15.12.1916, p.122.

34 Sideboard back

Designed by Ernest Gimson and made at Daneway by Ernest Smith in October 1915 in 135 hours.

English walnut panels, which hook on to stands inlaid with macassar ebony. The bases have green baize underneath. The solid walnut panels have warped considerably.

Stands 21¾ × 6¼ × 6¼ (552 × 160 × 160)
Panels 19⅞ × 25¼ × ⅜ (550 × 640 × 10)

Purchased in 1965 from the executors of Arthur Mitchell for £8 (see p.111), with a grant from the W.A. Cadbury Charitable Trust. 1965.92.

Record: CAGM letters of Ernest Gimson to Allan Tangye, September to October 1915. CAGM 1941.225.121, Gimson's workshop book, p.23. CAGM Glenfall House sale catalogue, lot 620.

Fig.115 **Cat.34** *Sideboard back by Ernest Gimson, 1915.*

Commissioned by Allan Tangye of Birmingham (see Cats 32 and 33) as a temporary splashback for an existing sideboard. In the correspondence, Gimson mentioned that he had used the ebony inlay 'to put the colour right with the red background' and that he had kept some pieces of the walnut in case Tangye ever wanted to add another standard and curtain. He sent the piece on approval because he was not at all sure that it was what Tangye was expecting, and the price was £9.

It was purchased by Arthur Mitchell with the Gimson sideboard (Cat.33) in 1953 and was used by him in front of the ebony plate rack.

35 Writing cabinet

Designed by Ernest Gimson and made by Harry Davoll in July/October 1919 in 649 hours. External handles by Alfred Bucknell or one of his staff, and interior handles by John Paul Cooper.

Burr elm veneer on a carcase of mahogany and oak, with main drawers of oak veneered. An inlaid bead is of macassar ebony and the feet of black ebony. The back is of mahogany and the small drawers of cedar with mahogany fronts veneered with burr elm. A separate rack of solid ebony and mahogany with a veneer of burr elm sits on the top. The construction is all concealed apart from four exposed tenons on each side of the base.

There are two small D-shaped wooden handles on the fall front, brass ring handles on octagonal plates with incised decoration on the main drawers, and small silver crescent-shaped handles on the inner fittings. The pull-out

supports for the flap have brass drop handles, hinges and lock.

Rails stamped x, xx and xxx. Rail under top right-hand drawer inscribed Top Bearer *and inscribed* Bottom Inside *inside bottom.*

$43\frac{3}{8}[+\text{rack }11\frac{5}{8}]\times 35\frac{1}{8}\times 22\frac{1}{4}$
$(1102[+294]\times 892 \times 565)$

Purchased in 1966 for £60, with a 50 per cent grant from the V&A Purchase Grant Fund. 1966.92

Design: CAGM 1941.222.343, similar design dated 2.8.1917.

Record: CAGM 1941.225.121, Gimson's workshop book, p.46.
EBET, Arthur Mitchell to Edward Barnsley, 22.3.53.

This cabinet was purchased from a private individual in London. There is very little correspondence about it in the Museum's files and it has always been catalogued as by Peter Waals, but has now been identified as a piece made in Gimson's workshop in 1919 for Allan Tangye and later owned by Arthur Mitchell. In the workshop book, several entries were made by Sidney Barnsley, who sorted out the business after Gimson's death, and this piece appears as 'Writing Cab. in Burr Elm for Tangye'. This includes details of eight octagonal handles, two drop handles and nine silver handles, and the price shown was £96.11.0.

36 Settee

Designed and made by Sidney Barnsley in about 1919-23. Fabric cover designed and printed by Phyllis Barron.

Fig.116 *Portrait of William Simmonds by Gerald Gardiner, about 1930. Simmonds was the original owner of the Sidney Barnsley settee (Cat.36).*

English oak. The softwood seat frame has large metal springs and coarse linen across the top, secured by small brass screws. Cushion covered with ungalled linen fabric printed with iron to produce an ochre yellow pattern.

$31\frac{3}{8}\times 77\frac{7}{8}\times 27\frac{3}{8}$; h. of seat 14 [including cushion] $(797 \times 1979 \times 695$; h. of seat 356)

Purchased in 1957 for £12.10.0 from the Friends Fund. 1957.71.

Bought from William Simmonds (1876-1968), the woodcarver, sculptor and puppeteer. There is no correspondence with Simmonds in the Museum's file, so there is little evidence of the piece's history. William Simmonds and Eveline Peart married

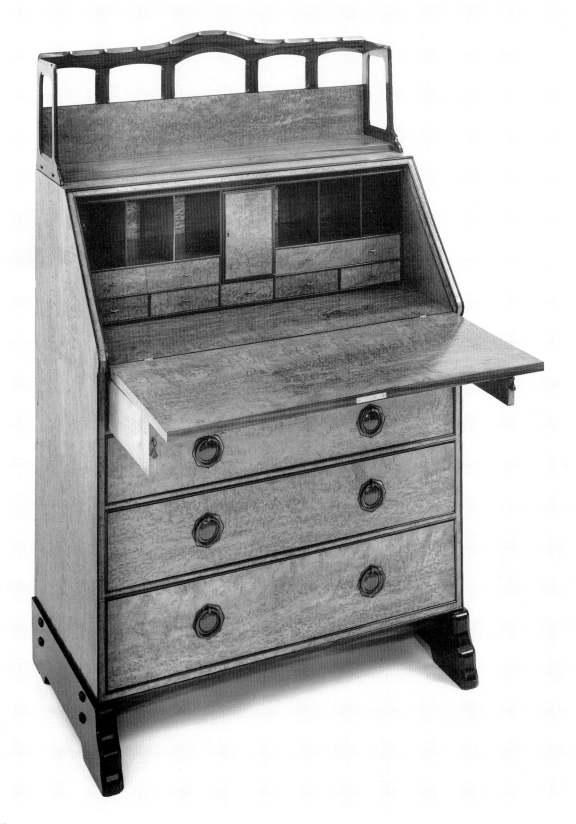

Fig.117 **Cat.35**

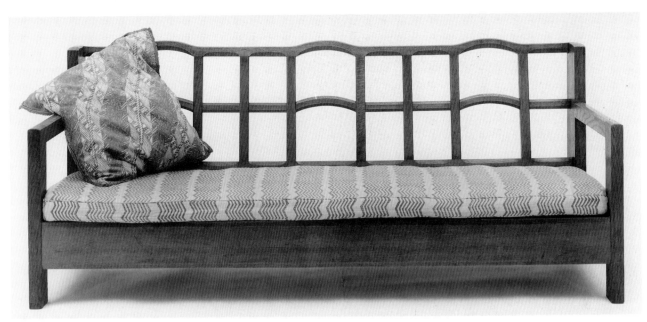

Fig.118 **Cat.36** *Settee by Sidney Barnsley, about 1919-23. The seat cover is by Phyllis Barron and the cushion by Barron and Larcher.*

in 1912 and lived in furnished rooms in London before moving to the Cotswolds in 1919. They set up home in Far Oakridge and must have bought or commissioned the settee at around this time. Sidney Barnsley gave up making furniture in late 1923 or early 1924.

If the fabric dates from 1919 it must be by Phyllis Barron alone. If later, it is possibly by Barron and Larcher, who met in 1921 or 1922 after Dorothy Larcher saw and admired one of Barron's fabrics at the Simmonds' house, but this design does not appear in the extensive records of their work at the Crafts Study Centre in the Holburne Museum at Bath. Two cushions from the settee survive in a private collection. There is also a later cover of flowered chintz with a green ground.

Both Barnsley and Gimson designed numerous variations on this theme of the settee with a chamfered lattice back, a feature derived from the superstructure often found on farm wagons (see Fig.207).

See Front Cover.

37 Dining table

Designed and made by Sidney Barnsley in 1923-4.

English oak. The top is of three planks joined together with double-dovetail joints and decorated along the edge with a chip-carved lozenge pattern. A small hexagonal patch in the top surface was always there and was presum-ably a repair to a fault in the timber. The sub-structure is joined with exposed dowels and protruding tenons which have been shaped at the ends and the top is fixed to the base with wooden 'buttons' attached with steel screws.

$29\frac{3}{4} \times 76\frac{3}{4} \times 38$ ($754 \times 1949 \times 965$)

Purchased in 1962 for £110 including other pieces (Cats 38, 39 and 46) with a 40 per cent grant from the V&A Purchase Grant Fund and money from the Friends Fund. 1962.100.1

Design: CAGM 1972.187.64, undated on paper watermarked 1921, a similar piece.

Record: CAGM 1962.100. Receipted bill dated Feb 28 1924 from Sidney Barnsley to Mrs Edge for £17.10.0. The total bill of £48.5.0 included the sideboard (Cat.38) and delivery charge of 15s (Fig.120).

Commissioned by Mrs M.Edge, South Hayes, Sandy Lane Road, Charlton Kings, Cheltenham, the mother of the vendor.

The Edge family returned to England from India in 1920 after Mr R.C.Edge retired from his post as an engineer with the Public Works Department. Mrs Edge's family had served in the army in India for five generations and her son later returned there. On first arriving in Cheltenham they took rooms in Lansdown Crescent until they moved to Charlton Kings in about 1924. Because they were setting up house after a long period abroad, quite a lot of furniture was needed. Mrs Edge somehow heard about Sidney Barnsley and went to see him in Sapperton. She commissioned

the dining furniture and was very enthu-siastic about his work, telling her family that it would be the antiques of the future.

As well as these pieces, Mrs Edge had several other items by Barnsley or by Geoffrey Lupton, and some rush-seated chairs, probably by Edward Gardiner. She was very pleased with it all and had some photographs taken in 1927 of the house before the family moved elsewhere in Cheltenham. Unfortunately the photo-graphs which survive do not include the dining room, but they are of considerable interest because they show that the furniture was used in conjunction with pieces bought in the East. In the hallway was a tiger skin rug hung upon the wall, a somewhat unexpected feature in a house furnished with Cotswold work (Fig.119).

The table was used in the dining room, which had plain white or cream walls, along with the chairs (Cat.46) and side-board (Cat.38), and probably also the cabinet (Cat.39). Mrs Edge's children used it for playing ping-pong. General Edge remembers that his mother, on Sidney Barnsley's instructions, did not polish the table, but that it was kept polished by his mother-in-law when it was in her care from the 1940s until the early 1960s.

Details of the complexities of construc-tion of this table can be found in articles in *Woodworker*, in *Fine Woodworking*, and in *Practical Woodworking*.[1] At least two copies of it have been made in recent years.

For a craftsman working on his own using only hand tools, such a piece would

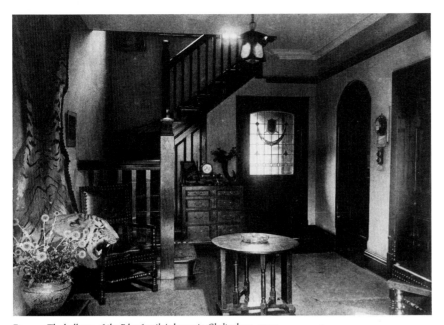

Fig.119 *The hallway of the Edge family's house in Cheltenham, 1927.*

Fig.120 *Sidney Barnsley's invoice to Mrs Edge (see Cats 37 and 38).*

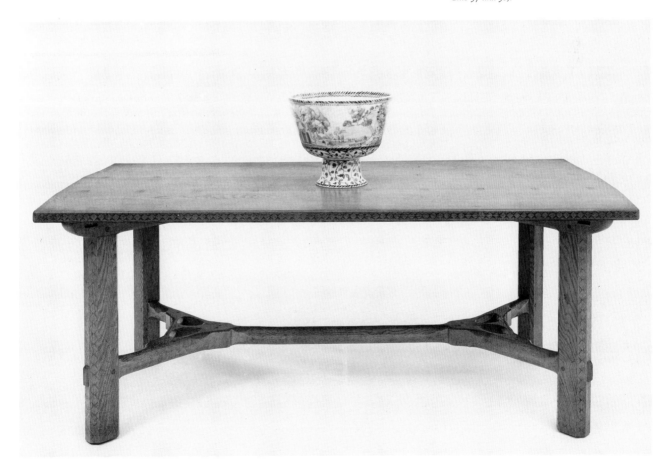

have involved hard physical work, though Sidney Barnsley had a pulley and hoist system for manoeuvring timber within his shop.

The chamfered stretchers were based on the form of hay rakes, and are often found in Gimson-Barnsley furniture.

Fig.121 **Cat.37** *The bowl is by Alfred Powell, 1928 (see Fig.38).*

1. April 1981, p.234; Sept/Oct 1984, no.48, pp.72-5; Feb 1990, pp.40-4.

38 Sideboard

Designed and made by Sidney Barnsley in 1923-4. Handles probably made by Alfred Bucknell.

English oak with oak drawer sides and cedar linings. Macassar ebony lock plates and brass handles. Wax polished. The separate splash-back was clearly functional and is covered with splashes. The central and right cupboards each have a fixed shelf inside.

Exposed dovetails, tenons and dowels. Base fixed with wooden buttons like those on the table (Cat.37). The splashback has two brass locating pegs which fit into holes on the top. It also has two holes drilled into the flat surface to take screws, which must be a later alteration. Locks by Hobbs & Co.

Marked underneath the drawers in pencil, Left and R.

$45\frac{1}{8} \times 64\frac{1}{8} \times 23$ (1147 × 1629 × 584)

Purchased in 1962 (see Cat.37). 1962.100.3

Design: CAGM 1972.187.90, related but with tall top structure.
General Edge has an earlier proposed design which has a taller top structure with shelves.

Record: CAGM 1962.100. Receipted bill dated Feb 28 1924 from Sidney Barnsley to Mrs Edge for £30.0.0. The total of £48.5.0 included the table and delivery (Fig.120).

Commissioned by Mrs Edge, the mother of the vendor.

The sideboard was used *en suite* with the dining table, and the two pieces must have been among the last designed by Barnsley, who gave up cabinet-making around this time. General Edge remembers that the drawers ran very smoothly.

39 Cabinet

Designed and made by Sidney Barnsley at Sapperton, probably in 1923-4.

English oak with waxed surface. Wrought steel handles. All joints are exposed and the back is panelled. Locks by Union and door fasteners appear to have been added after construction. The handle on the left door is a replacement made by Norman Bucknell in 1986.

$44\frac{7}{8} \times 79\frac{3}{8} \times 15\frac{3}{8}$ (1140 × 2017 × 390)

Purchased in 1962 (see Cat.37). 1962.100.2

Commissioned by Mrs Edge (see Cat.37) or possibly bought ready-made, since the cabinet does not appear to be en suite with the dining table and sideboard; it has steel rather than brass handles and was not included on the bill with the other items.

The gouged mark in the central stile was made by General Edge as a child, when he attempted to force open the cupboard to get at the jam.

40 Table

Designed by Ernest Barnsley and probably made in the Rodmarton Estate workshop in the early 1920s.

Oak with a pale scrubbed finish. Joined by through tenons and dowels, which have become loose in the joints.

$28\frac{5}{8} \times 47\frac{5}{8} \times 23\frac{3}{4}$ (728 × 1215 × 604)

Purchased 25.4.79 at Sotheby's Belgravia, Lot 17, for £220. 1982.195

Record: 'Country Life' photograph, reproduced in J. C. Rogers, 'Modern English Furniture', London 1930, p.72.

The table came from Rodmarton Manor, near Cirencester, and a similar one remains there. In the *Country Life* photograph, one of the two appears at the end of a bed in a room containing furniture by Peter Waals and a tapestry of leafy design.

Rodmarton is one of the great monuments of the Arts and Crafts in the Cotswolds. Designed by Ernest Barnsley in 1909, it was built in stages over many years and was not completed until after Barnsley's death. It was commissioned by the Honourable Claud Biddulph, the second son of Lord Biddulph, whose family home was nearby at Kemble, and was built as far as possible with local materials and labour.

Margaret Biddulph became much involved in the decoration and furnishing of the house, and John Rothenstein later described her as 'like the abbess of some great medieval religious house … the animating and directing force. Her husband, I fancy, for all his liberal support of her innumerable projects, must often have contemplated with astonishment the unusual environment that was growing up about them, at the large areas of new oak panelling and furniture, at the richly coloured wall hangings, the ample vases embellished with their coats of arms …'[1] It was Mrs Biddulph who ordered most of the furniture, some from the Barnsleys and Waals, and some made in the estate workshop under Alfred Wright. She also had impressive embroidered panels made by the Rodmarton Women's Guild, depicting scenes from village life.

Late in life, Mrs Biddulph gave numerous items from the house to different members of the family and some of these have appeared for sale at auction.

1. J. Rothenstein, *Summer's Lease: Autobiography 1901-1938*, London 1965, pp.50-1.

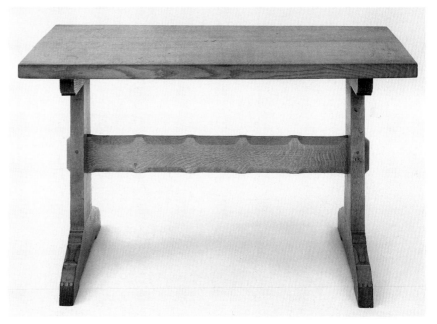

Fig.122 **Cat.40**

Fig.123 **Cat.38** *The carving is 'Autumn Calf' by William Simmonds, 1952.*
Fig.124 **Cat.39**, *with painted pottery of the early 1920s by Grace Barnsley.*

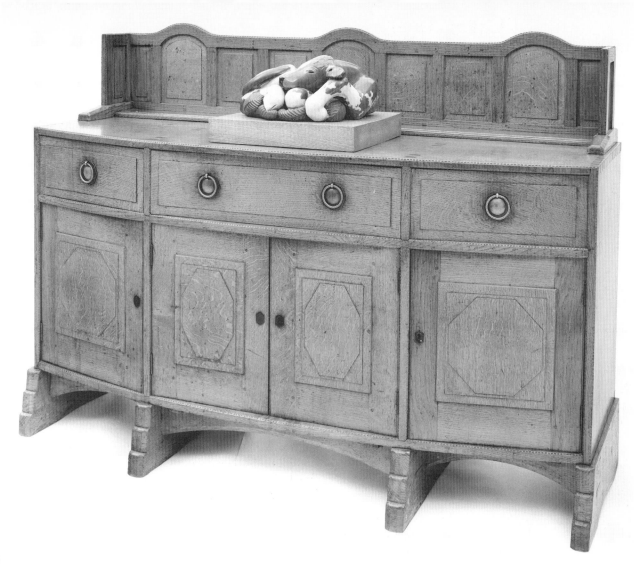

123

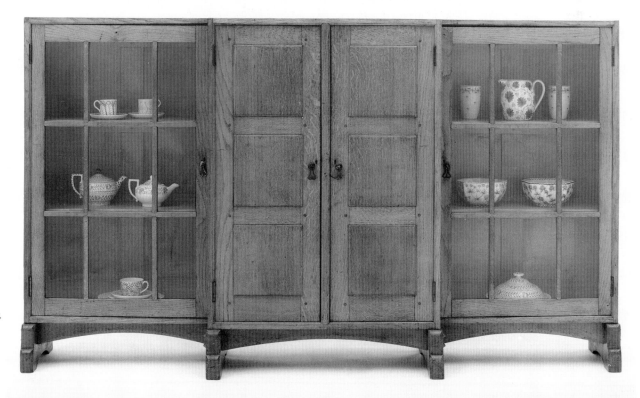

124

Ambrose Heal (1872-1959) and Heal & Son

Unlike most of the other furniture designers working in the 1890s, Ambrose Heal was not an architect but had a training in cabinet-making. His family firm, Heal & Son, started as a feather-dressing business in 1810, and by 1818 was established in Tottenham Court Road, already a centre for the furnishing trade in London by this date. The firm specialised in bedding, and it was only in the 1850s that it began to stock bedroom pieces other than beds. As it expanded in the 1880s, it diversified into drawing room furniture and became known for its innovative showroom displays of complete rooms.

Ambrose Heal served a short apprenticeship with a Warwick firm and six months with a cabinet-maker in Oxford Street, before joining Heal & Son in 1893. After working in the bedding department to learn the trade, he began designing furniture himself. He seems to have been much influenced by Ford Madox Brown's pieces for the model workman's dwelling at the Manchester exhibition of 1887, and probably also saw the products of Kenton & Company at their 1891 exhibition and subsequent Arts and Crafts shows. For his own work, he adopted plain forms made of solid, unvarnished English oak or chestnut, sometimes used as flat planks and sometimes panelled. Decorative strap hinges and metal handles often formed the only ornament, but some richer pieces had inlays of pewter with stylised flower or heart designs, and jolly mottoes, such as 'Fine feathers make fine birds' on the cornice of a wardrobe.

Very bold chequered inlays were also favoured from around 1900, and echoes of Baillie Scott's furniture designs appear in Heal's work, though it is difficult to be sure of which way the influence was working. Gimson certainly felt some concern about the copying of his work, and told his sister not to show too many of his things to Heal.[1]

Heal's modern designs, advertised as 'New but not "New Art"', were sold from the mid 1890s, alongside the shop's traditional ranges and adaptations of Hepplewhite and other eighteenth-century and earlier models. The firm's catalogues show the very wide range available, and also the long periods of time during which pieces were still being made.

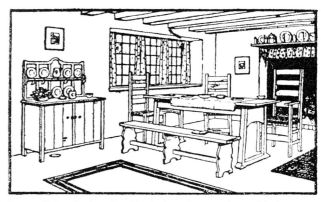

Fig.125 *Cottage furniture from 'An Aesthetic Conversion', a small book published by Heal & Son in 1909 (see Cat.41).*

Prices can also be compared in the catalogues, and they vary enormously. The lowest were for pieces in painted deal for servants, while the quality reproductions were the highest. Ambrose Heal's own designs come somewhere in the middle, and appear to cost slightly less than the Guild of Handicraft's plainest work and considerably less than Gimson's. Prices were based on simple construction techniques, use of standard timber sizes and batch-production in Heal's factory in Alfred Mews. Records show that work was also made by Restall Brown & Co, Gomme, Edwards, Romney Green, and F.Coote and his successor.[2] Heal's also bought in work from other makers, such as Philip Clissett and J.P.White.

Ambrose Heal's personal interest in London trade cards of the eighteenth century[3] must have been the source of the image of a bed and slogan 'At The Sign of The Four Poster', which was used widely in advertising. By employing designers such as C.H.B.Quennell and Eric Gill to work on brochures and lettering, Heal created a strong identity for the firm, which is still in existence today.

1. CAGM 1986.1245.6, account of an interview by John Gregory with Margaret Gimson, April 1954.
2. V&A AAD, Heal's archive 2-1978 SU28, SU43.
3. Heal published a book on this subject, *London Tradesmen's Cards of the XVIII Century*, London 1925.

41 Dresser

Designed by Ambrose Heal in about 1905 and made by Heal & Son in about 1905-30.

Oak with chestnut shelves inside and pine back. Brass cup hooks and hinges. The surface finish is not original.

$66\frac{1}{2} \times 53\frac{3}{4} \times 18$ (1690 × 1365 × 457)

Purchased in 1985 from B.G.Burrough, Colyton, for £950 with a 50 per cent grant from the V&A Purchase Grant Fund. 1985.660

Record: V&A AAD 2-1978, SU3, SU115, Heal's catalogues and press cuttings.

The dresser was owned by B.G.Burrough for some years and was lent by him to the Centenary exhibition at Heal's in 1972, when it was cleaned and varnished in the company workshop.

It was designed for the 'Cheap Cottage' exhibition at Letchworth Garden City in 1905 and was in production at Heal's for many years, rising in price from its original

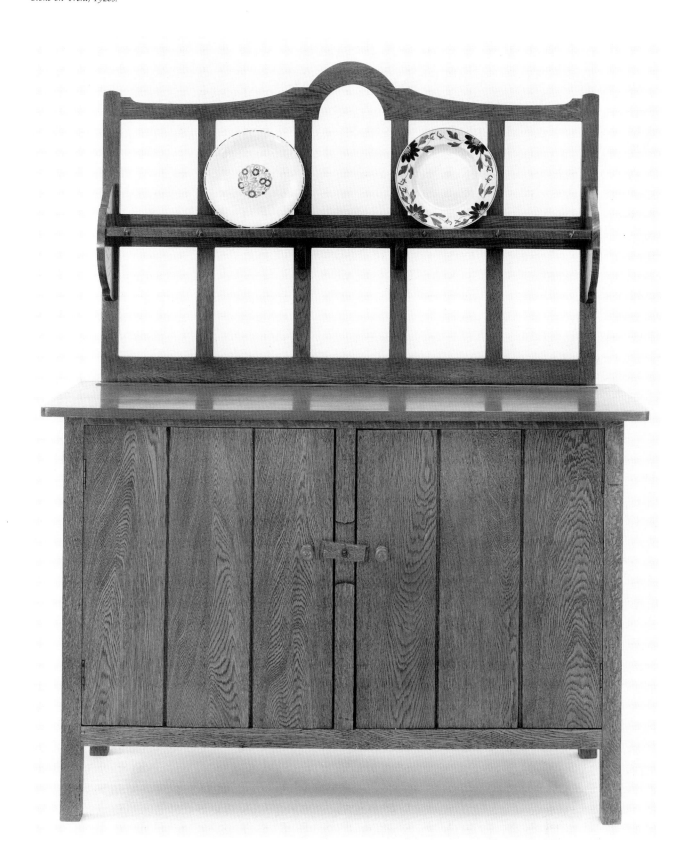

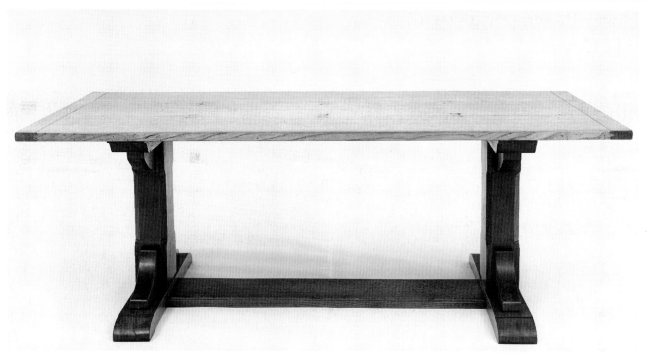

Fig.127 **Cat.42**

£6.15.0 to £7.10.0 in 1913, £8.17.0 in 1916, £11.15.0 in 1917 and £15 in 1930. Photographs and advertisements show it as part of a simple cottage interior with a plain table and ladderback chair. This image may have been the inspiration for Osbert Lancaster's 'Cultured Cottage' drawing in *Homes Sweet Homes*,[1] the description of which mentions 'BBC announcers' among the natural inhabitants of the cultured cottage. Since the BBC in Portland Place was very close to Heal's, this sounds like a cultural reference.

After about 1913, the dresser was also exhibited as suitable for use in the school-room and nursery, and it was still being advertised as late as 1930 in Heal & Son catalogues. It is not known how many were made.

The construction is very simple and was clearly designed to suit batch production with machine-tools.

See Fig.125.

1. O. Lancaster, *Homes Sweet Homes*, London 1939, p.63.

42 Table

Designed by Ambrose Heal in about 1916 and made by Heal & Son in about 1916-22.

Chestnut top and oak base, with metal plates to attach the two. Top made of three planks with tenoned cross-pieces at each end and thin butterfly-shaped insets across the joints.

$29\frac{1}{4} \times 84 \times 35\frac{7}{8}$ (743 × 2133 × 912)

Purchased in 1984 for £1150 with a 50 per cent grant from the V&A Purchase Grant Fund. 1984.171

Record: V&A AAD 1/117-1980, A&CES catalogue 1916, no.311.

The table came from the family of F. L. Griggs (1876-1938), the etcher. According to his widow, Nina, it was in his house in Chipping Campden in 1922 when they became engaged. It is not known exactly when Griggs bought it and the earliest date of production of this design has not been traced, but a similar table (or possibly this one) was shown at the 1916 Arts and Crafts exhibition. This was illustrated in *The Studio*.[1] In the catalogue of the exhibition it is described as 'Dining table, chestnut. Executed by G. Ravenscroft. Exhib. by Heal and Son £12.12s'. Ravenscroft does not appear in the staff wages book of Heal & Son, which suggests that the exhibited table was made by an outside firm rather than in Heal's factory.

There are several press cuttings books in the Heal's Archive, but no reference to this table design until 1924, in an article from *Homes and Gardens* about Heal's own house, Baylin's Farm, near Beaconsfield, Buckinghamshire.[2] The table is illustrated in the dining room. It was also advertised several times in 1926 and appears in a catalogue of 1933, as a 'Weathered oak refectory table' at £18.0.0,[3] so it was in production for a long time.

Heal's design was clearly inspired by early English oak tables. He kept boxes of cuttings from magazines of old pieces, and the file of tables includes many seventeenth-century examples and a few by Gimson and the Barnsleys.[4]

The butterfly-shaped inlaid pieces on the table top do serve some structural purpose in preventing the boards from moving apart, but are not made in the same way as the double-dovetail joints used by Gimson and the Barnsleys (Cats 32 and 37). Because they are quite thin and the top has been scrubbed in use, some have lifted and partly disappeared. This kind of jointing motif can also be seen on a sideboard designed by Cecil Brewer and made by Heal's in 1900, which is now in the Fitzwilliam Museum in Cambridge.[5]

1. Vol.69, p.131.
2. V&A AAD 2-1978, SU116.
3. ibid.
4. V&A AAD 2-1978, SU10.
5. M29 1982.

Harry Peach (1874-1936) and Dryad

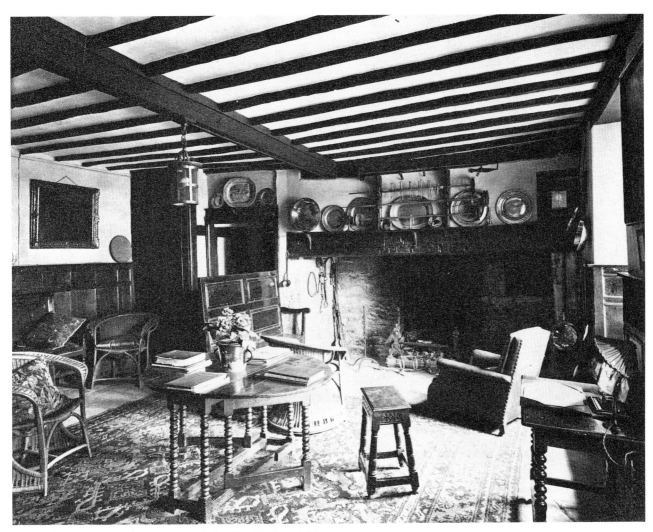

Fig.128 *The Lygon Arms Hotel in Broadway, with three Dryad chairs, probably photographed in the 1920s.*

Like Ambrose Heal, with whom he was closely associated as a founder member of the Design and Industries Association in 1915, Harry Peach was not an architect. He worked for some years as an estate agent in Leicester and by 1902 had set up as an antiquarian bookseller. It was through involvement with Socialist politics that he became interested in problems of design. His friend, Benjamin Fletcher (1868-1951), Head Master at the local college of art, introduced him to the writings of Lethaby, which he read avidly, and in 1906 Peach helped to organise an exhibition on the sweated trades, in which workers were present demonstrating their skills.

At around this time, Peach's eyesight was failing and he was considering alternative occupations. By chance he was looking for cane chairs suitable for a billiards room and was persuaded by Fletcher that this was a field in which British makers could compete with imports from the Continent. Fletcher had recently visited Germany and was impressed by the cane furniture of Richard Riemerschmid. Leicester already had a number of firms producing canework, of a very ornate kind, but Fletcher was to provide modern designs and Peach would deal with the business side.

Strong shapes, attention to the detailing and quality of construction were the hallmarks of Dryad's chairs, and the designs were based on a care for comfort in use and knowledge of the particular properties of cane. They were immediately successful, and thirty models were available within the first year. Peach had started with four men, including Charles and Albert Crampton, but by 1913 he had a staff of more than 100, and he employed several young

designers. The firm was run on the principle of intelligent co-operation between the employer and the employed, and encouraged its workers to study at the art school and to take part in social activities.

In 1912, Peach went into partnership with William Pick and started Dryad Metal Works, but the major change of direction for the firm came as a result of the First World War, when Dryad began to supply cane for basket-making to wounded soldiers in a local hospital. This led to the establishment of Dryad Handicrafts, supplier of materials and tools for an enormous variety of activities, and still in existence today.

The shapes of Dryad cane chairs became less expansive in the 1920s, in line with current fashion, and in the 1930s the firm experienced debilitating competition from other makers and from Lloyd Loom, which produced chairs of machine-woven twisted paper. Peach, however, involved himself in the handicrafts supply business and in educational work, publishing polemical works and practical guides on craftwork.

Dryad chairs can be spotted in many photographs of early twentieth-century interiors, and were particularly popular in hotels, hospitals and ships. Since they were very light, they were also suitable for aircraft. Many were used in gardens and conservatories, and for this reason they have become rare.

43 Armchair

Designed by Benjamin Fletcher in about 1907 and made by Dryad, Leicester, from 1907 to about 1920.

Framework of thick cane with the seat, back and arms in woven canework.
 Small metal label fixed to the centre back, stamped DRYAD
 REGISTERED

$38\frac{1}{4} \times 32\frac{1}{8} \times 28$; h. of seat $13\frac{1}{4}$
($971 \times 815 \times 711$; h. of seat 335)

Purchased in 1987 from H. Blairman & Sons Ltd, London, for £650 with a 50 per cent grant from the V&A Purchase Grant Fund.
1987.542

Nothing is known of the history of this particular chair. It is the 'Traveller's Joy' design, one of the earliest made by Dryad and clearly one of Fletcher's favourites, since he himself bought five in its first year of production.

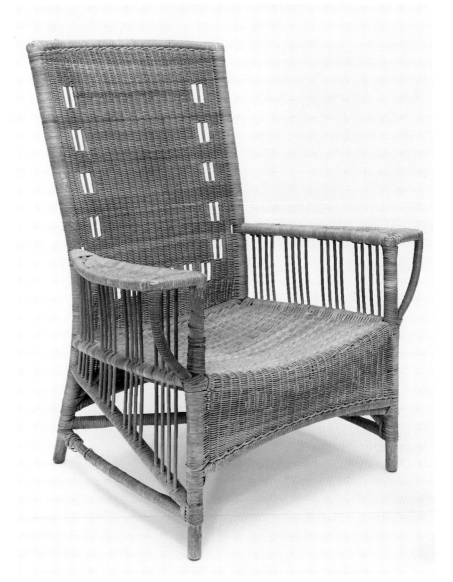

Fig.129 **Cat.43**

Anonymous designer

44 Armchair

Designed by an unknown Yorkshire maker
in about 1912-14.

*Oak with ebony inlay on the central splat, and
a drop-in rush seat. The joints on the back are
dowelled.*

$42\frac{5}{8} \times 23 \times 21$; h. of seat $16\frac{1}{2}$
(1083 × 585 × 533; h. of seat 419)

*Given in 1985 by Mr Frank Peachey.
1985.655*

Commissioned by the donor's parents in
Yorkshire just before the First World War.

 The designer of this chair has proved
elusive. The donor believed it to have been
Robert Thompson of Kilburn, before he
started marking items with a carved mouse,
but the present-day Thompson's firm have
confirmed that this is unlikely. George
Walton has also been investigated, since he
had Yorkshire connections, but this also
seems improbable. There is a Walton
design for a garden chair in the RIBA Walton
ledger,[1] which has similarities, but it is
much more curvaceous than this piece and
Edward Walton gave his opinion that the
Cheltenham chair was unlikely to be by his
father. It may be that it was made by a
little-known Yorkshire maker influenced by
work seen in *The Studio* or other magazines.
Any information would be gratefully
received.

1. 1965.23, p.244a.

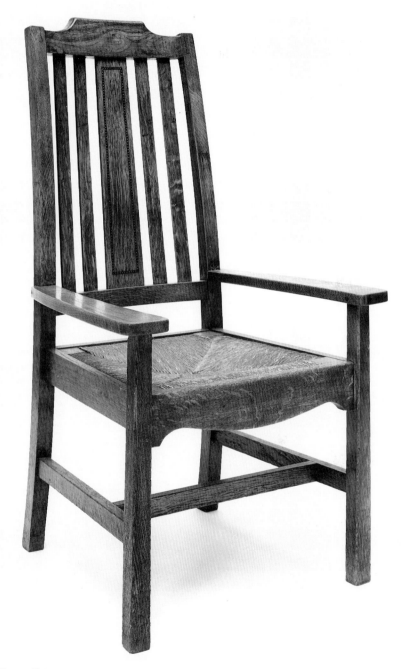

Fig.130 **Cat.44**

Peter van der Waals
(1870-1937)

Fig.131 *Design by Peter Waals for a cabinet of 1929 (see Cat.54). The drawing provides dramatic evidence of the workshop fire of 1937.*

After Ernest Gimson's death in 1919, Peter Waals set up his own workshop in Chalford with financial help from Squire James of Edgeworth (Fig.42). He continued the basic methods of work established at Daneway, though economic necessity prompted him to install a few machine tools, and he also carried on the tradition of offering apprenticeships to local boys.

Waals was very conscious of his own lack of training in design, and his work was much based on Gimson's, though it appears he did not have access to Gimson's drawings. He produced a similar range of architectural woodwork and domestic furniture, but introduced a few features of his own and made some subtle, perhaps even unconscious, amendments. His pieces were sometimes smaller in scale, to suit the houses and flats of the period according to Russell Alexander, who produced two illustrated accounts of his

work; and they were often more finished than the earlier work. From about 1930, Norman Bucknell (1910-) made many of the metalwork handles and fittings. He consciously made the decoration on them more delicate and detailed than the bold lines and dots used by his father, but later felt that maybe he was mistaken to do so.

Noteworthy commissions carried out by Waals included large tables for Leicester University and Eton College, and tiny pieces for Queen Mary's Doll's House.

People known to have worked at Chalford were Norman Bucknell, Percy Burchett, Harry Davoll, Derek and Fred Gardiner, Bert Hunt, Fred Orton, Frank Rust, Owen Scrubey, Ernest Smith, Percy Tanner, William Taylor and Rowley Young. Sir George Trevelyan's experience as a pupil at Chalford, and his appreciation of the skills of this team, is recorded in a vivid account written by him in 1969.[1]

Some of the craftsmen stayed on after Waals's death in 1937, when his widow and son attempted to keep going with help from Arthur Mitchell. The workshop moved to the nearby Cotswold Works but a fire destroyed all the work in progress, the drawings and records, and the craftsmen's tools. They moved to another part of the factory complex, but several craftsmen left and when Leo Waals was called up in 1939, this was the end.

Few designs survived the fire, but the Museum has two and Leicestershire Museums have two. Waals's client book is in the Gloucestershire Record Office and provides invaluable information on dating and prices. It starts on 25 November 1919 and stops at November 1936, presumably because it was only completed occasionally. This means there is a gap in the information about the last months of the workshop. In the Museum's collection are a number of pieces which cannot be identified to a known date, and it is just possible that these were made in the period after Waals's death.

Waals and Arthur Mitchell (1873 - 1965)

Arthur Mitchell spent his entire working life in his family's brewing business, of which he eventually became Chairman and then President. Youthful ambitions to become an artist had been discouraged, but he retained his interest in the arts and became a patron and a good friend of several Cotswold artists and craftworkers, particularly Fred Griggs and Peter Waals.

In 1920, Mitchell bought Glenfall House at Charlton Kings, Cheltenham, a small early nineteenth-century house. It is not known how he came into contact with Sidney Barnsley, but in 1923 he commissioned oak panelling for the Smoking Room, which incorporated built-in cupboards for fishing rods as well as glazed cupboards for books. This room also had a plaster frieze by Norman Jewson.

When the house was enlarged in 1929 by Overbury of Cheltenham, Mitchell ordered more furniture and panelling for it from Waals. Most rooms in the house appear to have contained a few pieces of modern furniture, apart from the Drawing Room. Mitchell's son, Lawrence, remembers the decoration of the rooms as rather dull apart from the Smoking Room with its panelling, open fireplace and parquet floor, and he recalls that his mother probably did not have much say in the acquisition of the furniture, which was definitely his father's interest.

After Waals's death in 1937, Mitchell made great efforts to help Mrs Waals continue the business, but when it failed, he turned his custom to Edward Barnsley, who found him an ideal client. He also bought secondhand pieces, such as the Gimson table and sideboard of 1916 (Cats 32 and 33).

Following Mitchell's death, a sale at Glenfall House was held by Young and Gilling of Cheltenham on 24 - 25 November 1965. Unfortunately the rooms had been changed round and the sale catalogue does not give a true picture of where the various items were used. Ten items were purchased by the Museum at the sale, and others were subsequently acquired.

1. Leicester Museum, *Ernest Gimson*, Leicester 1969, pp.43 - 5.

45 Table

Designed by Peter Waals and made by Owen Scrubey in about 1922.

Walnut with dowelled joints of the legs and rails, and wooden buttons fixing the top to the frame. The top has shrunk across the grain.
Stamped inside two rails O SCRUBEY

$26\frac{5}{8} \times 29\frac{5}{8} \times 29\frac{3}{8}$ (675 × 752 × 746)

Given in 1988 by Mr and Mrs R. H. Heaven.
1988.198

Commissioned by Margaret Biddulph of Rodmarton Manor and given by her to Owen Scrubey's father, who was her head gardener and also ran the local post office. Inherited from Owen Scrubey by the donors.

The table was made when Owen Scrubey was an apprentice at Waals's workshop, aged seventeen, and shows the nature of work expected in the early years of his training. According to an interview with Harry Davoll and Ernest Smith, Scrubey was the best apprentice they ever had.[1]

1. EBET Donnellan interview.

Fig.132 **Cat.45**

46 Set of six chairs (two armchairs and four small chairs)

Designed by Ernest Gimson around 1903 and made in Peter Waals's workshop at Chalford in 1923.

English oak, wax polished. One seat is covered with the original brown calf but the others have been recovered with brown leatherette at some time between 1962 and 1974. The seat rails have no corner blocks.

Marked with Roman numerals I-VI stamped inside front seat rails.

Armchairs $42 \times 22\frac{5}{8} \times 17\frac{3}{4}$; h. of seat $17\frac{1}{4}$
($1067 \times 575 \times 452$; h. of seat 438)
Smalls $39 \times 18\frac{7}{8} \times 17\frac{1}{4}$; h. of seat $17\frac{1}{4}$
($990 \times 479 \times 438$; h. of seat 438)

Purchased in 1962 (see Cat.37). 1962.100.4-9

Design: CAGM 1941.222.161, ladderback only; 167, related design with inlay, dated 1903; 171, related design with straight legs. All by Ernest Gimson.

Record: GRO Waals's client book, p.40 'Mrs M. Edge, 15 Lansdown Crescent, Cheltenham 21 March 1923 6 oak chairs £36.10.0'.

Commissioned by Mrs Edge (see Cat.37). Although the date of these chairs is earlier than that of the pieces made for Mrs Edge by Sidney Barnsley, it seems likely that she approached Barnsley first and he directed her to Waals for the chairs, as he had in the past sent clients to Gimson. He did not make chairs himself, simply because they are labour-intensive and very repetitive for a maker working alone. If Mrs Edge planned her dining suite all at one time, the difference in delivery dates would be explained by the fact that Barnsley worked on his own while Waals had numerous employees.

There is a similar single chair in walnut in the collection of Leicestershire Museums.[1]

1. 47 1962.

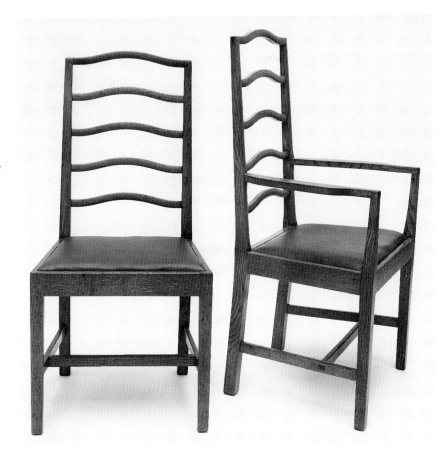

Fig.133 **Cat.46**

47 Set of eight chairs (two armchairs and six small chairs)

Designed by Ernest Gimson and made in Peter Waals's workshop at Chalford in 1923.

Mahogany with oak-framed seat covered in brown leather. The wood is faded. There are no corner blocks inside the seat rail. The drop-in seat has webbing but no fabric underneath.

Incised Roman numerals I-VIII inside the front seat rails.

Armchair $41 \times 21\frac{3}{8} \times 18\frac{1}{4}$; h. of seat 18
($1004 \times 543 \times 464$; h. of seat 455)
Smalls $38\frac{7}{8} \times 20 \times 18\frac{1}{4}$; h. of seat $17\frac{1}{4}$
($988 \times 509 \times 464$; h. of seat 438)

Bequeathed in 1952 by Mrs Alice Mary Burn, in memory of her husband, John Gunn Burn. 1952.94.1-8

Design: CAGM 1941.222.177, unsigned but by E.W.G. for armchair in oak.

Record: GRO Waals's client book, p.44.

Commissioned by J. G. Burn, Hyde Court, Chalford, Gloucestershire, at a cost of £69.

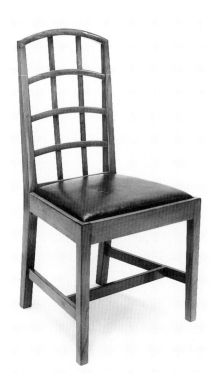

Fig.134 **Cat.47**

Described in Waals's client book as '2 arm and 6 small chairs in mahogany', 24 July 1923.

48 Dining table

Designed by Peter Waals and made at Chalford in 1923.

English walnut, inlaid around the edge with lines of ebony and holly stringing. The surface is faded. There is one rectangular spare leaf to extend the length to seat eight people. The extending mechanism is stiff and difficult to use and the central joint in the table top no longer fits together properly because of shrinkage.

The receipted bill is pasted underneath the table top.

$30 \times 50\frac{7}{8} \times 50\frac{1}{8}$ (762 × 1292 × 1273)

Purchased in 1967 with eight matching chairs (Cat.49) for £200 with a 50 per cent grant from the V&A Purchase Grant Fund and funds from the Leslie Young Bequest. 1967.177.1

Record: GRO Waals's client book, p.46 'Messrs Percy Tubbs & Son & Duncan, Architects, for Percy Tubbs Sept. 1923 Extending dining table £27.10.0.'
CAGM 1967.177.1 letters from Douglas B. Tubbs and Martin C. Tubbs.

This table and the chairs en suite were commissioned by Percy Burnell Tubbs FRIBA (1868-1932) for his son, Cecil, who was married in 1922. Tubbs gave his son as a wedding present the plans for a neo-Georgian house in Chiswick which was built in about 1923, and the dining suite was designed for this house. It is not known if the furniture was part of the wedding gift or if it was simply a convenience that it was commissioned via the firm.

Percy Tubbs was an architect interested in the Arts and Crafts Movement, who employed Waals and Bucknell for several projects. His son Douglas has written that he himself was probably sent to Bedales School because of his father's respect for Gimson's work.

Cecil Tubbs's son, Martin, took great pride in polishing the suite because his mother told him that from the day it was delivered the only treatment it had received was wax polish and 'elbow grease'.

When the furniture was too large for a flat to which Mr Tubbs was moving, he approached Sotheby's and Christie's, who at this time would not handle such 'second-hand furniture', and it was Douglas Tubbs's suggestion that it should be offered to the Museum, because of a family connection with Cheltenham.

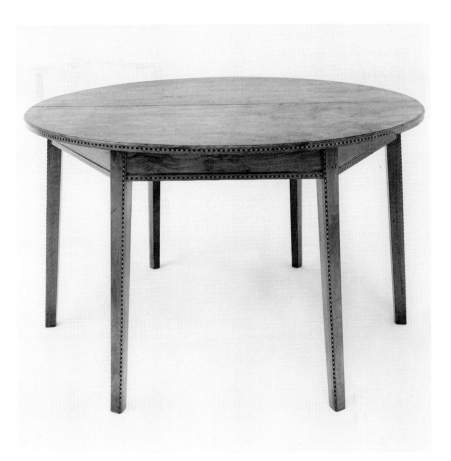

Fig.135 **Cat.48**

49 Set of eight dining chairs (two armchairs and six small chairs)

Designed by Peter Waals after Ernest Gimson and made at Chalford in 1923.

English walnut, inlaid on the back splats with an ebony and holly chequered bead. Seats covered in pink pigskin with coarse black fabric underneath. The chairs were made without corner blocks but these have been added to one at a later date because the joints were loose. The leather has faded slightly and is less orangey-pink than originally .

Marked in pencil inside front rail with numbers 1—8.

Armchair $42\frac{1}{8} \times 22\frac{7}{8} \times 16\frac{1}{2}$; h. of seat $17\frac{3}{8}$ (1070 × 581 × 419; h. of seat 441)
Chair $39 \times 18\frac{7}{8} \times 17\frac{1}{2}$; h. of seat $17\frac{3}{8}$ (991 × 479 × 444; h. of seat 442)

Purchased in 1967 (see Cat.48). 1967.177.2-9

Record: GRO Waals's client book, p.46 'Messrs Percy Tubbs & Son & Duncan, Architects, for Percy Tubbs Sept. 1923 6 small & 2 armchairs in walnut £54.0.0'.

En suite with the circular table (Cat.48).

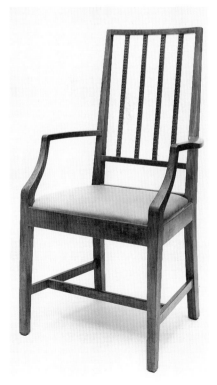

Fig.136 **Cat.49**

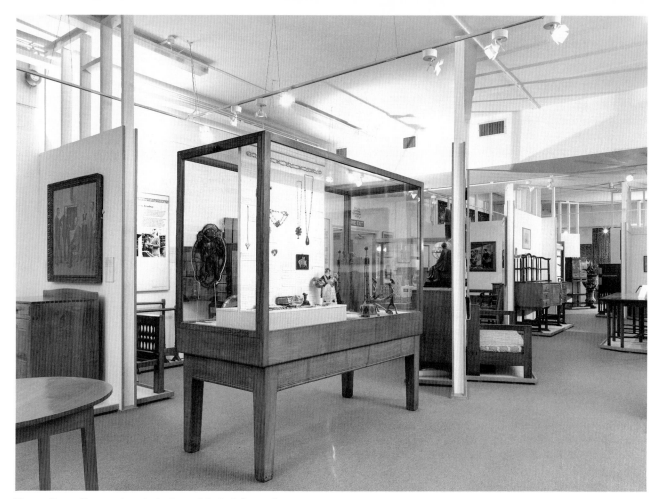

Fig.137 **Cat.50** *Show case in use in the Arts and Crafts Gallery at the Museum.*

50 Show case

Designed by Peter Waals and made in 1928.

English walnut with ebony handles, with waxed finish. Plate glass panels. Locks by the Western Trading Co, Gloucester.

$77\frac{5}{8} \times 75\frac{3}{4} \times 33\frac{7}{8}$ (1972 × 1925 × 860)

Commissioned in 1927 from Peter Waals by D. W. Herdman, Librarian and Curator at Cheltenham Museum, for £44. 1993.344

Correspondence in the Museum's files shows that D. W. Herdman was eager that Waals should design this piece so that the Museum would have at least one case made 'on first-class lines' and that 'it would do something to take away the reproach that while we have craft exhibitions we do not possess a modern example ourselves'. 'Do please help me!', he finished.[1]

Waals was not keen on the commission because the price suggested by the Museum (£40) would not cover all his costs and he was concerned about the possible breakage of expensive plate glass. He accepted the job but found, as he anticipated, that the agreed price was not adequate.

The letters also indicate that the case was made with two platforms inside and old photographs show two stands which survive. These are of unpolished brown ebony.

1. CAGM, Daniel W. Herdman to Peter Waals, 27.10.27.

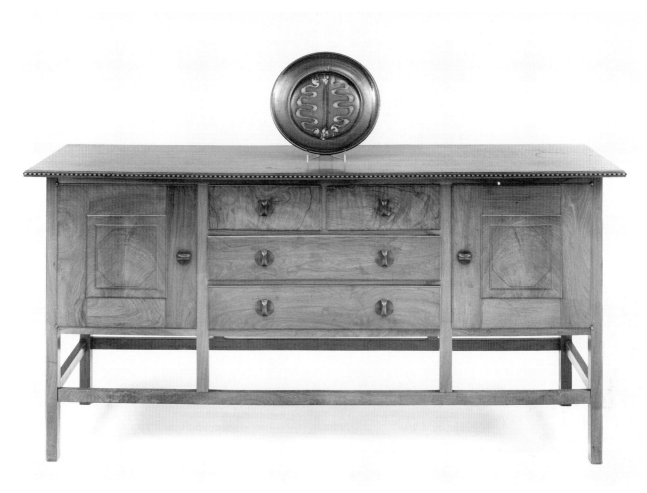

Fig.138 **Cat.51** *The dish is by Ray Finch, Winchcombe Pottery, 1967.*

51 Sideboard

Designed by Peter Waals after Sidney Barnsley and made at Chalford, probably around 1928-37.

English walnut with a line of ebony and holly inlay around the top. Brass hinges.

$37 \times 78 \times 27\frac{3}{4}$ (940 × 1976 × 602)

Purchased in 1965 from the executors of Arthur Mitchell for £140 (see p.111), with a 45 per cent grant from the V&A Purchase Grant Fund. 1965.91.

Record: CAGM Glenfall House sale catalogue, 24-25.11.1965, lot 619.

The sideboard was used in the entrance hall at Glenfall House.

Its dating is problematic because it does not appear in Waals's ledger but the piece seems rather too substantial to have been made without a client. It is possible, however, that it was made for exhibition.

A.E.Bradshaw dates it to 1928.[1] *Handmade Woodwork of the Twentieth Century* was published in 1962 before Arthur Mitchell's death, so this information could have come from him, though the caption on the photograph suggests that it did not.

The design is close to that of a sideboard by Sidney Barnsley in the Leicestershire Museums' collection.[2]

1. p.25.
2. See A.Carruthers, *Ernest Gimson and the Cotswold Group of Craftsmen*, Leicester 1978, p.35.

52 Dressing table

Designed by Peter Waals and made at Chalford in 1929. Handles made by Norman Bucknell.

Mahogany with ebony inlay and brass handles with incised decoration. The wood is very faded. Lock by Chubb, London.

$35\frac{3}{4} \times 78\frac{1}{2} \times 24\frac{3}{4}$ (907 × 1994 × 628)

Purchased in 1972 for £750 with grants from the W.A.Cadbury Charitable Trust and the National Art-Collections Fund. 1972.26.1

Record: GRO Waals's client book, p.67, Sept 1929, Arthur Mitchell ... 'Mahogany dressing table & mirror £130.0.0'.
CAGM Glenfall House sale catalogue, lot 598, £200.

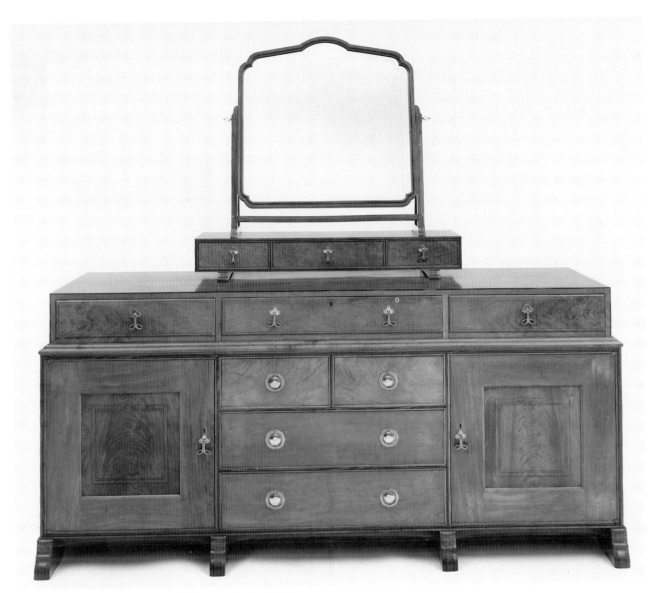

Fig.139 **Cats 52 and 53** *Dressing table and toilet mirror by Peter Waals, 1929.*

| ### 53 Toilet mirror | ### 54 Cigar cabinet |

The piece was purchased by the vendor, a Cheltenham man, at the sale of Arthur Mitchell's effects in 1965 (see p.111).

Commissioned by Arthur Mitchell for his house in Charlton Kings, it was used in the main bedroom with the matching mirror (Cat.53). The fading of the timber, which was noted in 1965, was probably due to the fact that Mitchell had the house glazed with 'Vita-glass', which optimised ultra-violet light. Waals displayed the suite at the Arts and Crafts Exhibition at the Royal Academy in 1931 and Sir George Trevelyan remembers the rich effect of the mahogany at that time.

53 Toilet mirror

Designed by Peter Waals and made in 1929. Handles by Norman Bucknell.

Mahogany with cedar drawer linings and brass handles with incised decoration. The wood is badly faded.
 Inscribed in pencil on backs of drawers, Left, Right and Centre.

$35\frac{1}{2} \times 39 \times 12\frac{5}{8}$ (901 × 991 × 320)

Purchased in 1972 for £350 with grants from the W. A. Cadbury Charitable Trust and the National Art-Collections Fund. 1972.26.2

Record: GRO Waals's client book, p.67, Arthur Mitchell ... Sept 1929 'Mahogany dressing table & mirror £130.0.0'.
CAGM Glenfall House sale catalogue, lot 599, £45.

En suite with Cat.52.

54 Cigar cabinet

Designed by Peter Waals and made in 1929.

English oak, wax polished, with macassar ebony handles and lock-plate and brass hinges. Lock by Chubb. An asbestos lining was added to the cabinet in 1930 and removed in the 1970s.

$65\frac{1}{2} \times 38\frac{1}{2} \times 19\frac{5}{8}$ (1664 × 978 × 498)

Purchased in 1965 from the executors of Arthur Mitchell for £70 (see p.111), with a grant from the W. A. Cadbury Charitable Trust. 1965.87

Design: CAGM 1980.1130, undated (Fig.131).

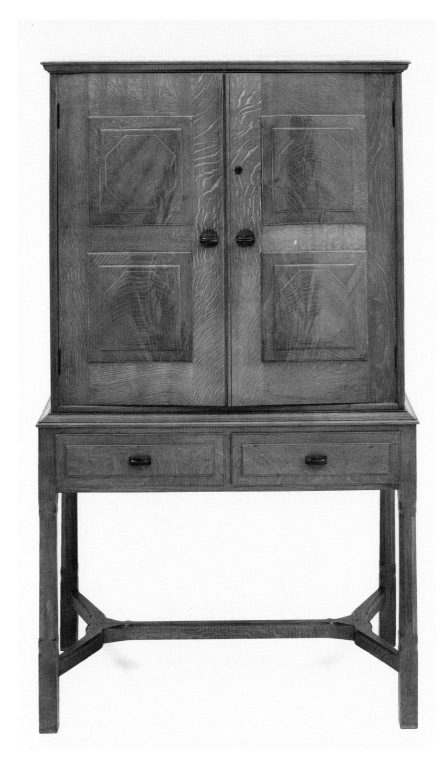

Fig.140 **Cat.54**

Fig.141 **Cat.55**

55 Wall mirror

Designed by Peter Waals after Ernest Gimson and made at Chalford, around 1929-37

English walnut and macassar ebony frame with plate glass mirror. Wax polished.

$23\frac{1}{2} \times 29\frac{3}{4} \times 1\frac{3}{4}$ (597 × 755 × 45)

Purchased in 1965 from the executors of Arthur Mitchell for £38 (see p.111), with a grant from the W. A. Cadbury Charitable Trust. 1965.85

Record: CAGM Glenfall House sale catalogue, 24-25.11.1965, lot 579.

At Glenfall House the mirror hung in the entrance hall above the coffer (Cat.63). It does not appear in Waals's ledger, which may mean that it was made as stock and bought by Mitchell at an exhibition, or that it dates from the period 1936-7 which is not covered by the client book.

56 Table

Designed by Peter Waals after Ernest Gimson and made at Chalford, around 1929-37

English oak with macassar ebony handles. Oak drawer sides and back and cedar lining. Wax polished.
 Back rail inscribed inside in pencil Back Rail.

$30\frac{7}{8} \times 33 \times 20\frac{5}{8}$ (784 × 836 × 525)

Purchased in 1970 for £50 with a contribution from the Leslie Young Bequest 1970.261

Record: CAGM Glenfall House sale catalogue, lot 612.

Record: GRO Waals's client book, p.67 'Arthur Mitchell ... Sept 1929 Oak cigar cabinet £40.0.0. 1930 Lining cigar cabinet with asbestos £4.10.0'.
CAGM Glenfall House sale catalogue, 24-25.11.1965, lot 597.

Used in the Smoking Room/Library at Glenfall House, this cabinet appears in one of the very few photographs of Mitchell's furniture *in situ*, reproduced in Gordon Russell's *The Things We See: Furniture.*[1]
 See Fig.131.

1. West Drayton 1947, p.36.

The table was bought by the vendor, a Cheltenham man, at the sale of Arthur Mitchell's effects in 1965 (see p.111). It is not in Waals's ledger, so probably dates from 1936-7 unless Mitchell purchased it from the workshop or an exhibition. This is the kind of small piece that could have been produced when commissions were slack.

57 Umbrella stand

Designed by Peter Waals and made in his workshop at Chalford in 1930. Metal drip tray probably made by Alfred Bucknell.

English oak, wax polished, with a wrought steel tray painted black. The framework is made of small sections of wood with chamfered edges around thin vertical panels. The tenons have been shaped at the ends and the tray has incised decoration of diagonal lines around the edges. The wood is badly marked by water.

 Marked in ink underneath the base

P WAALS

CHALFORD

GLOS 1930

$27\frac{1}{8} \times 37\frac{1}{2} \times 21\frac{1}{2}$ (689 × 951 × 546)

Purchased in 1965 from the executors of Arthur Mitchell for £20 (see p.111), with a grant from the W. A. Cadbury Charitable Trust. 1965.83

Record: GRO Waals's client book, p.67 'Arthur Mitchell Esq. ... 1930 Umbrella stand in hall £7.15.0'.
CAGM Sale catalogue, Glenfall House 24-25.11.1965, lot 303.

Commissioned by Arthur Mitchell and used at his house in Charlton Kings, probably in a downstairs lavatory for women, according to his son, Lawrence.
 Norman Bucknell, who trained as a cabinet-maker with Waals, has said that the piece would not have been difficult to make, would have taken two or three weeks, and was probably made by an apprentice or one of the younger craftsmen. He thought that the tray must have been made by his father, Alfred Bucknell.

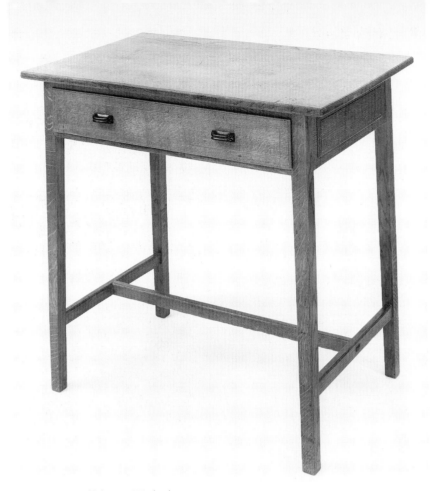

Fig.142 **Cat.56** *Table by Peter Waals, about 1929-37.*

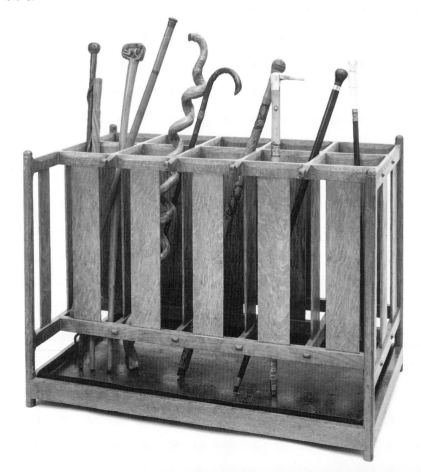

Fig.143 **Cat.57** *The sticks are from the Museum collection.*

58 Stick stand

Designed by Peter Waals and made in his workshop at Chalford in 1930.

English oak, wax polished. The construction of the frame and panels is very similar to, and is perhaps intended to match, the umbrella stand (Cat.57). All dowel joints are exposed.

$59\frac{3}{4} \times 35\frac{1}{4} \times 24$ (1518 × 895 × 61)

Purchased in 1965 from the executors of Arthur Mitchell for £15 (see p.111), with a grant from the W. A. Cadbury Charitable Trust. 1965.84

Record: GRO Waals's client book, p.67, 'Arthur Mitchell … 1930 High-back stick stand £10.10.0.
CAGM Glenfall House sale catalogue, 24 - 25.11.1965, lot 304.

Commissioned by Arthur Mitchell and placed in the gentlemen's lavatory at Glenfall House.

59 Radiator cover

Designed by Peter Waals and made at Chalford in 1930.

Oak. A shelf was added inside so the piece could be used as a shoe cupboard by the donor, and this has been removed.

$26\frac{1}{4} \times 57\frac{3}{8} \times 10\frac{3}{4}$ (667 × 1457 × 272)

Given in 1983 by Mrs P. Bayley. 1983.152

Record: Waals's client book, p.67, 'Arthur Mitchell 1930 Oak radiator casing in hall £4.18.0'.
CAGM Sale catalogue, Glenfall House, 24 - 25.11.1965, lot 608.

Commissioned by Arthur Mitchell for Glenfall House (see p.111) and purchased by Mr and Mrs Bayley at the sale in 1965.

Virtually a fixture rather than movable furniture, this is typical of the kind of everyday fittings Waals and Edward Barnsley were happy to undertake for their clients.

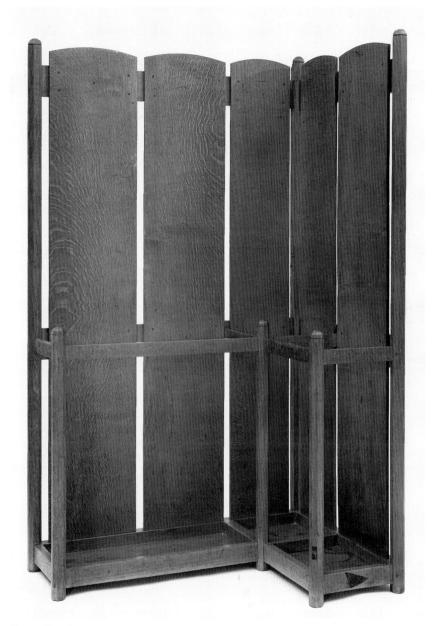

Fig.144 **Cat.58**

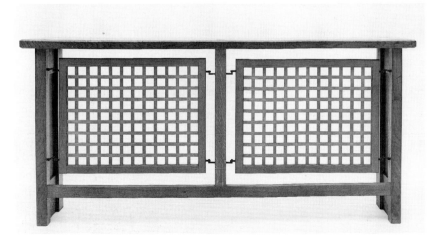

Fig.145 **Cat.59**

60 Table

Designed by Peter Waals after Ernest Gimson and made at Chalford in 1931.

English walnut, wax polished. Exposed tenons on the feet and rails.

$26\frac{7}{8} \times 41\frac{1}{2} \times 42\frac{1}{8}$ (682 × 1055 × 1070)

Purchased in 1965 from the executors of Arthur Mitchell for £65 (see p.111), with a 45 per cent grant from the V&A Purchase Grant Fund. 1965.89

Design: CAGM 1941.222.390, Gimson design of about 1913, similar.

Record: GRO Waals's client book, p.67 'Arthur Mitchell ... April 1931 Circular table £13'.
CAGM Glenfall House sale catalogue, 24-25.11.1965, lot 602.

According to Lawrence Mitchell, the table was used in the Smoking Room/Library.

It is possible that Waals adopted this form of leg, which changes from square to octagon, from Voysey, for whom he made some pieces in 1921-3.[1]

1. See M. Comino, *Gimson and the Barnsleys: 'Wonderful furniture of a commonplace kind'*, London 1980, pp.199-200.

61 Longcase clock

Case designed by Peter Waals and made in 1931, with panels designed and carved by Norman Jewson. Clock movement by W.E. Evans, Birmingham.

English oak case with openwork carving on the side panels of the top in a design of briar roses. Brass face with enamelled decoration in the lunette. The movement gives a choice between two chimes, Whittington or Westminster. Where the heavy weights have fallen, the inside of the base is damaged.
A small brass plaque inside the door is inscribed
PRESENTED BY WW, HA & AE BUTLER TO MR ARTHUR MITCHELL 1908.

$89\frac{3}{4} \times 20\frac{1}{4} \times 13$ (2280 × 514 × 330)

Purchased in 1965 from the executors of Arthur Mitchell for £100 (see p.111), with a grant from the W.A. Cadbury Charitable Trust. 1965.90

Record: GRO Waals's client book, p.67 'Arthur Mitchell ... August 1931 Oak clock case £58.0.0'.
CAGM Glenfall House sale catalogue, lot 606.

The clock was used in the Smoking Room/Library at Glenfall House.

Norman Jewson (1884-1975), who made the carved panels, trained as an architect with Herbert Ibberson in London and then worked with Gimson at Sapperton. After Gimson's death, Jewson set up on his own and had quite a thriving practice, specialising particularly in the sensitive restoration of old houses but also building new.

Along with his architectural work, Jewson practised several crafts, as Gimson had done, and he designed metalwork which was made for him by Alfred and Norman Bucknell. For Arthur Mitchell he carried out plasterwork at Glenfall House.

Jewson shared with Mitchell a mutual friendship with Fred Griggs, whose prints Mitchell avidly collected, and was something of a connecting link between the Sapperton group and the craftworkers in Campden. His *By Chance I Did Rove* has become a minor classic of rural literature for its vivid descriptions of the people and places in both areas.

See Fig.39.

62 Cabinet

Designed by Peter Waals and made at Chalford in 1931.

Walnut with fine feathered walnut panels and ebony and holly stringing. Ebony inlaid letters, M.E.PLAYNE, and macassar ebony handles. Cedar of lebanon drawer sides and linings, shelves and back. The shelves are supported by wooden pegs. Brass hinges lacquered to the same colour as the wood. Made in two parts for ease of moving. Locks by Hobbs & Co, and door fastener by Gays & Son.
Inscribed in ink under the left drawer (Fig.20).

$83 \times 38\frac{3}{4} \times 19\frac{3}{8}$ (2108 × 984 × 492)

Given in 1978 by the Governors of the Gloucestershire College of Education. 1982.196

Design: CAGM 1982.197, signed but undated. The design shows the piece as executed but without the inlaid letters.

This piece was known as the 'Playne Memorial Cabinet' and was housed in the Staff Common Room of the Gloucestershire College of Education, which closed in 1980. It does not appear in Waals's client book under any of the names associated with it, but should do so if it dates from

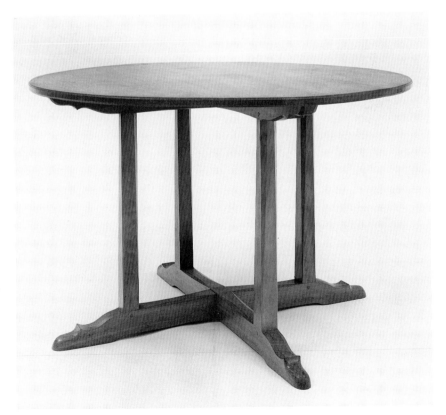

Fig.146 **Cat.60**

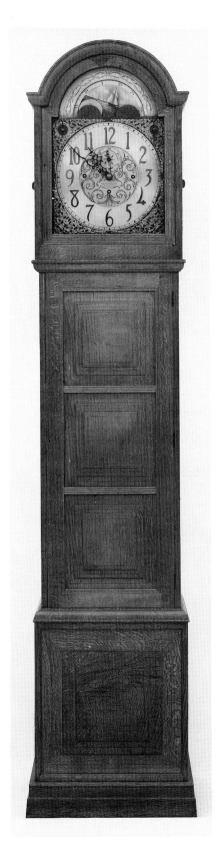

Fig.147 **Cat.61**

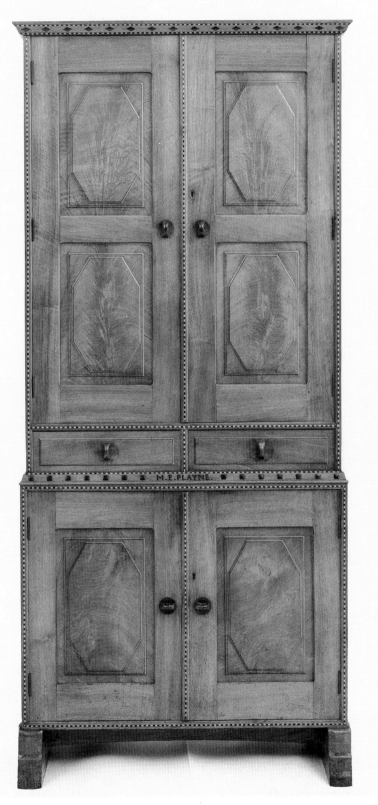

Fig.148 **Cat.62**

1931 as inscribed. This means that we cannot be sure who commissioned and presented it.

It was certainly a memorial to Mary Elizabeth Playne (1848-1923), a sister of Beatrice Webb and one of the nine daughters of Richard Potter of Stonehouse, Gloucestershire.[1] She married Arthur Playne of Minchinhampton and became actively involved in trying to improve the conditions of the rural poor by, among other things, founding the Gloucester School of Cookery, which became part of the Gloucestershire College of Education. She was Chairman of the Governors from 1893 to 1909.

Another member of the Playne family had alterations carried out at a house in Minchinhampton by one of the Barnsleys in the early 1920s, so there is a history of family interest in the Arts and Crafts.

Norman Bucknell has said that in his opinion, based on details such as the spacing of the chequered inlay, the piece was made by Harry Davoll, who was the most accurate of the craftsmen.

See Fig.20.

1. See B. Caine, *Destined to Be Wives: The Sisters of Beatrice Webb*, Oxford 1986, p.160.

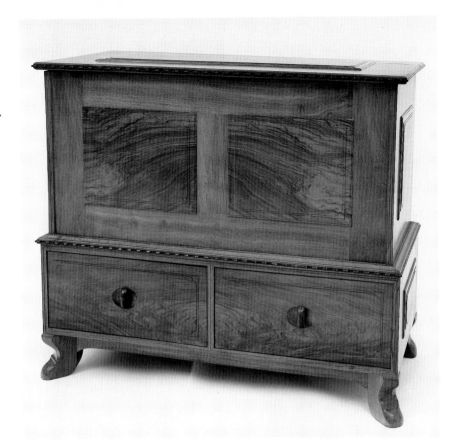

Fig.149 **Cat.63**

63 Coffer

Designed by Peter Waals and made at Chalford, after about 1931.

English walnut with macassar ebony inlay.

$42 \times 49 \times 22\frac{5}{8}$ (1067 × 1245 × 568)

Purchased in 1965 from the executors of Arthur Mitchell for £90 (see p.111), with a 45 per cent grant from the V&A Purchase Grant Fund. 1965.88

Record: CAGM Glenfall House sale catalogue, 24-25.11.1965, lot 600.

Since this coffer is not in Waals's client book it could date from 1936-7, or it is possible that it was made without a client and was purchased by Mitchell from an exhibition. It was used in the entrance hall at Glenfall House with the mirror (Cat.55) hanging above it.

This form of carved foot was a design of Waals's own, based on something from his native Holland, according to Sir George Trevelyan, and was introduced into his work in about 1931-2. Edward Barnsley believed that a pupil of Waals persuaded him to use these feet, and that they were a mistake.

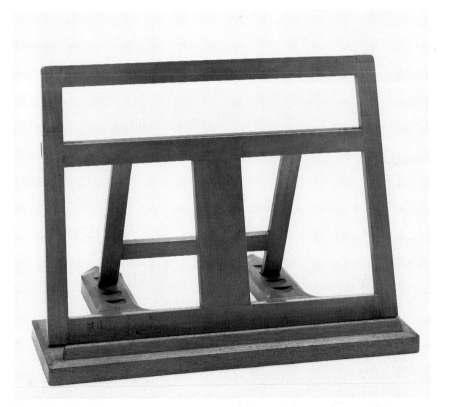

Fig.150 **Cat.64**

64 Picture stand or easel

Designed by Peter Waals and made at Chalford, about 1935.

Mahogany with brass hinges.

$15\frac{3}{4} \times 22 \times 11\frac{1}{2}$ (400 × 559 × 290)

Purchased in 1935 from Peter Waals for £2. 1935.190

This small stand for use on a table top was bought from the exhibition of Cotswold Art and Craftsmanship at Cheltenham Museum in 1935.[1] There is no correspondence about it in museum files and it was probably made as a stock item rather than as a commission.

1. Cat.231.

65 Desk show case

Designed by Peter Waals and made at Chalford, 1936-7.

Honduras mahogany and glass on a base of dark-stained oak. Brass handles, label holders and locks.

$41\frac{1}{2} \times 90\frac{7}{8} \times 56\frac{3}{4}$ (1054 × 2309 × 1442)

Commissioned in 1936 from Peter Waals by D. W. Herdman, Librarian and Curator, for Cheltenham Museum for £76. 1993.345

The brief (dated 7.5.36) was to supply a case similar to one already in use in the Museum and three quotations were received, one from Edmonds & Co at £105, one from Cheltenham Shopfitting Co at £85, and one from Waals at £76 in mahogany or £80 in walnut. The order was given to Waals in June 1936 and in January (12.1.37) of the following year Herdman asked for early delivery. Waals appears to have been putting his craftsmen to work on other more urgent or lucrative jobs and replied that he was sorry to have taken too much advantage of Herdman's willingness to allow him time (13.1.37). In March, when the case was delivered, he wrote that it had cost far more than he had expected, largely because of a rise in the price of materials, and that any repeat would cost £112.

Herdman (8.3.37) was sorry that the new case 'of which we greatly approve' had cost more, but pointed out that it had been ordered a long time ago so material costs should not have gone up. He was concerned that Waals had lost over it, considered the repeat price of £112 prohibitive, and stated that he was thoroughly satisfied with the craftsmanship.

66 Chair

Designed by Peter Waals after Ernest Gimson and made at Chalford, about 1936-7.

Walnut inlaid with ebony stringing and with chamfered ebony uprights in the back. Upholstered drop-in seat covered in dark blue leather, which appears to have been replaced at some time. There are no corner blocks holding the seat rails and legs together because Waals believed that the construction should be strong enough without.

Marked under the seat with incised numerals VIII *and on the seat rail* V.

$35\frac{3}{4} \times 18\frac{3}{4} \times 17\frac{5}{8}$; h. of seat 17 (908 × 476 × 448; h. of seat 432)

Purchased in 1937 from Peter Waals at the Painswick Exhibition, for £8.10.0 from the Friends Fund. 1937.282

In the Catalogue of an Exhibition of Gloucestershire Art and Craftsmanship this

Fig.151 **Cat.65**, *with Owen Scrubey's toolbox, given by Mr and Mrs R. H. Heaven.*

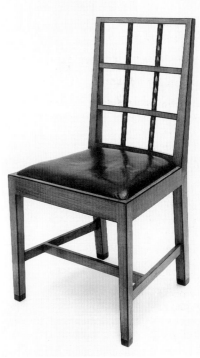

Fig.152 **Cat.66**

piece appears as catalogue no. 172, 'Small chair in ebony and walnut £9.9s.'

A set of four almost identical chairs was made at Chalford for the Misses Goddard in 1930 and is now in the collection of Leicestershire Museums.[1]

The different numbers incised on the seat and rail suggest that it was part of a set and the seats have been mixed.

1. 456.1963/1-4.

67* Bookcase

Designed by Peter Waals after Ernest Gimson and made in his workshop by Ernest Smith in 1936-7.

Macassar ebony with a French-polished and waxed finish. The grain of the timber is arranged to make a dramatic rhomboid pattern on the doors. Locks by Hobbs & Co.

$71\frac{1}{4} \times 55 \times 13\frac{7}{8}$ (1810 × 1396 × 352)

Given in 1981 by Mr & Mrs J. Cadbury. 1981.1359

This piece does not appear in Waals's workshop book, but it is known that it was made for John Cadbury, the son of William Cadbury, as a wedding gift from the firm.

In an interview for a radio programme made by Philip Donnellan, Ernest Smith mentioned this as a piece he was making when Waals died, and said that they were running out of ebony and the patterns were not perfectly matched, but Peter had told him to pick out the most suitable pieces and make the best of it.[1]

See Col. Fig.59.

1. EBET Donnellan interview.

68 Table

Designed by Peter Waals after Ernest Gimson and made at Chalford, probably in about 1936-7.

English oak.

$30\frac{1}{4} \times 66\frac{1}{8} \times 53\frac{1}{2}$ (770 × 1068 × 1036)

Purchased in 1972 for £750 with grants from the W. A. Cadbury Charitable Trust and the National Art-Collections Fund. 1972.27

Record: CAGM Glenfall House sale catalogue, 24-25.11.1965, lot 609.

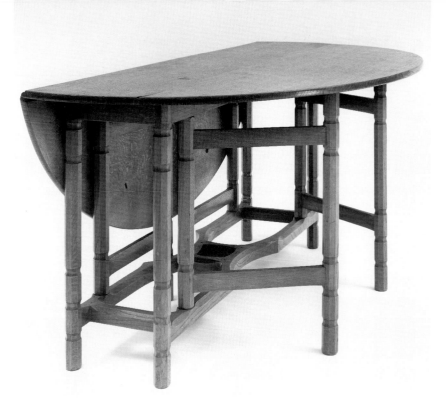

Fig.153 **Cat.68**

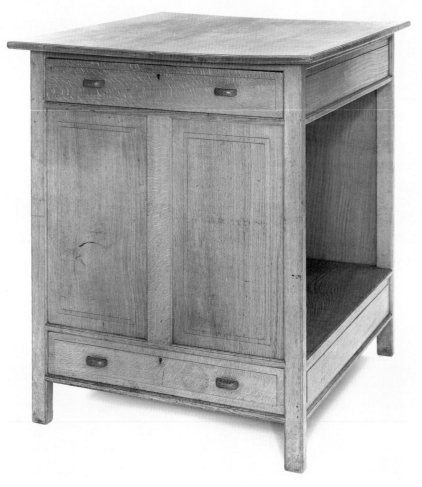

Fig.154 **Cat.70**

Commissioned by Arthur Mitchell or purchased by him from Waals's stock. The dating of the piece is uncertain because it does not appear in Waals's client book with other items ordered by Mitchell. It was purchased by a Cheltenham man in 1965 and sold by him in 1972.

The table was used in a large lobby at the back of the house where the Mitchell family often had tea because it was a sunny area.

69 Bookcase

Designed by Peter Waals and made at Chalford, probably in 1936-7.

English oak, wax polished, with shelves supported by round pegs. The original form of the piece is not clear but it has been altered at some time, not very well, and may originally have been made to fit in a corner. The central section has been made deeper and has had vertical compartments added inside the lower cupboard. The cornice no longer fits together. Locks by Chubb, London.

$84\frac{1}{4} \times 144\frac{1}{8} \times 23\frac{1}{4}$ (2014 × 3068 × 59)

Purchased in 1965 from the executors of Arthur Mitchell for £105 (see p.111), with a 45 per cent grant from the V&A Purchase Grant Fund. 1965.86

Record: CAGM Glenfall House sale catalogue, 24-25.11.1965, lot 595.

This piece is not included in the list of items made by Waals for Mitchell in the workshop ledger, which suggests a late date. It is even possible that it was made after Waals's death when his widow was attempting to keep the workshops going.

In the Glenfall House sale catalogue, it appears in the library. It may originally have been on the landing at Glenfall House, or in a small upstairs study used by Mitchell after about 1929, but it was later moved to the hallway.

Lawrence Mitchell believes the piece might have been altered when his father turned from collecting sporting books to prints by Griggs and others, and that Mitchell may have brought in a local carpenter to carry out the alteration rather than Waals.

Fig.155 **Cat.69** *Only one-third of the piece is shown. The books are in the Max Burrough Collection and the Alec Miller Collection.*

70 Bookshelf

Designed by Peter Waals and made at Chalford, probably 1936-7.

Oak with cedar drawer sides and linings and brown oak handles. Panelled construction.

$39\frac{3}{4} \times 40 \times 34\frac{1}{4}$ (1010 × 1016 × 870)

Given in 1940 by Mr Walter Butt. 1993.346

Commissioned by the donor, who lived at Hyde Lodge in Chalford, from Peter Waals, probably in 1936 or 1937 since the piece does not appear in the Waals client book.

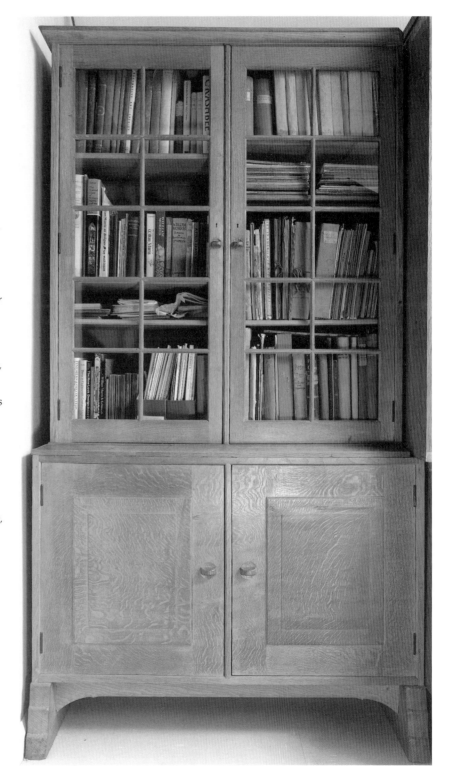

Mr Butt wrote to D.W.Herdman on 20 November 1940 saying that he was sending 'a small bookshelf made for my big books by Mr Waals of Chalford' because he had sold his house and books and had no further use for it. The two drawers were for his watercolours.

The piece was not accessioned into the Museum collection but was used for storage and was included in the equipment inventory as no.125, described as a map-case by Edward Barnsley with a note about the attribution to Waals. It is not recorded in the Barnsley workshop records and there seems no reason to doubt the donor's information.

71 Bed

Designed by Peter Waals and made at Chalford, probably in 1936-7. Bed by Heal's, London.

Oak with wax finish. Divan bed covered in striped ticking.

Headboard 44 × 36$\frac{1}{8}$ × 1$\frac{5}{8}$
(1117 × 917 × 42)

Bequeathed in 1962 by Mrs Mary Agnes Herdman. 1962.118

This bed does not feature in Waals's client book and must date from 1936-7 unless it was bought from the workshop as a stock piece or was purchased by the Herdmans secondhand.

Fig.156 **Cat.71**

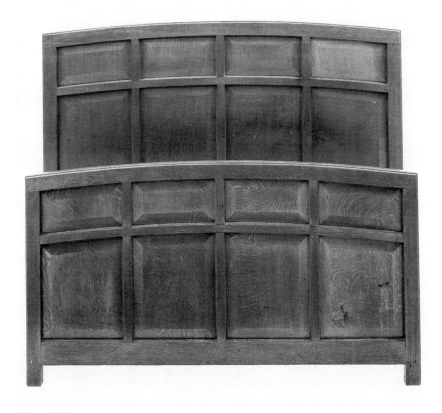

Fig.157 **Cat.73**

72 Wardrobe

Designed by Peter Waals and made at Chalford, probably in 1936-7.

English oak with brass lock, fastener and hinges, and chromed hanging rail. The interior is fitted with two rails and five sliding trays in the lower right-hand side. Exposed cogged dovetails at the top. Lock by Martin & Co, Birmingham.

$80\frac{1}{8} \times 48\frac{1}{2} \times 23$ (2035 × 1232 × 584)

Purchased in 1967 with a matching bed (Cat.73) for £150 with a 50 per cent grant from the V&A Purchase Grant Fund. 1967.92

Purchased from John Bridgeman, who was Head of the Department of Handicraft at the East Midlands Training College in Loughborough where Waals was adviser on design from 1935-7. It seems likely that the wardrobe and bed were commissioned then.

73 Double bedstead

Designed by Peter Waals and made at Chalford, probably 1936-7.

English oak with faceted panels and chamfered rails. There is evidence of castors which have been removed at some time.

Headboard $48 \times 54\frac{3}{4} \times 1\frac{3}{4}$
(1218 × 1390 × 45)
Footboard $30 \times 54\frac{3}{4} \times 1\frac{3}{4}$
(762 × 1390 × 45)

Purchased in 1967 (see Cat.72). 1967.93

The bed is presumably en suite with the wardrobe (Cat.72) as the design of the panels is very similar.

　The mattress now with it is not the original but was bought by the Museum for display purposes.

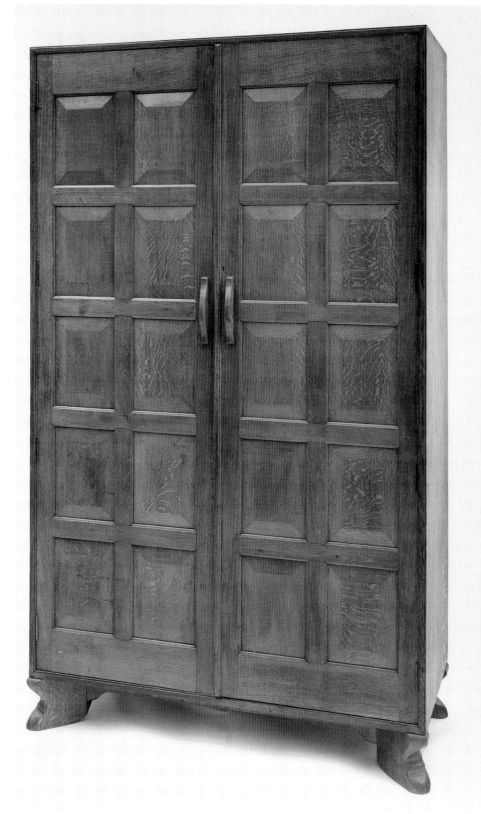

Fig.158 **Cat.72**

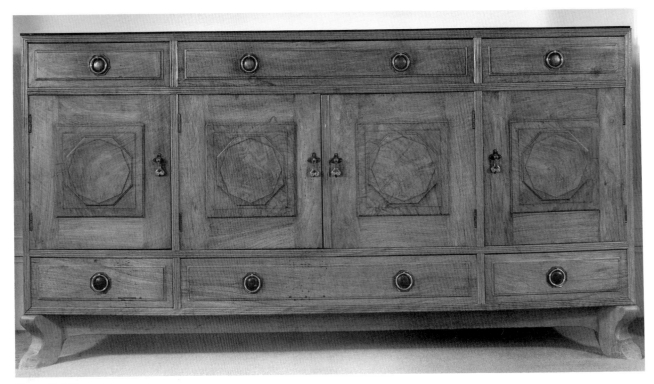

Fig.159 **Cat.74**

74 Sideboard

Designed by Peter Waals and made by students at the East Midlands Training College in Loughborough, in 1935-7. Handles probably by Norman Bucknell.

English walnut with oak back panel, drawer sides and backs, and oak-faced ply drawer linings. Brass ring and drop handles, the latter concealing the key holes. Plate glass protective top. The upper corners have decorative cogged dovetails, and through tenons appear on the top. Inside the drawers there are trays and dividers and a fitting to hold cutlery. On the drawers, the dovetails are of the narrow English type rather than the wider form usually used in Waals's workshop. The piece is very faded. Locks by Hobbs & Co, London, and door stay by VRON.

$35\frac{3}{4} \times 69\frac{3}{8} \times 21\frac{3}{4}$ (908 × 1762 × 553)

Purchased in 1967 for £250 with a donation from a private charitable trust. 1967.91

According to a letter from Sir George Trevelyan, who was instrumental in enabling the Museum to acquire this piece from John Bridgeman (see Cat.72), it was made 'under Waals' direction by first-rate craftsmen at Loughborough'.[1] This dates it closely to the period when Waals was Design Adviser at the College. Bridgeman's office at the college was equipped with items designed by Waals and clearly he extended his enthusiasm to the furnishing of his own house.

It is extremely well made with beautifully finished fittings in the drawers.

An earlier sideboard of this design belonged to George Trevelyan when he was Warden at Attingham Park, The Shropshire Adult College, near Shrewsbury.

1. George Trevelyan to Harold G. Fletcher, 11.4.1967.

Arthur Romney Green
(1872-1945)

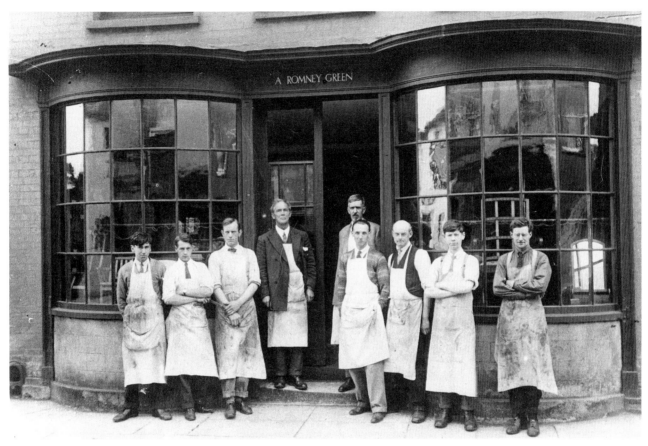

Fig.160 *Romney Green and his staff at Christchurch in the 1920s. Green is fourth from the left and Eric Sharpe fifth.*

As a boy of fifteen, Romney Green built himself a sailing boat. Some twelve or thirteen years later, when he was teaching mathematics at a boys' school in Devon, he made another, and a colleague seeing it exclaimed, 'If I could do work like that I should chuck this dull business of teaching and set up as a gentleman carpenter'.[1] As he had recently become interested in the ideas of William Morris, this appealed to Green.

He was thus inspired to try a new career, and set up a workshop first at Haslemere in Surrey, then at Hammersmith, and finally from 1919 or 1920, at 3 Bridge Street, Christchurch in Hampshire (Fig.160). The main workshop here accommodated five or six benches and an old building at the back had two or three rooms filled with more. Stanley Davies later described how Green 'attracted around him a medley of craftsmen in differing crafts and of varying abilities as well as pupils, some working quite independently, but all willing to give a helping hand when needed. Every Quarter there was a "Company" meeting in the large

upstairs room … when all associated with the place would meet and Green would show us the books and tell us how the financial affairs of the business stood, and say how much he himself expected to gain from the work of each man and pupil. I believe he would have liked to start a profit sharing scheme but the profits were not large enough to warrant it'.[2]

On Sunday evenings there were readings and discussions, 'with visiting fellow craftsmen, artists, poets, social reformers, eccentrics and forward looking people', and Davies remembered his association with Green as 'an education, inspiration, enlightenment and joy'.[3]

Within the workshop, Green believed in the value of himself executing at least some of the pieces he designed, and directly supervising the rest. Only in this way, he felt, could improvements be made to the work, and in discussing draw tables, a type about which he felt proprietorial, he wrote that he was 'so far from standardising my designs that I still expect to produce the best I have yet made for the next customer who wants it'.[4]

In 1904, Green had visited Gimson's workshop at Sapperton and his admiration for the work of Sidney Barnsley and Gimson is clear from his pamphlet, *Instead of a Catalogue*, of 1928. How much the development of his style owes to them, and how much he worked out himself from first principles, is difficult to evaluate, but his furniture certainly belongs in the same tradition. English timbers were generally used with constructional details featuring as decorative elements along with chamfering and simple inlays. His conscious use of mathematical principles for working out proportions is more unusual.

Romney Green had a local clientele, but he was a member of the Arts and Crafts Exhibition Society from 1926 and his work was also widely known through international exhibitions to which he contributed, in Paris, Milan and St Louis. From his Hammersmith days he had many contacts in Arts and Crafts circles and his furniture was shown at the New Handworkers' Gallery in London, which also published *Instead of a Catalogue*.

Throughout his life, Green pursued a range of interests. He was a keen yachtsman and boat-builder, a poet and writer on the crafts and social reform, and from 1931, supervisor of workshops for the unemployed in the distressed areas of England and Wales. His philosophy was 'to know wonderful things, to make beautiful things, to do adventurous things'.[5]

1. AHAG AH2880/92, biographical details written by Hockin-Jones.
2. AHAG AH2880/92, typescript entitled *The Christchurch Workshop*, dated 4.11.1967.
3. ibid.
4. *Instead of a Catalogue*, p.13.
5. AHAG AH2880/92, Hockin-Jones as above.

75 Chair

Designed and made by A. Romney Green at Christchurch in about 1920-5.

Walnut. The seat has an oak frame and leather cover with a wired frame to prevent sagging. It rests on corner blocks at the back and on the tops of the legs at the front.
 Metal tag under the seat embossed with Non-Sag and Pat. no.173358.

37 × 18¼ × 16½ ; h. of seat 17⅞
(937 × 464 × 420 ; h. of seat 441)

Given in 1978 by the executors of Stanley W. Davies. 1978.487

Design : AHAG AH2880/92, related but not identical, undated.

Presumably acquired by Davies when he worked for Green, the chair was mentioned in a letter to Oliver Morel[1] as Davies wanted advice on bequeathing certain pieces of furniture to museums. As a result, Cheltenham received this chair and a cabinet (Cat.82), and other items went to the V&A and to Abbot Hall.

Although the chair was described as suitable for sitting at a dining table, there is no suggestion in the correspondence that it was one of a set, and it is not known in which room it was used.

The design in Kendal is for an armchair with the back made of curved laths. Green described this as a 'wheatsheaf' and on the drawing gives detailed typed instructions on the mathematics of converting a straight wheatsheaf into a parabolic one. The curve of the arms and the gradient of the seat were also calculated mathematically.

1. AHAG AH2880/92 6.8.1972.

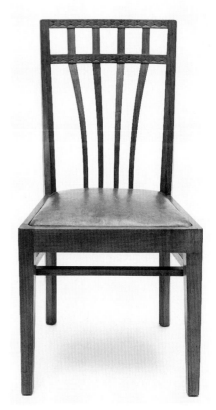

Fig.161 **Cat.75**

Eric Sharpe (1888-1966)

Eric Sharpe's background sounds like that of someone who was destined to become an artist-craftsman. He was born in Hampstead, went to school at Bedales, and from about 1907 trained as a draughtsman in the office of T. Hamilton Crawford. Much of his time in the years up to 1915 was spent in cycling all over England to visit churches and other buildings. At some time he also studied at the Central School of Arts and Crafts. Sharpe joined the Artists' Rifles in 1914 and travelled widely during the war, most significantly to Egypt. He studied Greek in the museum in Alexandria when on leave before demobilisation, and devised his monogram at this time, using it for his *Ex Libris* in 1918.

On his return home, Sharpe took up woodwork and in 1921 went to Romney Green's workshop at Christchurch. After eight years, a quarrel with Green precipitated a change, and in 1930 he had a house and workshop built for him by an architect friend, T. Lawrence Dale, with whom he collaborated on several large commissions. These included the carving on a screen at Stratton Audley Church in Oxfordshire, which was made by another friend, Edward Barnsley. In his new premises, Thorn at Martyr Worthy, near Winchester in Hampshire, Sharpe worked as a cabinet-maker and carver until his death. It seems that he intended to train pupils, but sadly he never did.

A brochure produced by Eric Sharpe in 1930 set out his position. He believed that 'The function of small workshops … is to keep alive and develop the best traditions of the craft, which are threatened by an Age of mechanical standardisation, and to preserve individuality with good workmanship'.[1] His furniture was to be largely hand-made, and he suggested that the opportunity to experiment and improve each piece was the major advantage of the small workshop where the designer and executant are one, for some new ideas only come through practical work at the bench.

In relation to style, he mentions three fundamentals — requirements, material and tools — and gives some examples of other important factors, such as harmonious proportions, contrasts of curved and straight lines, the repetition of forms and so on. Sharpe had visited Sapperton twice in 1914-16, and his admiration of Gimson's work is clear both from his own furniture and from the chapter he wrote on 'Woodwork' for John Farleigh's *Fifteen Craftsmen on their Crafts*, published in 1945.

Fig.162 *Eric Sharpe's monogram in Greek lettering on the armchair of 1943 (Cat.81).*

Sharpe's own unique contribution to twentieth-century crafts was to combine what he learned from Gimson and from Green with an enthusiasm for lettering and wood carving, resulting in some striking pieces, often with symbolic content. For this reason, he attracted commissions for ecclesiastical and presentation pieces, including ceremonial chairs for the University of Southampton and the Pharmaceutical Society of Great Britain and a Freedom Casket presented to Winston Churchill during the War. His domestic furniture followed in the Cotswold tradition, being made predominantly of solid English timbers with revealed construction and simple carved or inlaid details. It was sometimes marked with his monogram (Fig.162).

In his 1930 booklet, Sharpe wrote that 'Furniture designed specially for a room grows into that room, and improves and mellows with care and age, just as the house mellows into the landscape'.[2] The Museum is fortunate that, with the help of Oliver Morel, it was able to acquire a representative group of Sharpe's work, all from his own house.

1. AHAG AH2904/93, Untitled booklet of 1930.
2. ibid.

76* Settee

Designed and made by Eric Sharpe at Martyr Worthy, probably in 1929-30. Woven seat cover by Alice Hindson, and loose seat cover of fabric designed by William Morris and probably made by Sanderson's in the 1960s.

English oak with oak drawers sides and backs and plywood linings. Exposed dovetails and through tenons and dowels, with narrow dovetails on the drawers. Seat of horsehair covered in a woven linen and silk mixture, and loose cover of printed linen union.

Drawers marked 1 2 3. Two drawers also have printed paper labels on the undersides with a large V containing the words SILVEN *and* Made in England.

$27\frac{3}{4} \times 69\frac{1}{4} \times 21\frac{3}{4}$ (705 × 1752 × 552)

Given in 1967 by the Trustees of Eric Sharpe via Miss Joan Sharpe. 1967.103

Design: AHAG AH2904/93, undated.

Record: AHAG as above, undated photograph.

Oliver Morel remembers the settee in Sharpe's house in the early 1930s, so it probably dates from when Sharpe planned to move, though it is possible that he made it while at Romney Green's workshop.

It is also Oliver Morel's suggestion that the fabric was by Alice Hindson, a weaver from the New Forest with whom Sharpe often exhibited. She trained with Luther Hooper and specialised in the sophisticated technique of draw-loom weaving. In 1958 she wrote *Designer's Draw Loom*, published by Faber & Faber, and she and Sharpe designed the loom together. Her work is represented in the collection of the Crafts Study Centre at the Holburne Museum in Bath.

See Col. Fig.60.

77 Wall mirror

Designed and made by Eric Sharpe at Martyr Worthy, around 1930.

Mahogany with boxwood and ebony inlay of lines and circles.

$40\frac{1}{2} \times 18 \times \frac{7}{8}$ (1030 × 458 × 22)

Given in 1967 by the Trustees of Eric Sharpe via Miss Joan Sharpe. 1967.104

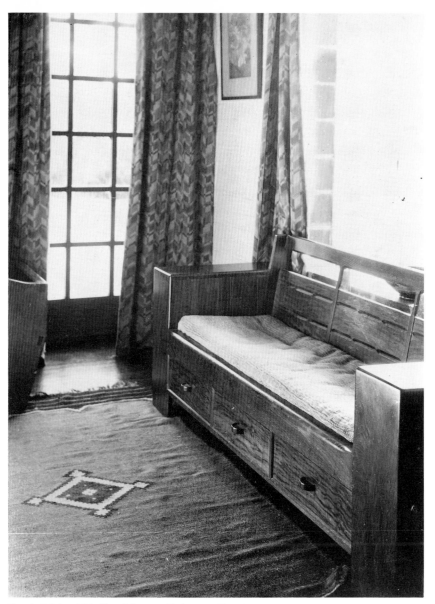

Fig.163 *Interior at Eric Sharpe's house, with the settee (Cat.76).*

78 Chest cabinet on stand

Designed and made by Eric Sharpe at Martyr Worthy, probably early 1930s.

English walnut with ebony handles fixed with brass screws. Oak drawer sides and backs, and plywood linings. Mahogany tray inside the top. There is a cupboard at the back similar to the one on the front. Exposed dovetails and dowels. The dovetails of the drawers are narrow.

Engraved inside lid with Sharpe's monogram.
Drawers marked in pencil L & R *and*
L R L R
1 1 2 2

$35\frac{1}{2} \times 37\frac{1}{2} \times 19\frac{1}{2}$ (901 × 951 × 494)

Given in 1967 by the Trustees of Eric Sharpe via Miss Joan Sharpe. 1967.102

A design for a similar piece is in the collections at Abbot Hall Art Gallery, Kendal.[1] The almost Art Deco shape of the rail was used by Sharpe on a piece of 1932, the McRobert chest, now lost, and Edward Barnsley also made furniture with this feature.

1. AH2904/93 Eric Sharpe Archive.

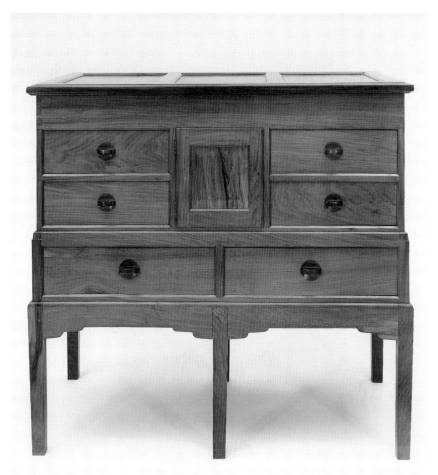

Fig.164 **Cat.77** Fig.165 **Cat.78**

79 Bookcase

Designed and made by Eric Sharpe at
Martyr Worthy, probably about 1935.

*English oak with plywood back. Large exposed
dovetails at the upper corners and through
tenons on the sides. Brass hinges and
ball-fasteners.*

$38\frac{7}{8} \times 45\frac{3}{4} \times 9\frac{3}{8}$ (987 × 1162 × 238)

*Given in 1967 by the Trustees of Eric Sharpe
via Miss Joan Sharpe. 1967.105*

The dating is a little uncertain because
although Sharpe used very similar handles
on a desk made in 1935,[1] he also made a
bookcase very like this in 1956.[2] These
handles are clearly based on the carved
shapes developed by Gimson and the
Barnsleys.

1. Made for G.L.Brown, sold at Sotheby's
 2.5.1990, lot 274.
2. Information from Richard Coppin.

Fig.166 **Cat.79**, *with books from the Max Burrough Collection.*

133

80 Standard lamp

Designed and made by Eric Sharpe at Martyr Worthy, in the 1930s. The shade possibly by Douglas Cockerell & Sons, Cambridge, 1969.

English oak. The shade is of cream-coloured vellum edged with braid.

$56\frac{1}{4} \times 13\frac{5}{8}$ [without shade] (1428 × 345)

Given in 1967 by the Trustees of Eric Sharpe via Miss Joan Sharpe. 1967.106

From correspondence in the Museum's files it appears that a shade was to be made at the expense of Miss Joan Sharpe by Douglas Cockerell & Sons because Eric Sharpe had a similar one at his house. Unfortunately, the evidence is not complete and we cannot be sure if Cockerell supplied the shade or if the Curator bought one locally.

81 Armchair

Designed and made by Eric Sharpe at Martyr Worthy in 1943.

Walnut with inlay of holly and ebony. Dowelled joints and double dovetails on the underside of the seat rails.
 Monogram ES inlaid on front stretcher as part of the decoration.

$44\frac{5}{8} \times 23\frac{3}{8} \times 21\frac{1}{4}$; h. of seat 18
(1133 × 592 × 539; h. of seat 457)

Given in 1979 by Sir George Trevelyan. 1979.2514

Design: AHAG AH 2904/93.

There is no indication on the design that this was made for a customer and the prominent inclusion of Sharpe's monogram might suggest that it was intended for his own house or that it was a gift to his wife, Marian. It was her favourite piece.
 This chair was sometimes described as 'Semi-Ceremonial' and its decoration is restrained by comparison with Sharpe's

'Ceremonial' chairs, one of which incorporates Egyptian motifs and another, crocodiles. It was exhibited widely by Sharpe and was shown in the Arts and Crafts Exhibition Society display at the V&A in 1950.

Swans' heads of this type often appear on French furniture of the early nineteenth century. In view of Sharpe's interest in symbolism, it is possible that the decoration has symbolic meaning.
 See Fig. 162.

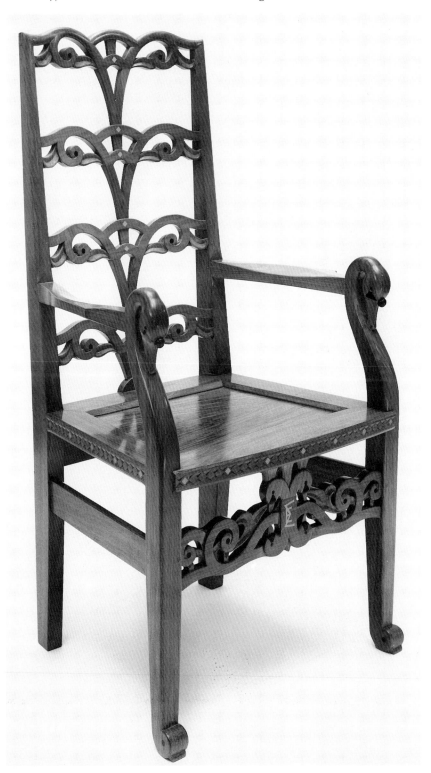

Fig. 167 **Cat. 81**

Stanley Webb Davies
(1894-1978)

Stanley Davies came from a wealthy Lancashire mill-owning family, was sent to Bootham, the Quaker school in York, and then studied History at Oxford. He joined the 'War Vics'[1] during the First World War and went to France to build huts for refugees, which intensified the love of woodwork he had developed at school.

After the War, Davies spent a short time in the cotton mill but in 1920 he joined the workshop of Romney Green. 'In retrospect', he wrote in 1974, 'I almost worship Romney Green. I can recall now the thrill at first seeing his work'.[2] Three years later, with the help of his father, he had a workshop built for him by the architect, Kenneth Cross (Fig.169). He also built a house, which was completed in 1926 and here at Windermere, in the Lake District, he remained until his death.

All the internal fittings for the house, including the staircase and doors, were made by his assistants. He usually had between three and seven staff, with additional paying pupils. In the 1950s he went through a lean period of few orders, and it is clear that he never made much of a living from his workshop.[3] He began winding down the business in 1959-60, when only two staff remained, and he retired in 1961.

Davies's writings give evidence of a strong belief in the views of Morris and Ruskin. An article on 'The Common Art of Woodwork' describes his attitude to 'craftsman-industry versus machine-production', which he regarded 'first and foremost from the worker's point of view. In the one case your work provides a man with healthy, varied and interesting occupation, satisfying the necessity for physical exercise, for thought and concentration, and for the human desire for creation, to do something to prove one's power

Fig.169 *Drawing of Stanley Davies's workshop by Kenneth Cross, used by Davies on his letterheads and leaflets.*

THE WORKSHOP, WINDERMERE

Fig.168 **Cat.80**

over nature and over circumstance. In the other case the average job in industry is deadly monotonous, often affording only the minimum of physical exertion, giving no occasion for thought, and at the end of the day's work, nothing fresh achieved. The one is capable of building up a race of intelligent citizens, the other is begetting a race of thoughtless seekers after relaxation'.[4]

Alec McCurdy, who joined the workshop as a fee-paying student in 1953, felt that Davies was a natural designer, whose ideas came from within.[5] He developed a style which was recognisably his own but clearly based on the work of the Cotswold group and Romney Green. Where he differed from Gimson was in emphasising the quality of truth to the extent that he felt veneers obscured the constructional character of timber and were therefore false.

Davies designed domestic and ecclesiastical furniture, presentation pieces, and items for boardrooms and offices. In *A Woodworker Speaks*, a radio talk of 1933, he suggested that instead of furnishing a whole house at once, which was then the custom, people should think about 'the joy of gathering together pieces of furniture that are works of art and exactly suited to ones present needs'.[6] Most of his work was made to commission but he kept a small stock and produced several leaflets with printed illustrations. He exhibited regularly with the Red Rose Guild in Manchester and also with the Arts and Crafts Exhibition Society, until he resigned in 1957 because they said his work was not modern enough.[7]

Abbot Hall Art Gallery in Kendal has a large archive from the workshop of Stanley Davies and several items of his furniture.

1. The Friends' War Victims Relief Unit.
2. AHAG AH2880/92, letter Stanley W. Davies-Oliver Morel.
3. EBET Stanley W. Davies-Edward Barnsley 20.7.1942.
4. AHAG AH2880/92, offprint of a piece originally published in *Practical Education and School Crafts*.
5. Alec McCurdy-Annette Carruthers 8.6.93.
6. AHAG AH2880/92, *A Woodworker Speaks*, p.2.
7. AHAG AH2880/92, Arts & Crafts file.

82 Dwarf cabinet

Designed by Stanley W. Davies and made by Brian Braithwaite in 1950.

Walnut with feathered walnut panels on doors, cocus handles, and drawer sides and linings of a pale wood. Adjustable shelves inside, with wooden pegs. Brass hinges and key holes. Exposed dovetails at the upper and lower edges and wide dovetails on the drawers.
 Carved monogram (Fig.171) inside the left side.

$12\frac{1}{2} \times 20\frac{3}{4} \times 10\frac{1}{4}$ (319 × 526 × 260)

Given in 1978 by the executors of Stanley W. Davies. 1978.486

Design: Abbot Hall, Kendal.

Record: AHAG AH2880/92, Stanley Davies's Costing Book E, p.85.

Since it was still in the designer's possession when he died, the cabinet was probably made 'on spec' or as an exhibition piece. Alec McCurdy remembers that it used to stand in the hall of Davies's house. It was included in the 'Good Citizen's Furniture' exhibition in Cheltenham in 1976, and it was probably because of this that Davies bequeathed it to the Museum.

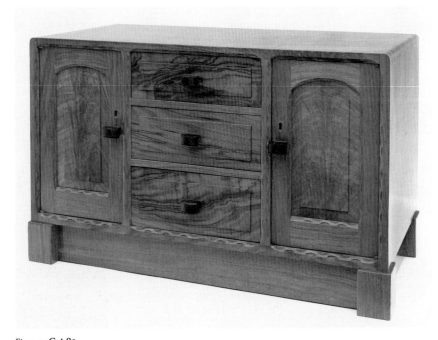

Fig.170 **Cat.82**

The costing book shows that this was Job 1556 made by Braithwaite in $253\frac{1}{2}$ hours, with another $27\frac{1}{4}$ done by others, over a period of five months. Materials and labour seem to add up to just under £41 and a price of £56.7.8 is noted in the book.

Fig.171 **Cat.82**
The mark cut inside the cabinet.

Edward Barnsley (1900-87)

As the son of Sidney Barnsley, Edward had an early start in furniture making, though his father warned him that he would never make a living from the craft. Nevertheless, after he left Bedales School, Edward Barnsley trained with Geoffrey Lupton, an ex-pupil of Gimson's, and in 1923 took over Lupton's workshop at Froxfield, near Petersfield in Hampshire.

In the early years, Barnsley executed quite a number of projects for architects as well as producing domestic furniture along similar lines to the Cotswold group. The 1930s proved a testing time, as orders were badly affected by the depression, and Barnsley designed a number of pieces in a clean-lined, almost modernist style, though he continued to produce framed and panelled furniture in solid English woods until after the Second World War. Then he reassessed his ideas, and began to develop a personal style of his own, lighter in appearance, often veneered rather than solid, and adopting and adapting features from eighteenth-century work. Exotic woods, such as black bean and padauk, received delicate inlays of pale sycamore, and light tambour fronts often replaced panelled doors.

Barnsley made some furniture himself until 1976, but increasingly from the 1940s he concentrated on design work, and the making was carried out by his assistants. From Lupton he had taken over a small staff, and he generally had between four and fourteen in the workshop. Herbert Upton, who was his first apprentice in 1924 and became foreman in 1938, was to a considerable extent responsible for the very high quality of work produced. Occasionally an experienced craftsman joined the workshop, but most of the staff began as apprentices, and since 1924 more than twenty apprentices and sixteen pupils have been trained. In 1981, an educational trust was established to ensure the continuation of the business and the opportunity for practical training.

Until the 1950s, Barnsley resisted all suggestions that he should install machine-tools, in the belief that these would change the nature of the work and the craftsman's enjoyment of it. Financial and practical necessity forced a change, and a small range of machines was installed in the late 1950s and early 1960s, making it possible for the workshop to compete for large corporate commissions and to keep prices down. Nevertheless, post-war Barnsley furniture was expensive in comparison with the products of more automated workshops, such as Russell's and Heal's.

The Barnsley workshop must be one of the best-documented in Britain. In the archive of the Trust can be found workshop job books, client books, letters between Barnsley and his suppliers and clients, and over 4000 designs for a wide range of furniture types. Most of the work was commissioned by individuals and by companies, though smaller pieces were sold at exhibitions and from 1950 through the Crafts Centre of Great Britain at Hay Hill in London.

Much of the work is still in the possession of the original clients or their families, and little has been collected by museums as yet. Cheltenham's small selection is in no way representative, since it does not include any of the mature work of the post-war period.

83 Armchair

Designed by Edward Barnsley (or possibly Sidney Barnsley). Made at Froxfield, about 1925-8.

English oak with back and seat upholstered in brown hide. Black linen under seat.

$38\frac{7}{8} \times 27\frac{1}{8} \times 21\frac{5}{8}$; h. of seat $17\frac{1}{2}$
($987 \times 689 \times 549$; h. of seat 445)

Given in 1947 by Miss Ethel Mathieson. 1947.148

Record: EBET client book, p.170. CAGM 1976.272. Two letters between E.B. and client, including invoice dated 24.6.1935. EBET photo. 34/6.

Purchased by Mr & Mrs Sydney Wales, Hyde Tyning, Minchinhampton, Gloucestershire, in 1935 for £7.16.0 (£6.6.0 for chair and £1.10.0 for reupholstery in hide).

When Mr Wales enquired about a chair to use with his desk (Cat.84), Barnsley suggested that he might like an armchair which he had in stock and which he himself had been using. He sent a photograph, which probably came from the catalogue he produced in the late 1920s, labelled 'No.4, Library Chair in Oak'.[1] Another photograph shows this in the Barnsleys' cottage around 1929-31.[2]

The design for this does not survive in the Barnsley archive, where there are no chair designs before 1930, so it is possible that this was made to a design by Sidney Barnsley.

It does not seem possible to identify exactly when and by whom it was made since there are several possible entries in Barnsley's Job Book between 1925 and 1928.[3]

1. 1972.272.2.
2. Illustrated in A. Carruthers, *Edward Barnsley and His Workshop: Arts and Crafts in the Twentieth Century*, Wendlebury 1992, p.67.
3. EBET Job Book 1 pp.13, 20, 23, 25.

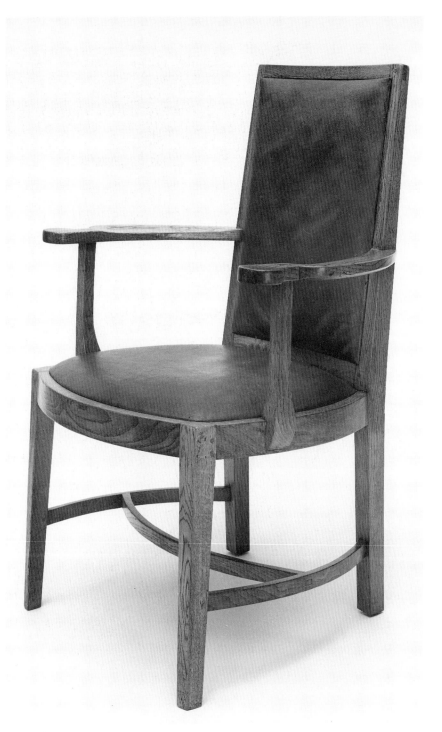

Fig.172 **Cat.83**

84 Writing desk

Designed by Edward Barnsley in 1934 and made in his workshop by George Brown and Herbert Upton in $213\frac{1}{2}$ hours in 1935. Steel handle probably made by Alan Knight.

Japanese oak with chestnut fittings inside and plywood back and drawer linings. Small strip light fitted at the top. Black leather set into the writing flap. Steel drop handle and lock-plate and turned oak handles on drawers (some replaced), flap supports and cupboard. Wax polished. Lock by Hobbs & Co.

$49 \times 39\frac{7}{8} \times 15\frac{7}{8}$ ($1245 \times 1012 \times 402$)

Given in 1947 by Miss Ethel Mathieson. 1947.147

Design: CAGM 1976.272. 1 signed and dated 1934.

Record: EBET workshop book 1, p.52, job 10/35.

EBET client book, p.170.
CAGM 1976.272.2, letters between E.B. and client.

Commissioned by Mr & Mrs Sydney Wales, Hyde Tyning, Minchinhampton, Gloucestershire, at a cost of £38.

Mr & Mrs Wales bought a walnut dish from Barnsley in June 1934 and seem to have first enquired about a desk in December. A proposal for a tall writing cabinet

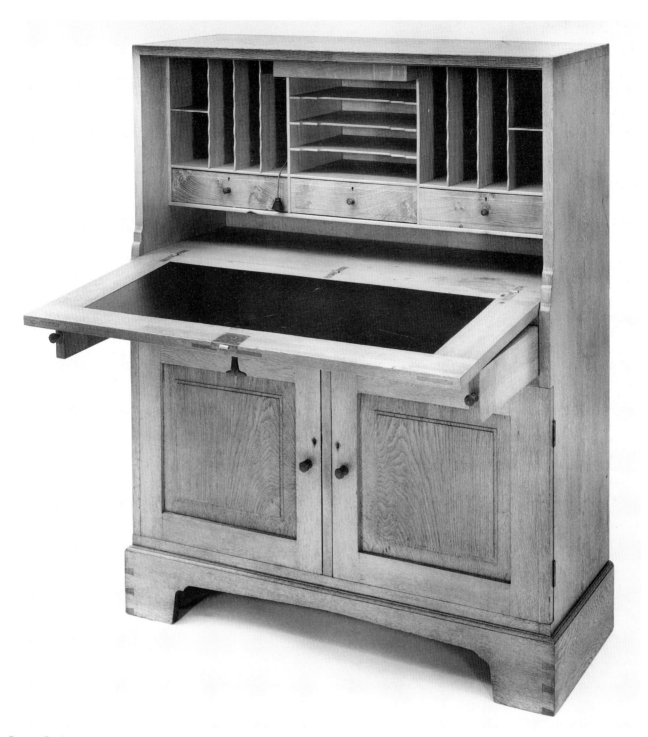

Fig.173 **Cat.84**

was rejected on grounds of cost and replaced by a shorter one quoted at £38.18.0, which Mr Wales approved, subject to it being delivered by March 1935. There were a few minor problems with the strip light and the doors had to be eased, but Mr Wales was pleased with the desk and in May 1935 enquired about a chair to use with it (see Cat.83).

The donor was the sister of Mrs Wales and lived at Moor Court, Stroud, when she first contacted Mr Herdman about this piece in 1944.

When he saw this desk in the 1970s, Barnsley said that he disliked the design and would wish to consign the desk to a bonfire. This was probably because he used a feature which appears on some of his other pieces from the 1930s, a raised section down the outer edge of each door, which gives the impression that the doors are set into the framework, disobeying all Arts and Crafts principles about honesty of construction. In fact they are hinged in front of the stiles and when the door is opened it gives the disturbing impression that the frame is moving.

In the correspondence it is variously described as desk, writing desk, writing cabinet and bureau.

85 Stool

Designed by Edward Barnsley and made by Fred Eastlake in 1936. Embroidered seat cover by Ethel Mathieson.

Walnut with oak corner blocks. Upholstered seat covered in cross-stitch embroidery with black linen underneath. Exposed dowels at all joints.

Frame without seat $9 \times 18\frac{1}{8} \times 12\frac{1}{2}$ $(228 \times 459 \times 319)$

Bequeathed in 1956 by Miss Ethel F. Mathieson. 1956.25

Record: EBET workshop book 1, p.56.

The Barnsley workshop book covering 1936 records a stool covered for Miss Mathieson at a cost of £1.12.6. This may have been made by Eastlake, who certainly covered the seat, or it could have been a piece made for stock, probably by an apprentice, at some time in the previous few years.

It appears that Miss Mathieson came into contact with Barnsley through her sister and brother-in-law, Mr and Mrs Wales (see Cats 83 and 84). She is listed in Barnsley's client book, but this stool is not included with her other purchases, a book-case, mirror and two trays.

Harry Davoll was the second cabinet-maker taken on by Barnsley and Gimson, in November 1901, and he worked in the temporary workshop at Cirencester until the move to Daneway in March 1902. He was born in Derbyshire, served his apprenticeship in Hereford, and had been employed by Waring & Gillow in Liverpool for nearly ten years, but trade was slack and he was out of work, so he was pleased to have a job and to be back in the country. Gimson's job book shows that he was entrusted with many of the major pieces made in the workshop.

When Waals moved to Chalford, Davoll went with him and stayed until 1933, when he left to work on his own. He had a small workshop by his cottage at Oakridge Lynch, and made many pieces of furniture in the Cotswold style, usually of walnut and often decorated with ebony and holly inlaid lines and light-catching fielded panels. Much of his work was smaller in scale than Gimson's, to suit the smaller houses of the mid-twentieth century.

Davoll was a life member of the Guild of Gloucestershire Craftsmen and frequently showed and sold his work at the annual exhibitions. In 1941 he was asked by the British Council to submit a piece for the 'Exhibition of Modern British Crafts', which was sent to the United States and the Dominions as part of the war effort to show how much would be lost if Britain did not receive the support it needed. In later years he did not have the strength to produce such pieces as this writing desk, but he carried on working into his eighties, making small boxes and cigarette cases.

The Museum has a collection of documents, designs and photographs relating to Harry Davoll's career as a cabinet-maker, donated by Mr and Mrs M. Worgan.

Fig.174 **Cat.85**

Fig.175 *Harry Davoll in his workshop in the 1940s.*

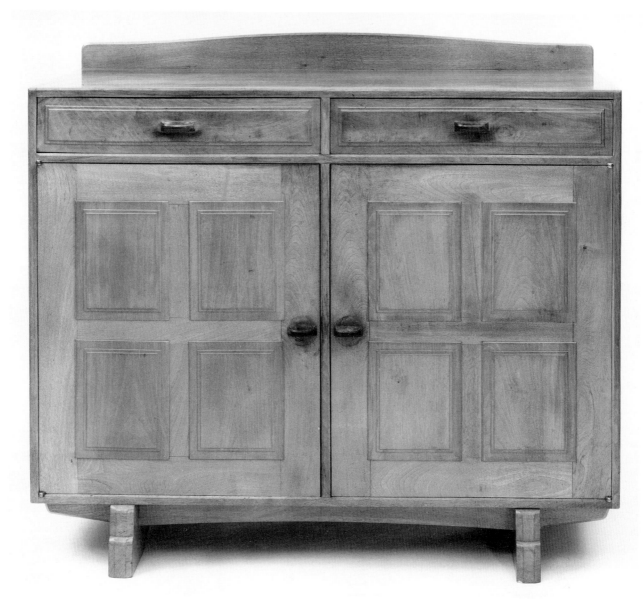

Fig.176 **Cat.87**

86 Trinket box

Designed and made by Harry Davoll, about 1938.

English walnut.

Purchased in 1938 from Harry Davoll at the Painswick exhibition, for £1.10.0. 1938.243

The box was no.172 in the Exhibition of Gloucestershire Art and Craftsmanship held at Painswick and Cheltenham in 1938.
 Not illustrated because present location unknown. Not seen by M.G. or A.C.

87 Sideboard

Designed and made by Harry Davoll in 1946.

Walnut with oak back, drawer sides and linings, and all internal fittings. Brass hinges. The drawers are lined with green baize. The timber is very faded. Exposed dovetails and through tenons are used for decorative effect.
 Inscribed in ink under the left drawer (see Fig.177).

$39\frac{1}{8} \times 45 \times 22\frac{1}{2}$ (997 × 1142 × 570)

Bequeathed in 1986 by Mrs Winifred Jew in memory of W. H. E. Davoll. 1986.1383

Mrs Jew was Harry Davoll's daughter and

> MADE BY.
> W. HARRY. E. DAVOLL.
> HILBRAE.
> OAKRIDGE LYNCH.
> STROUD.
> GLOUCESTERSHIRE.
> 1946.

Fig.177 **Cat.87** *Inscription under the drawer.*

he made the sideboard for her as a wedding present. It is en suite with the table and chairs (Cats 88 and 90). Davoll's other daughter had a very similar one.

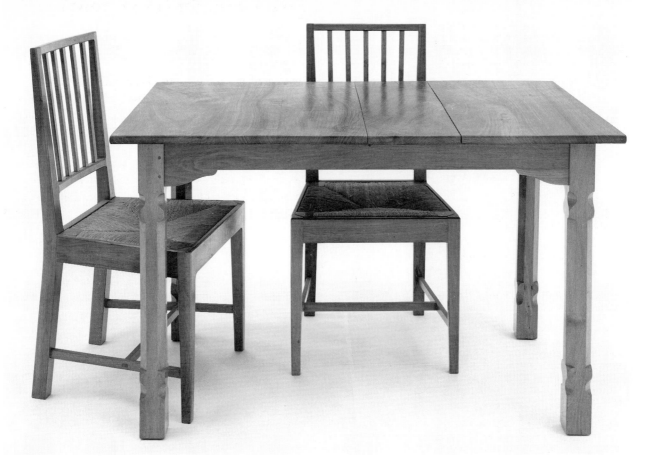

Fig.178 **Cat.88**, *with chairs by Fred Gardiner* **(Cat.90)**.

88 Dining table with spare leaf and stand

Designed and made by Harry Davoll in 1946.

Walnut with brass fittings for the leaf. The piecing of the timber on the table top is irregular.

Stamped on the inside of the short rails of the table H. DAVOLL. *Stamped on the runner of the leaf and the base of the stand*
H. DAVOLL OAKRIDGE STROUD. GLOS.

Table $28\frac{3}{4} \times 47\frac{5}{8} \times 29\frac{7}{8}$ (755 × 1210 × 759)
Stand $35\frac{7}{8} \times 19\frac{3}{4} \times 9\frac{1}{2}$ (910 × 501 × 241)

Bequeathed in 1986 by Mrs Winifred Jew in memory of W. H. E. Davoll. 1986.1384

Made for Mrs Jew en suite with the sideboard (Cat.87). The slightly odd construction of the top might suggest that Davoll did not have access to the ideal timber at this date, shortly after the War.

Fig.179 **Cat.88**

Fred Gardiner (1890-1963)

Fred Gardiner was the son of a builder and was born at Water Lane in Gloucestershire. After training as an apprentice with Gimson at Daneway, he went to work for Waals at Chalford until the workshop closed and then took up building. During the Second World War he joined Tylers of Thrupp to make gliders, and afterwards decided to start up his own small workshop at Cotswold Cottage, Oakridge. His son, Philip, worked with him after his release from the army in 1947.

They used primarily English oak and walnut, and had a varied clientele, which included Princess Margaret, William Simmonds, Girton College, Cambridge, and Sir Stafford Cripps. Fred Gardiner was also the village undertaker.

89 Box

Designed and made by Harry Davoll in about 1945-50.

English walnut with ebony inlay. Exposed dovetails down the corners.

$6\frac{1}{8} \times 9 \times 6\frac{1}{4}$ (155 × 230 × 161)

Bequeathed in 1986 by Mrs Winifred Jew in memory of J. George Jew. 1986.1386

Design: CAGM 1986.1375a, design for the initials and lock-plate.

The small design has holes pricked through it, so it was clearly used by Davoll when making the inlay.

Fig.180 **Cat.89**, with two designs by Davoll and some strips of ebony and holly prepared for use as inlay.

90 Set of six dining chairs

Designed by Harry Davoll or Fred Gardiner after Ernest Gimson and made by Gardiner in 1946. Seats probably rushed by Neville Neal in Edward Gardiner's workshop.

English walnut with rushed drop-in seats.

$35 \times 18\frac{1}{4} \times 18$; h. of seat $16\frac{5}{8}$
($889 \times 463 \times 457$; h. of seat 422)

Bequeathed in 1986 by Mrs Winifred Jew in memory of W. H. E. Davoll. 1986.1385

Record: CAGM, invoices from F. P. Gardiner and Edward Gardiner, September 1946 and 28 August 1946.

Made for Miss Winifred Davoll before her marriage. The bill from Fred Gardiner, 'Cabinet-Maker & Joiner' is for six chairs at £7.10.0 each, £45.0.0. Edward Gardiner's invoice, from his workshop at Hill View, Priors Marston, nr Rugby, is for 'Seating 6 chair frames in English rush', 17/6 each, total £5.5.0, plus postage. Neville Neal remembers doing a number of rush seats for Fred Gardiner.

There are several Gimson designs of this type, though they have only four splats rather than five.[1]

See Fig.178.

1. CAGM 1941.222.160, 170, 649.

91 Show case

Designed by Fred Gardiner and made by his son, Philip, at Oakridge, Gloucestershire, in about 1958-63. Lock by 'O&S'

L

Oak with drawer back and lining of cedar, and brass hinges. All the construction is concealed except for the tenons on the stretchers. Differential fading on the underside and two wooden buttons without function indicate that an alteration has taken place.

A brass plate on the top is inscribed
GIVEN BY THE OLD STUDENTS' GUILD
IN MEMORY OF
KATE AGNES VOLLER
1881-1958
FORMER STUDENT AND FOR 30 YEARS
HEAD OF THE NEEDLEWORK DEPARTMENT

$38\frac{1}{2} \times 47\frac{5}{8} \times 23\frac{1}{4}$ ($978 \times 1210 \times 590$)

Given in 1979 by the Governors of the Gloucestershire College of Education. 1979.2667

The case was given to the Museum when the College closed.

Fig.181 **Cat.90**

Fig.182 **Cat.91**, with a dish by William De Morgan of about 1880.

Gordon Russell (1892-1980) and his firm

Gordon Russell's career as a furniture designer began in 1908 in the workshop set up by his father to repair antiques for the Lygon Arms hotel in Broadway. Although only sixteen years old, he was put in charge of several skilled craftsmen and during these early years developed a love of seventeenth-century English furniture which remained with him throughout his life. When he started to make new designs for the workshop from about 1911, he was also much influenced by the work of Gimson and the Barnsleys, and the earliest work made at Broadway was produced by traditional hand methods.

After service in the First World War, Russell returned home to the family firm, which was renamed Russell & Sons. He revived the antiques business and in the early 1920s turned his attention again to the design of new furniture. The first of his meticulous Design Record books starts in 1922, but he is known to have produced a few designs before this date.

Following the success of his contribution to an exhibition in Cheltenham in 1923, Russell was invited to design a model café for display at the V&A, and this brought in further work and the opportunity to show at the British Empire Exhibition at Wembley in 1924.

In order to reduce production costs and the price of the furniture, he began to introduce machine tools in the mid 1920s, and some items were made in batches rather than as individual pieces. Throughout the period up to 1930 when Russell himself was designing, his work shows the influence of the Cotswold group combined with decorative details derived from seventeenth-century furniture. Russell & Sons also made turned, rush-seated chairs and Russell employed Harry Gardiner, one of the smiths who had worked for Gimson, to make steel fire dogs and brass sconces.

Changes in the style of work occurred when Richard Drew Russell (1903-81), Gordon's younger brother, began to have a greater influence in the firm after he began his architectural training in 1927 at the Architectural Association in London. He introduced a simple Modernist idiom which was better suited to machine production and was often, though not always, cheaper than the furniture of the 1920s.

Dick Russell and a number of his friends from the AA, such as Eden Minns and Marian Pepler, were important in giving the firm a new direction and, as they became better known, in supplying a certain prestige. Due credit should also be given, however, to the work of staff designers, and in particular to 'Curly' Russell (no relation). W. H. (Curly) Russell started with the firm as a cabinet-maker in 1924 after training at Shoreditch Technical Institute. He became

Gordon Russell's assistant in the drawing office in 1926 and was Chief Designer of the firm from 1932 until his retirement in 1968. Many of the company's most popular pieces were his designs and he made an important contribution to its success, especially after the War.

Wartime conditions brought major changes. In 1940 Gordon Russell was forced to resign as Managing Director in circumstances which have not been fully explained, and two years later he was asked to join the Utility Furniture Advisory Committee. His experience here led to his appointment in 1947 as Director of the Council of Industrial Design and he had an increasing influence on British design in the 1950s and 1960s, as a writer and lecturer. In the late 1970s, Russell once again became involved in furniture design, when he produced a small series of pieces in yew, which were made for him by Adriaan Hermsen.

In Broadway, the firm continued under the control of R. H. Bee and then Ted Ould. It produced good-quality

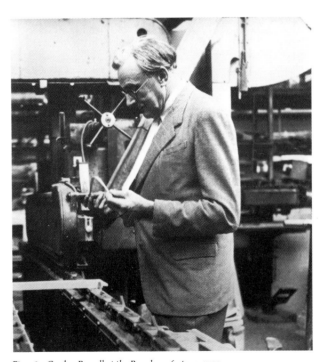

Fig.183 *Gordon Russell at the Broadway factory, 1959.*

domestic furniture designed by staff designers and by freelances until 1970, when it withdrew from the retail market to concentrate on contract work. It is now owned by Steelcase Strafor and makes office furniture.

Many of the items in the Cheltenham collection were lent to the Museum shortly after Lady Russell's death in 1981,

along with other pieces which belonged to Russell and reflect his interests. These include pewter plates, a leather 'blackjack', an earthenware pot from his garden and craftwork by Alan Caiger-Smith, David Pye and Ray Finch of Winchcombe Pottery. These were generously donated by the Gordon Russell Trust, formed in 1982, which has an

archive collection, currently based at Broadway with the remarkable archive of Gordon Russell Ltd. This documents most aspects of the history of the firm and is an important resource for the study of the crafts and the furniture trade in the twentieth century.

Fig.184 *Advertisement from the catalogue of the Cotswold Arts and Crafts exhibition held in Cheltenham in 1923.*

Fig.185 **Cats 92** *(right)* **and 93**

92 Towel rail

Designed by Gordon Russell and made in the Russell Workshops in about 1911 or later.

Oak with wax finish. Dowelled joints. Watermarked.

$32 \times 23\frac{5}{8} \times 9$ (814 × 600 × 227)

Given in 1984 by the family of Sir Gordon and Lady Russell via the Gordon Russell Trust. 1984.139

From Kingcombe, the home of Gordon and Toni Russell, either from the 'Room from garden' or from Lady Russell's dressing room.

Russell started designing furniture as a result of his work in his father's workshop, which restored antique furniture for use in the hotel. Presumably antique towel rails

were difficult to find and the exercise of designing a functional piece stimulated him. This is the first version and it was subsequently refined (see Cat.93).

93 Towel rail

Designed by Gordon Russell and made in the Russell Workshops in about 1911 or later.

Oak, wax polished. Tenoned and dowelled joints. Watermarked.

$28\frac{1}{2} \times 26\frac{7}{8} \times 8\frac{5}{8}$ (724 × 682 × 220)

Given in 1984 by the Gordon Russell Trust. 1984.140

Design: GR Archive, no.20, signed and dated 8.23, and blueprint copy by W. H. Russell dated 24.6.27.

Record: GR Archive, Design Records, no.20.

From Kingcombe.

This second version of the towel rail design was considered a great improvement by Russell because the way the chamfering of the uprights joins the upper rail is more completely thought through and the octagonal finial gives a pleasing finish.

Both towel rails are dated to 1911 by Baynes and by Myerson,[1] presumably on the basis of information from Gordon Russell himself. The design and records in the Archive indicate a later date but also raise the question of whether all of Russell's designs were fully worked out on paper before production, or whether some were drawn from a finished piece when methods of construction were decided or a repeat was required.

1. K. and K. Baynes, *Gordon Russell*, London 1981, p.26; J. Myerson, *Gordon Russell: Designer of Furniture*, London 1992, p.27.

94 Bed

Designed by Gordon Russell and made by Edgar Turner at Russell & Sons in 1921. The carving was carried out by Will Hart. Bed frame by Mono.

Walnut with blue paint and gilding on the carving. Joined by large exposed dowels.

Headboard $45\frac{3}{4} \times 54 \times 2\frac{1}{2}$
(1163 × 1369 × 63)
Footboard $29 \times 53\frac{5}{8} \times 2\frac{1}{4}$
(735 × 1362 × 58)

Given in 1984 by the family of Sir Gordon and Lady Russell via the Gordon Russell Trust. 1984.137

Made as their marriage bed for Gordon Russell and Toni Denning in 1921. It was in the main bedroom at Kingcombe until Lady Russell's death, and was flanked by two small cupboards which are in the collection of the Gordon Russell Trust.

The bed does not appear in the Russell Archives and no design for it is known.

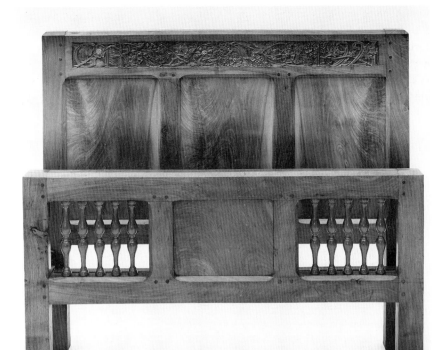

Fig.186 **Cat.94**

95* Print cabinet on stand

Designed by Gordon Russell in November 1924 and made by Tommy Lees of Russell & Sons under foreman Edgar Turner, in 1925.

Frame of bog oak with external panels, doors and drawers of mahogany veneered with laburnum oysters and burr elm. Inner sides of doors veneered with laburnum and yew. Inner drawer fronts of yew edged with holly and drawer handles of chestnut. Outer drawers and handles of bog oak. Brass hinges and hand-made brass key with stylised flower design.

Paper label attached under top drawer on right side, printed and inscribed, (see Fig.19).

Stamped on the framework of the front below each set of drawers T. LEES *Printed in black under the right drawer of the stand, an image of the rising sun.*

$60 \times 41\frac{1}{2} \times 19\frac{3}{4}$ (1524 × 1054 × 502)

Purchased in 1983 from Fischer Fine Art in association with Dan Klein Ltd for £5510 with grants from the V&A Purchase Grant Fund (50 per cent) and the National Art-Collections Fund. 1983.33

Design: GR Archive, no.195, signed and dated 11.24.

Record: GR Archive, Design Records, no.195. This gives a price of £175.

Fig.187 *The hand-made key of the print cabinet* (**Cat.95**).

In the absence of any evidence in the Gordon Russell Archive that this cabinet was commissioned, we must assume that it was made as an exhibition piece. Nothing is known of its history before it was acquired by Dan Klein.

Notes made in preparation for the 1981 Gordon Russell exhibition at the Design Centre indicate that Russell particularly liked this piece.

The framework of octagonal members is inherently unsound since there is not enough timber to make a strong joint, and the piece has had to be repaired several times. According to the design, it was intended to have silver handles.

Russell was clearly influenced by the style of seventeenth-century pieces when designing this cabinet.

See Fig.19, Col. Fig.58.

96 Sideboard

Designed by Gordon Russell and made in the Russell Workshops by Herbert Allaway in 1926.

English oak with laburnum handles, chestnut drawer linings and plywood drawer stops. The piece has always been scrubbed rather than polished and is therefore very pale. Small brass hinges with incised patterns on the knuckles. Exposed dovetails and tenons.

Paper label pasted under right drawer with printed and inscribed details (see Fig.189). Drawers marked in pencil on the backs with characters which are difficult to read but are probably R and L. Also marked on bearers I and II.

$37\frac{7}{8} \times 59\frac{1}{4} \times 17\frac{3}{4}$ (960 × 1504 × 450)

Given in 1984 by the Gordon Russell Trust. 1984.138

Design: GR Archive, no.545, signed and dated 4.11.1926.

Record: GR Archive, Design Records, no.545, Price in brown oak, £35, or in oak £29.17.6d. GR Archive, catalogue of 1926, price £32.10.0.

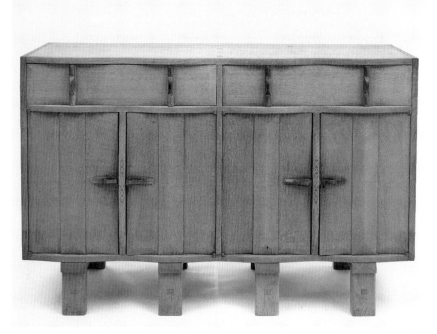

Fig.188 **Cat.96** *Sideboard by Gordon Russell, 1926.*

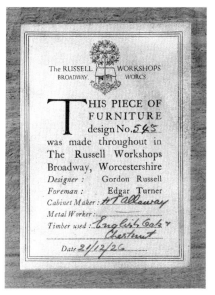

The RUSSELL WORKSHOPS
BROADWAY. WORCS.

THIS PIECE OF
FURNITURE
design No.*545*
was made throughout in
The Russell Workshops
Broadway, Worcestershire
Designer : Gordon Russell
Foreman : Edgar Turner
Cabinet Maker : *H.T.Allaway*
Metal Worker :
Timber used : *English Oak &*
Chestnut
Date *21/12/26*

Fig.189 **Cat.96** *Printed and inscribed label under the drawer.*

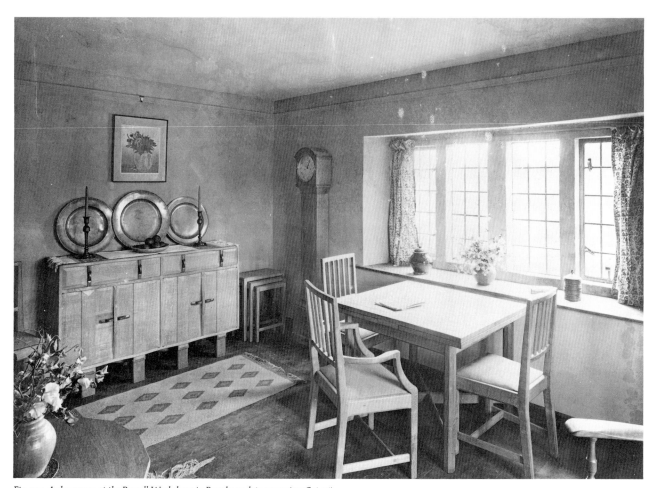

Fig.190 *A showroom at the Russell Workshops in Broadway, late 1920s (see Cat.96).*

Used in the hallway at Kingcombe, Gordon and Toni Russell's home, with pewter plates displayed on the top. When it came to the Museum the sideboard contained a note from Toni Russell that it had always been scrubbed rather than polished and this explains its pale silky finish.

The design indicates that figured timber was to be used for the doors and drawer fronts. Russell was pleased with this design and especially liked the serpentine line of the front. Trevor Chinn remembers designing a piece in the 1960s with a shaped front which Russell compared happily with this sideboard.

It was not a one-off design but was repeated several times. One was sold at Sotheby's Belgravia[1] with a label dated 1930, so production continued over some years.

See Fig.174.

1. 10.12.1981, lot 206.

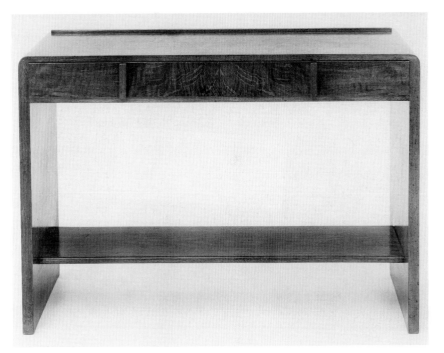

Fig.191 **Cat.97**

97 Sideboard, side table or serving table

Designed by R.D.Russell and made by Gordon Russell Limited in about 1930-5.

Walnut. Oak drawer sides and backs and ply-wood linings. French-polished.

$33 \times 47\frac{7}{8} \times 16\frac{7}{8}$ (838 × 1216 × 403)

Given in 1984 by the family of Sir Gordon and Lady Russell via the Gordon Russell Trust. 1984.143

Used by Gordon and Toni Russell in the dining room at Kingcombe. The fact that the design is not included in the stock numbers at the Gordon Russell Archive suggests that this was a one-off piece, made for Gordon Russell or kept by him after a client refused it. There is a photograph of a similar piece in an album in the Russell Archive, described as a 'writing table', but the 33 inches height of the Museum's example is correct for a serving table.

Although this piece is in the clean-lined 1930s style which suggests that it is veneered, it is actually made of solid timber.

98 Box

Designed by R.D.Russell and made by Gordon Russell Limited, probably in the 1930s.

Fig.192 **Cat.98**

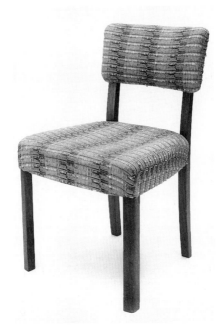

Fig.193 **Cat.99**

Veneered with seven different woods in a striped pattern. Lining of cedar and beech. Hinged lid. Black felt on base.

$2 \times 5\frac{1}{4} \times 4\frac{1}{8}$ (50 × 134 × 104)

Given in 1984 by the family of Sir Gordon and Lady Russell via the Gordon Russell Trust. 1984.155

Used at Kingcombe in the main bedroom. The size suggests that it was designed as a cigarette box but since Russell did not smoke it must have been used as a trinket box.

There are no records at Gordon Russell Limited of the design or production of this piece, but it has been dated on grounds of style.

99 Dining chair

Designed by W.H.Russell and made at Gordon Russell Limited from 1934. Fabric probably by Donald Brothers, Dundee.

Mahogany with upholstery covered in textured fabric in natural creams, pale green and browns.

$32\frac{5}{8} \times 20\frac{1}{2} \times 18$; h. of seat $18\frac{1}{2}$
(829 × 521 × 457; h. of seat 470)

Given in 1985 by John Beer in memory of John Compton. 1985.142

Design: GR Archive, 1098.

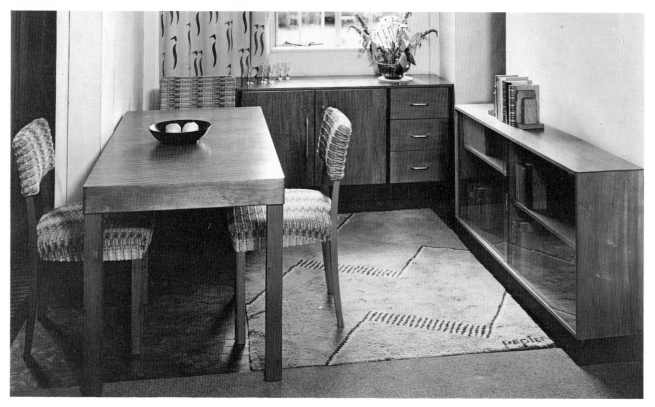

Fig.194 'Welbeck' chairs displayed with Dick Russell's 'Finstock' room, 1930s
(see Cat.99).

Record: GR Archive, photograph of 'Welbeck' room, chair at £3.17.0 with sideboard and table by Dick Russell at £22 and £11.15.0. CAGM Russell Album, photo 1098 1105 (Fig.194).

This chair was part of a set put into store in Cheltenham in the 1930s by a Mr Watkins, who never reclaimed his furniture. It was sold at auction, where this and other items were purchased by the donor.

It was a popular chair, sold with several of Dick Russell's different rooms as well as with the 'Welbeck' suite for which it was designed.

100 Radio

Cabinet designed by R.D.Russell and made by Gordon Russell Limited from 1935. Radio by Murphy Radio Limited.

Walnut-veneered bent plywood with fabric panel over speaker.
Plastic labels pinned on the back, one of
MURPHY RADIO LTD TYPE A28C 5372

(with other technical details), and one of
MODERN RADIO CO.
 15 CLARENCE ST
 CHELTENHAM

$35\frac{3}{4} \times 20\frac{1}{8} \times 10\frac{1}{4}$ (909 × 512 × 260)

Given in 1990 by Miss C. Edwards. 1990.860

Bought in Cheltenham by the parents of the donor.

Gordon Russell Limited began working with Murphy Radios to produce well-made, modern radio cabinets in 1931, and this collaboration proved vital to the survival of the firm during the 1930s, when orders for furniture were hit by the depression. Dick Russell's carefully developed simple designs were not liked at first by retailers and their reps, but they proved popular with the public and the increasing number of orders prompted the opening in 1935 of a special factory at Park Royal in west London for machine production. Thousands were made of some models. As their success with Murphy Radios grew, the firm also began to design for Bush and Ecko.[1]

1. For a clear account of this see R. Allwood and K. Laurie, *R. D. Russell Marian Pepler*, London 1983, pp.6-7, 58, 74-7.

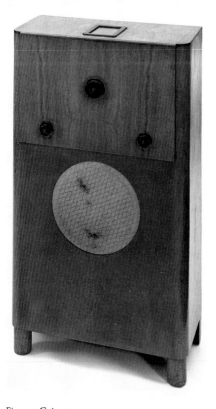

Fig.195 **Cat.100**

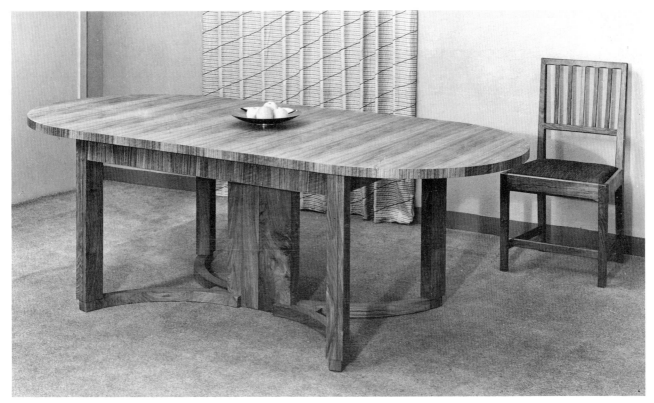

Fig.196 **Cat.101**, photographed in a Gordon Russell Limited showroom. The chair is not in the Museum collection.

101 Extending table

Designed by James A. Wilson and made by Gordon Russell Limited, Broadway, in 1936.

English walnut veneered onto Ibus board (mahogany-laminated core board) with mahogany rails veneered in walnut and oak. Solid walnut legs and stretchers. The top is badly faded in comparison with the spare leaves. Brass fittings to hold the leaves together.
Metal label pinned underneath top
Gordon Russell Ltd *(in script)*
BROADWAY WORCS

$30\frac{1}{4} \times 89\frac{3}{4} \times 42$ (768 × 2280 × 1065)
Leaves $23\frac{7}{8} \times 41\frac{7}{8}$ (607 × 1064)

Purchased in 1962 for £100 with donations from the W. A. Cadbury Charitable Trust and Mr Arthur Mitchell. 1962.68a

Record: GR Archive, X Number Book 4, x2880.
CAGM, label under table inscribed '25 1936 £72.10s'.

The table was made for Captain Arthur Gibbs in 1936 and was in constant use until March 1962. At that time, Mrs Barbara Gibbs, who lived in Church Street, Kensington, London, seems to have had another table made for her at Gordon Russell and to have sold this one through the firm to the Museum. Some minor restoration work was carried out at this time.

Captain and Mrs Gibbs had a number of items from Gordon Russell, including bookshelves, a carving board and a desk in mahogany.

A similar table was commissioned by the Marchioness of Normanby for use in the library at Trinity College, Dublin.

Unfortunately, many x-numbered designs, which were for one-off pieces, were discarded by the firm, and this one does not survive.

102 Sideboard

Designed by David Booth and made by Gordon Russell Limited in 1951-2.

Mahogany with doors of birch ply veneered with Bombay rosewood. Brass hinges and brassed copper ring handles. Aluminium door fittings. Brown baize inside drawer. Inside the cupboard is a shelf with a cut-out section at the left to accommodate bottles, and a drawer under the right end.

The decoration is achieved by cutting through the top layers of veneer to reveal the paler colour below. The timber is very faded and the contrast was originally much more striking.

Small metal label fixed to the back,
GORDON RUSSELL
LIMITED
BROADWAY WORCS

$33 \times 48 \times 18\frac{1}{4}$ (838 × 1216 × 463)

Given in 1985 by Mr and Mrs R. Seegar. 1985.657

Design: GR Archive, design R407.

Record: GR Archive, Design Records, R407, 1951.

Purchased by the donors at Story's of Kensington, London, in 1952 for £28. Mr Seegar worked there as a buyer and decided as soon as he saw it that he would save up for this sideboard because it was such a contrast to the dull wartime furniture of this date. Story's sold a lot of Russell furniture at this time and this design was popular with people in their twenties, as Mr Seegar was.

David Booth was a contemporary of Dick Russell at the Architectural Association. He worked for a while in the drawing office at Broadway in the 1930s and then went into partnership in Oxford with an interior designer, Judith Ledeboer. As a freelance, he made a number of designs for Gordon Russell Ltd just after the Second World War, working within the government restrictions on the use of materials. This is one reason why the construction and interior fittings of this sideboard are so simple. It was made in batches, in small numbers at first and then in larger batches as orders increased, and probably 500 or more of this design were made in all.

The V&A has an example of this sideboard, purchased by the donors at Liberty's, and there are others in the collections of the Geffrye Museum and Gordon Russell Ltd.

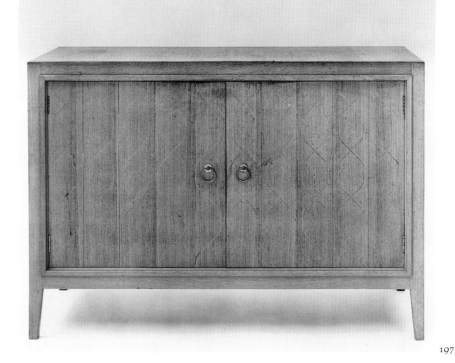

197

103 Show case

Designed by W. H. Russell and made at Gordon Russell Limited by Herbert Allaway in April 1962.

Cherry frame to glazed upper section on walnut base. Finished with heat- and spirit-resistant lacquer. Walnut key holes.

Printed label underneath
DESIGN NO.X8318 DATE April 1962
MATERIALS Walnut & Cherry
CABINET MAKER H T ALLAWAY
DESIGNER W H RUSSELL FSIA
MADE BY GORDON RUSSELL LIMITED
FURNITURE MANUFACTURERS BROADWAY
WORCS

$65\frac{3}{4} \times 47\frac{3}{4} \times 27$ (1670 × 1215 × 682)

Commissioned in 1962 from Gordon Russell Ltd by Cheltenham Art Gallery. 1980.1131

Design: GR Archive, x8318.

Record: GR Archive, X Number Records, x8318,

It was repaired at Gordon Russell in 1966 after minor damage was incurred at a Gloucestershire Guild of Craftsmen exhibition.

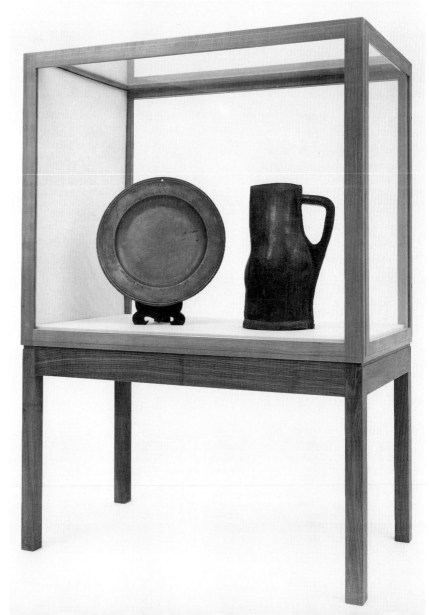

Fig.197 **Cat.102** *Sideboard by David Booth for Gordon Russell Limited, 1951-2.*
Fig.198 **Cat.103** *The pewter dish and leather jug are from Gordon Russell's personal collection.*

198

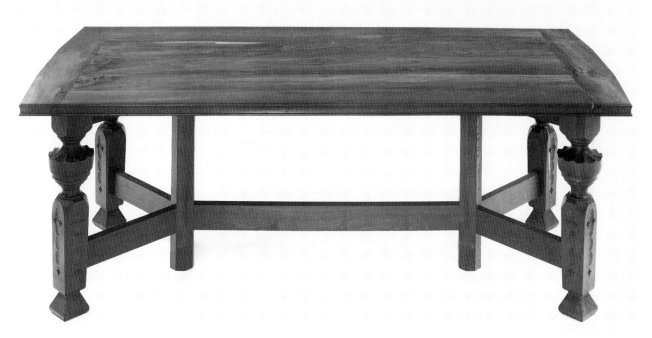

Fig.199 **Cat.104**

104　Dining table

Designed by Gordon Russell and made by Adriaan Hermsen at Gordon Russell Limited in 1977-8.

Yew top with cellulose finish on a base of laburnum. The legs are built up from several pieces of timber glued together.

$27\frac{1}{4} \times 77 \times 36$ (692 × 1955 × 914)

Given in 1984 by the Gordon Russell Trust. 1984.141

One of a small number of pieces in yew designed by Russell in his old age and made for him by Hermsen, who had recently retired from Gordon Russell Ltd. There are no designs in the Gordon Russell Trust Archive.

Most of these late pieces, which included three large tables, were used at Kingcombe, and this one was made for the dining room.

The design shows a return to Russell's early interest in seventeenth-century furniture.

105　Table

Designed by Gordon Russell and made by Adriaan Hermsen at Gordon Russell Limited in 1979.

Yew with a cellulose finish. The top is screwed to the base.

$18 \times 18\frac{1}{2}$ diam (457 × 456)

Given in 1984 by the Gordon Russell Trust. 1984.142

One of the small series of pieces designed by Russell late in life. This table was used in the drawing room at Kingcombe and appears in a photograph.[1]

1. Illustrated by K. and K. Baynes, *Gordon Russell*, London 1981, p.65.

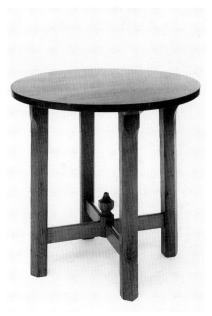

Fig.200 **Cat.105**

Oliver Morel (1916-)

Oliver Morel began his training with Edward Barnsley in 1934. He describes himself as 'NOT a "craftsman" solely – like Romney Green', but has always been involved with woodwork. His youthful interest had been encouraged at Rendcomb School, a progressive boarding school near Cirencester, which had links with Gordon Russell's workshop at Broadway.

At Froxfield, Morel learnt quickly and built up a close relationship with Edward Barnsley. He enjoyed hard physical work as well as designing, and remembers Dutch sawing (vertical sawing with the saw teeth away from the body) the stock of walnut offcuts into blocks suitable for turning into bowls. He became a full member of the workshop in 1936.

During the late 1930s, he taught some woodwork classes at Bedales and also looked after pupils at Froxfield. He decided to study part-time for a teaching qualification, and in 1938 got a job teaching at Rendcomb.

He returned to Froxfield in 1942 as a result of a plea from Edward Barnsley, whose workforce had been lost to war work. Morel was a Quaker and, like Barnsley, a conscientious objector.

Influenced by the ideas of Eric Gill, Oliver Morel left Froxfield in about 1944 to try to combine craftwork with running a smallholding. He and his wife bought a sheep farm near Abergavenny in Wales. It was during this period that he took on Hugh Birkett as a pupil. The two men worked closely together at Moreton-in-Marsh in Gloucestershire from the late 1960s onwards.

Morel was greatly influenced by the work of Romney Green and Eric Sharpe, as well as by the Gimson-Barnsley tradition. He had met Eric Sharpe in 1934 and became close to the craftsman and his family. When Sharpe died in 1966, his widow asked Morel to be literary executor, to keep the Sharpe workshop effects together and available and to put together a photographic record of his work. From 1969 until about 1980 he ran the Eric Sharpe Centre at Moreton, as a resource centre for professional and amateur handworkers.

Until about 1988, he continued making furniture himself, working mainly in solid woods and usually to commission. His particular speciality was decorative raised inlay work of extraordinary delicacy designed by Alice Barnwell, in which he employed natural motifs of flowers and plants executed in exotic timbers.

106 Casket

Designed and made by Oliver Morel in 1988.

Nineteenth-century Cuban mahogany with pearwood panels and walnut feet. Four brass hinges. A sliding lift-out tray inside is of ebony with a stained oak base lined with green felt.

$6\frac{1}{2} \times 25\frac{3}{8} \times 12$ (165 × 644 × 304)

Given by the maker in 1993. 1993.348

The box was commissioned by a client who subsequently changed his mind.

Oliver Morel and Hugh Birkett have both made a number of panelled boxes since the 1960s.

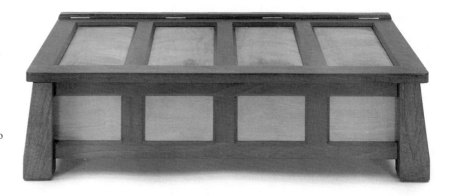

Fig.201 **Cat.106**

Hugh Birkett (1919-)

Hugh Birkett was born into the Arts and Crafts Movement, as his parents were involved in the design and making of metalwork in Birmingham in the early years of this century. His mother, Anne G. Stubbs, had been a prize-winning student at the Birmingham School of Art, and his father a partner in Jesson Birkett & Company.

After leaving school, Hugh Birkett did three and a half years of an engineering apprenticeship, which was interrupted by the Second World War. He worked for the International Voluntary Service for Peace, first in the East End and then in Greece, and decided he no longer wanted to be an engineer. In 1947, he attended the Birmingham School of Furniture for one term, but found it was not the training he was looking for, so he advertised for someone to take him on. A man who knew Oliver Morel answered his advertisement and in 1948 Birkett went to Wales to train with Morel. His teacher was good and he was an apt pupil, and he stayed for about eighteen months.

He then went to work with Edward Gardiner for a while, making turned chairs, and in 1949 set up on his own in the garage of his mother's house at Lapworth, near Solihull. Here he made domestic furniture and woodwork for churches, influenced by Gimson's work, which he had discovered when he had bought his father a copy of *Ernest Gimson, His Life and Work*[1] during the War.

In 1966, he moved to Moreton-in-Marsh, to a house with a large workshop, formerly an engineering works. He bought a few machine tools, including a circular saw, planer, thicknesser, morticing machine and band-saw, to make the work faster and easier and to keep his prices down. He has always used solid timber because he is not interested in veneering, and the choice of wood usually depends on the client. In the past he made drawings, but latterly he sets out the dimensions directly on to the wood and trusts to experience.

Hugh Birkett's furniture still shows his interest in the Cotswold tradition, though his style has become lighter in proportion and construction. He mainly works to commission, but also exhibits regularly with the Worcestershire Guild of Designer Craftsmen.

In addition to his work as a furniture designer and maker, Hugh Birkett is a skilled bookbinder.

1. W.R.Lethaby, A.H.Powell and F.L.Griggs, *Ernest Gimson His Life and Work*, Stratford-upon-Avon 1924.

Fig.202 *Hugh Birkett, about 1990.*

107 Display cabinet

Designed and made by Hugh Birkett in 1989.

Indian laurel with Brazilian mahogany interior and two shaped glass shelves and brass lock-plates.

$71\frac{3}{8} \times 28\frac{7}{8} \times 16\frac{3}{4}$ (1814 × 734 × 425)

Commissioned from the maker in 1989 for £1150 with a grant from the Area Museums Council for the South West. 1989.890

Hugh Birkett has made quite a number of glazed display cabinets for domestic use in recent years and so this piece, as well as being of practical use for the display of craftwork from the collection, represents a typical aspect of his work.

Fig.203 **Cat.107**, *with pottery by Michael Cardew, Bernard Leach and others, 1930s - 50s.*

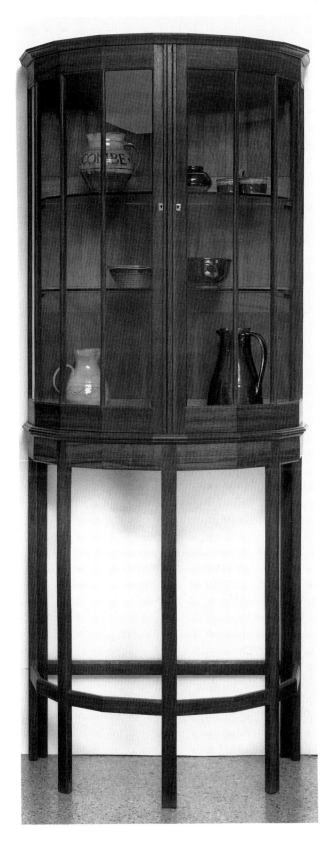

Alan Peters (1933-)

Alan Peters joined the workshop of Edward Barnsley in 1949. He had the usual thorough training under the eye of Bert Upton and after his apprenticeship finished, he worked for Barnsley for a short period. In 1957 he had a change of direction and went to Shoreditch College in London for a two-year teacher training course, followed by a scholarship to the Central School to study Interior Design. He spent a few years teaching, but in 1962 established his own workshop at Grayshott, near Hindhead in Surrey. In spite of his experience and qualifications, the banks were not interested in lending money for his new business, which was supported at the beginning by the work of his wife, Laura, and by his own part-time teaching.

Although Peters's early work retained elements of the Barnsley style, such as narrow inlaid lines, exposed dovetails and through tenons, and beautifully finished panels, his college training had also brought him into contact with more fashionable work of the 1960s and his designs were more rectangular and less ornamented than Barnsley's. As well as free-standing domestic pieces he also worked on built-in fitments. By 1970, he had built up his reputation sufficiently to give up teaching and live from cabinet-making.

Throughout his career, Alan Peters has been influenced by the tradition within which he trained. In 1975, he was awarded a Crafts Advisory Committee bursary, to enable him to take stock, and in search of inspiration for decoration of furniture, he made a visit to Japan. This proved to be of enormous importance for his development. Impressed by the subtle shapes of Japanese buildings, by the intricate joinery of their construction and the simplicity of traditional interiors, he brought back a renewed interest in form and texture and methods of making. This soon became evident in elegant sidetables of contrasting timbers, in asymmetrical arrangements of elements in his designs, and in strong forms made of thick slabs of wood, sometimes with complex decorative joints. In recent years, this fundamental feeling for Japanese design can still be seen in Peters's work, and new directions have also been explored, using fluted elements, for instance, from 1930s design.

Since 1973, Alan Peters has been based at Kentisbeare in Devon, a rural setting close to a motorway for essential contact with London. His chief assistant, Keith Newton, has worked with him for many years, and he usually employs several others. The workshop is well equipped with machine tools, but much work is done by hand, and Peters always develops the new designs himself.

Most of the workshop's clients are individuals, but Peters also receives commissions from businesses and institutions. Small items can be purchased direct from the workshop or from exhibitions, but most work is done to commission.

Alan Peters has written a book and numerous magazine articles. His *Cabinetmaking: The Professional Approach* gives an excellent introduction to the complexities of running a workshop in the twentieth century.

108* Serving table

Designed and made by Alan Peters in 1985.

Wenge with yew drawer fronts. The sides of the drawers are in wenge, and the linings in yew.

Stamped on the top of the right drawer front ALAN PETERS

$35\frac{1}{8} \times 67 \times 19\frac{7}{8}$ (889 × 1703 × 508)

Purchased in 1986 from Alan Peters for £1800 with a 50 per cent grant from the V&A Purchase Grant Fund. 1986.1392

Design: CAGM 1987.541

Alan Peters designed this as a project for *Practical Woodworking* magazine sponsored by Evo-Stik, and the design and full instructions on how to make it were published.[1]

It is a development of a piece made in oak in 1984 for the Open Exhibition at the Crafts Council gallery, and in its shape and dark colour it reflects Alan Peters's interest in Japanese design. With its dramatic use of a constructional feature as a decorative device, it also derives from Peters's deep understanding of Gimson-Barnsley work, and he considers it a 1980s development of the Cotswold School.

In his article in *Practical Woodworking*, Alan Peters explains that the projecting tenons on the top are used to express the construction and form of the piece and are a concession to appearance over function. Other aspects are entirely functional and he intended the piece to replace the more traditional sideboard, no longer needed in houses with fitted kitchens. 'It provides two quite generous surfaces for the temporary storage of prepared foods and plates and a row of shallow drawers to accommodate place mats, napkins, cutlery etc as required'.[2]

See Col. Fig.61.

1. Feb/March 1986, pp.856-9.
2. p.856.

John Makepeace (1939-)

Probably the best known of craft furniture makers today, John Makepeace himself first came across well-designed, hand-made furniture when his father commissioned a piece from Hugh Birkett. At school he had the intention of entering the Church, but realised that he wished to become a furniture maker and began investigating the possibilities. Edward Barnsley, repeating the advice of his own father, warned him that it would be difficult to make a living, but like Barnsley he ignored what he was told and was apprenticed to Keith Cooper, a lawyer turned cabinet-maker in Dorset.

Cooper provided a purely practical training and encouraged Makepeace to take up teaching, which he did for two years. He also studied in Scandinavia and the United States and then set up his own workshop, initially in Warwickshire and then at Farnborough Barn, near Banbury, Oxfordshire, in 1963. He had come to the view that design is about visual communication, not craftsmanship for its own sake. This approach brought him commissions from Terence Conran,

Liberty and Kodak Limited among others, and in 1976 he took the bold step of expanding into very much larger premises. Parnham House in Dorset is a sixteenth-century manor house with substantial grounds, and here Makepeace established workshops and Parnham College, to combine the teaching of design, craftsmanship and business management. Furnished rooms at Parnham are opened to the public to demonstrate that contemporary furniture can sit happily in an old house, and exhibitions and lectures are also held there. In 1983, the Parnham Trust purchased 350 acres of woodland four miles away and some five years later Makepeace opened Hooke Park College, to research, develop, teach and demonstrate the industrial uses of indigenous forest produce for buildings and other affordable products.

At Parnham, Makepeace employs six craftsmen, making furniture to his design and to the highest standards. He prefers native woods, but has often used others, and his design ranges from sophisticated structural techniques to simple but bold carved forms.

109 Folding garden seat

Designed by John Makepeace and made in series at his workshops at Parnham. Copyright 1985.
Iroko with brass screws and a steel folding mechanism. The heads of the screws are all neatly lined up and make a decorative feature.

$31\frac{5}{8} \times 54\frac{1}{4} \times 31$ (803 × 1378 × 787)

Given in 1990 by Mr John Baker. 1990.861

Purchased by the donor at Parnham in about 1985 for £750 and used in his garden at Cheltenham.

John Makepeace says that 'What is unusual about the design are the seven pivot points to enable the curved profile of the seat and the back to nest neatly when it is not in use. The seat was also designed to give a degree of comfort which is unusual'.[1]

1. CAGM, Caroline Ducie (PA to John Makepeace) to Mary Greensted, 28.10.93.

Fig.204 **Cat.109**

Tony McMullen (1942-)

Tony McMullen's training began in the furniture trade and he had a thorough grounding in the techniques of cabinet-making. He was also sent by his firm one day a week to Birmingham College of Art, where the tradition of involvement in the Arts and Crafts Movement remained strong. In his own words, 'It was an enjoyable period of my working life; I served a worthwhile apprenticeship at the firm and was trained in the art and craft of cabinet making at college. In those days design was an integral part of craft training together with drawing and the history of furniture. The staff were good and the whole experience made me feel part of an evolutionary process.'[1]

Since about 1970 McMullen has had his own workshop in Bromsgrove. He worked at the College (later Birmingham Polytechnic and now the University of Central England) full time until recently, and like many others involved in the crafts, finds teaching supportive and enjoys working in a creative environment. He now spends one and a half days per week at the College and gives the rest of his time to his own furniture.

At the beginning of his career, half the work he made was designed by others, but he wished to be in control of the design as well as the making. From the mid 1970s, the advent of a few specialist galleries, such as Ann Hartree's Prescote Gallery at Banbury and the Warwick Arts Trust in London, gave him the opportunity to exhibit pieces which developed ideas he had been incubating for a long time and also brought clients attracted by his design work.

He creates bold and dramatic forms, mainly in wood but also using other materials when the design requires them. Similarly, traditional hand methods and machine-assisted techniques are employed as necessary.

Major influences on McMullen's style have come from design of the 1920s and 1930s, and he favours the use of curved and veneered shapes, crisp lines and vibrant geometric marquetry. He also draws inspiration from all forms of creative involvement and is interested in earlier traditions of cabinet-making; he remembers the impact of Sidney Barnsley's work, in particular, at the 1976 exhibition of 'Good Citizen's Furniture'. In recent years he has been consolidating his ideas and simplifying his designs.

McMullen's work is frequently exhibited and is included in the Crafts Council's index of makers. Much of his furniture is made to commission, to suit particular spaces and purposes, but he also has some regular orders, such as the

Fig.205 *Tony McMullen in his workshop, 1987.*

canteens he makes for Robert Welch, the silversmith and designer in Chipping Campden. He has made show cases and fittings for several galleries and in 1992 received a large Public Arts commission for the City of Birmingham libraries.

1. CAGM Notes by Tony McMullen, 1993.

110 Display case

Designed and made by Tony McMullen at Bromsgrove in 1989.

Sycamore and black-stained oak, with glass shelves supported on aluminium rods, and pink billiard ball finials.

$74\frac{1}{2} \times 39\frac{3}{4} \times 21\frac{7}{8}$ (1892 × 1007 × 557)

Commissioned in 1989 from the maker for £1600 with a grant from the Area Museums Council for the South West. 1989.889

Design: CAGM 1989.894

Tony McMullen had designed display cases and other fittings for Birmingham Art Gallery and Museums and so was an obvious choice when the Museum wished to commission a new case. This piece is a development of a narrower display cabinet made for domestic use.

Fig.206 **Cat.110** *The glass bowl by Christopher Williams, two jugs by Walter Keeler, and sycamore bowl by Anthony Bryant were given by the Contemporary Art Society.*